IMAGES OF EARTH & SPIRIT

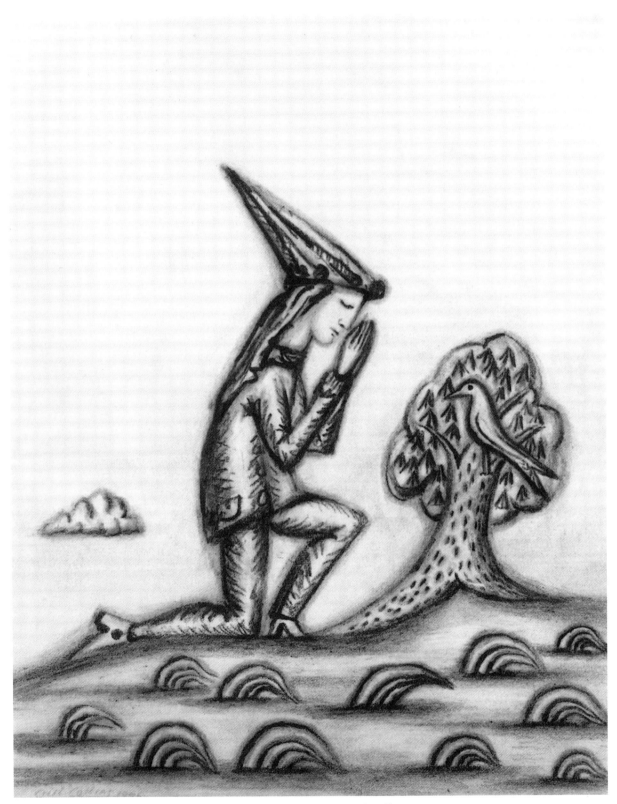

Fool praying: painting by Cecil Collins

Images of Earth & Spirit

A Resurgence art anthology

Edited by John Lane and Satish Kumar

Designed by David Baker

Green Books

First published in 2003 by Green Books Ltd
Foxhole, Dartington, Totnes, Devon TQ9 6EB
www.greenbooks.co.uk

in association with Resurgence magazine
Ford House, Hartland, Bideford, Devon EX39 6EE
www.resurgence.org

Distributed in the USA & Canada by
Chelsea Green Publishing Company
www.chelseagreen.com

The photographic artworks in the 'Hymns to Nature' section (pages 86–123) are
all by the artists, with the exception of the following: page 88, Neil Fletcher;
page 90, Alfio Bonanno; page 105, Dimitri Tamviskos; page 116 Chris Chapman

Printed in England by Butler & Tanner Ltd, Frome, Somerset

British Library Cataloguing in Publication Data available on request

ISBN 1 903998 29 8

CONTENTS

CONTENTS continued

Dedication

The book is dedicated to the memory of Maurice Ash, whose steadfast support over many years was invaluable to both Resurgence and Green Books.

Editor's Note
and Acknowledgements

This art anthology has been arranged in four chapters, but this is a somewhat arbitrary arrangement: in reality they converge in the crucible of colours, beauty, wonder and love. These works are gifts of grace and cannot be divided into categories or compartments. There is an underlying integrity in the images which goes beyond any school, fashion or faction. Readers are invited to join the artists in their journey of joy and adventure.

In making the selection, we chose some articles and interviews which were featured in *Resurgence* over twenty years ago: we felt they were of such interest that we should include them in the anthology. In order to give the book consistency and a timeless flavour, we have removed some references which date these older articles.

I would like to apologize to those artists whose work has been published in *Resurgence* but could not be included in this anthology due to limitation on space or unavailability of appropriate images. I hope that there will be another opportunity, when their work may form part of a new book.

Thanks go to Gordon Campbell of The Academy of Everything Possible, in Dublin. It was Gordon who initially had the vision for this anthology. His financial support and encouragement have been invaluable.

Heartfelt thanks also go to Karen Holmes, who put enormous energy and time into co-ordinating the project. Thanks to Clive Gilson for his help in proof-reading and general overview of the book.

Last but not least, I would like to thank all the artists and authors who have given us their kind permission to use their artwork and articles in this anthology, free of charge.

I consider this book as a contribution to the arts of human, spiritual and ecological well-being. May this anthology inspire more artists to undertake such adventurous journeys of imagination.

Satish Kumar
Editor of Resurgence

INTRODUCTION

Singing the Deep Song

COUNTLESS BOOKS HAVE BEEN WRITTEN about Modernism and its no less countless manifestations: Fauvism, Cubism, Surrealism, Abstractionism, Abstract Expressionism, Dada, and of course the current styles of the day, Conceptual, Video and Installation Art. Studying the history of this phenomenon can leave an impression of almost bewildering variety, but in fact modern art – the art of the twentieth and twenty-first centuries – has been fashioned by a number of unchanging premises which are self-evidently patterned on the world-view of our materialistic, technological culture.

These premises include the complete autonomy or separateness of art and artists, and their undeviating commitment to Progress. In the final analysis, it has been assumed that art should be pioneering and anarchic, produced by self-directed professionals and, it goes without saying, urban, even metropolitan, in spirit. As a result, anything touching on the visionary, the cosmic and transpersonal dimension becomes more or less taboo – as largely, too, have the mythological, the symbolic, and anything that could be described as literary or, worst of all, useful to society. In this context, talk about harmony, environmental responsibility or even aesthetics is an anathema to those who revel in their freedoms and sovereign specialness. Art for Art's sake has one and only one theme: it is about art, and its practitioners should be left alone to practise it.

The artists featured in this book have, either consciously or unconsciously, adopted something of a different agenda. 'The best achievements of British art, this century,' wrote Peter Fuller, 'have always involved a *refusal* of certain aspects of Modernism', and I would say that this is probably true of the artists featured in these pages. Some of them have sought to re-root aesthetics in the study of nature and natural form, some to develop a fresh language for expression of the symbolic and the mythological; yet others, hostile to secularism, are seeking to give voice to the transcendental in their work.

But nonetheless, it's a mixed bunch. Some – say Alan Davie, Cecil Collins and Andy Goldsworthy – have established reputations, while others are almost unknown. None subscribe to any particular School of painting or sculpture and, as far as I know, most of them neither know one another nor one another's work. This, then, is a collection of essays about a number of artists who have little in common except that their work was originally featured in the pages of the bi-monthly journal *Resurgence*. And why, then, were they chosen? Quite simply because it could be seen that there was something about their work which was giving imaginative expression to the ideas and values that Resurgence has always sought to promulgate.

Those ideas and values are broadly representative of the powerful sea change now beginning to affect our world-view and in consequence, the

arts. And if, as has been said, artists are the antennae of the race, it is a sea change of which we will be hearing much more.

Resurgence is not an art magazine – nor, for that matter, a strictly green one – yet it exists to question the very roots of Western thought, and in their place it proposes a number of positive alternatives. These include alternatives to the chimera of unending material progress, the importance of rurality, and the necessity for re-enchantment and spirituality. It also stresses the wisdom of beauty and, above all else, the holistic view – the relevance of interconnectedness.

From the point of view of the artists featured in this book, every one of these factors is of importance; the ecological in its broadest reading, and the spiritual in a no less open interpretation. Both, of course, have been understood in a thousand different ways: here the ecological implies listening to the voice of the Earth, respecting its power and beauty, celebrating its diversity and understanding how the human fits within it – not as a greedy, arrogant, self-appointed Owner, but as a species that accepts the responsibilities of consciousness informed by compassion and reverence.

The spiritual is probably an even vaguer term, and not one necessarily limited to a belief in one of the great religious traditions, though these can provide an important inspiration. Rather, I suggest, it implies a transcendence of the Humanist, secular and largely materialist culture of our time and a reaching out for the things of the spirit: love, beauty, prayer, wholeness – the values that may not pay for life but always sustain it.

The composer Michael Tippett once stated that 'the artist's job is to renew our sense of the comely and the beautiful. To create a dream. Every human being has this need to dream.' Whether or not these 'inner voids' of the spirit are called upon, they are always there. Known or not known, despised or rejected, what Socrates called 'a Divine Something' exists to call each one of us to live and give expression to our whole selves. This calling can come as a prophetic dream, a vision, an oracular knowing, an inspiration (such as Blake and Mozart experienced), or the Shaman's journey; either way it comes as a visitation that directs us to respect the truth of the soul's interior abundance. As artists, we carry a special responsibility to act as its guardians. Our responsibility, in the beautiful phrase of Federico Garcia Lorca, is to sing 'the deep song'.

An attitude such as this may be foreign to the sterile and fashion-conscious world of the commodified art market, and the tyranny of the museum committed to the pretence of the vanguard. Yet if the painters and sculptors discussed in this book should be as hungry for 'success' as, say, some of the most famous art practitioners, that is not the reason why they are represented here. They are here for quite another reason. To my eye, their work carries the healing needed for our redemption. It speaks of a new sense of the universe, a new sense of spirituality, holism and interconnectedness, openness and non-determinism. It gives hope for the renewal of life in the future. For just as a sick animal will search for the healing herbs necessary for its survival, so we now need to find the nourishment to feed our starving souls. For that purpose I urge a study of the images featured in this book.

John Lane
Art Editor of Resurgence

LIVING
TRADITION

The greatest thing that a human soul ever
does in this world is to see something and
to tell what it saw in a plain way.
Hundreds of people can talk for one who
can think and thousands can think
for one who can see.
To see clearly is poetry, philosophy
and religion – all in one.

John Ruskin

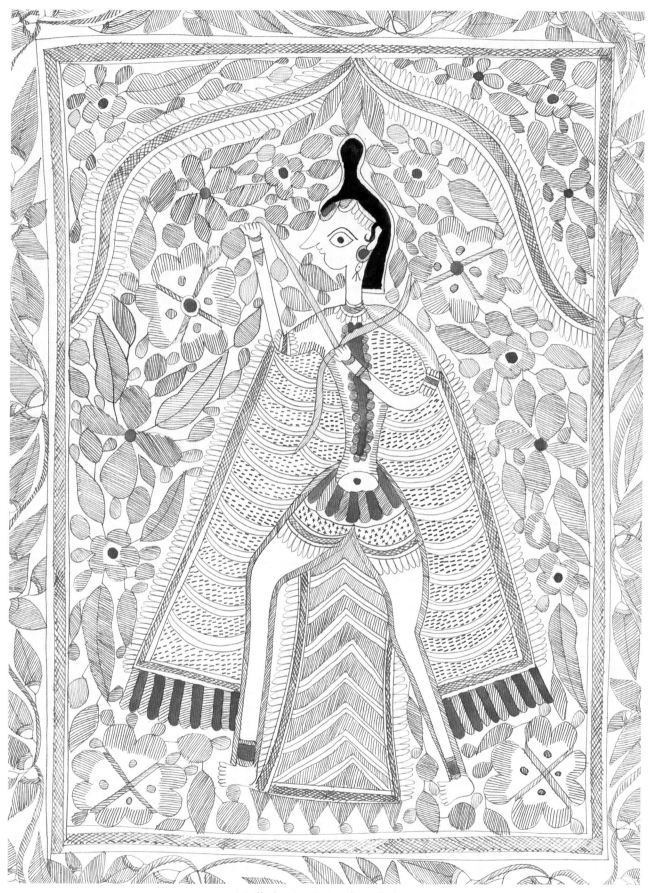

Madhubani painting from Gujarat

11

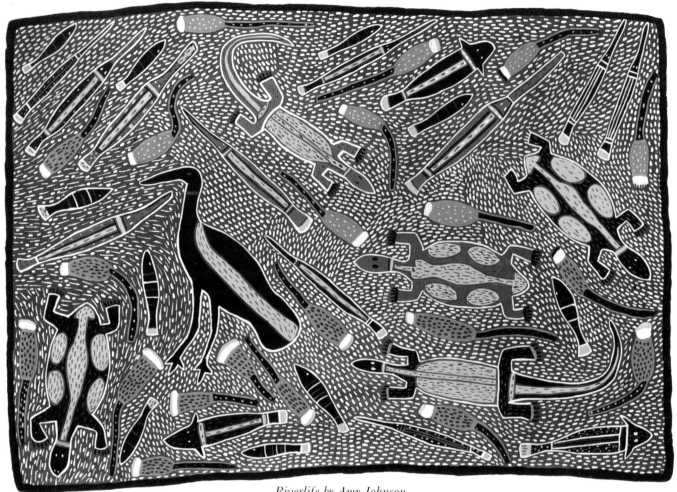

Riverlife by Amy Johnson

ABORIGINAL ART
Images of Dreaming

Fifty per cent of the Aboriginal people of Australia
consider themselves to be artists, says *Victoria King*

THE ABORIGINAL ART of Australia contains an extraordinary vision, incorporating a non-dualistic seeing and a profound sense of place.

Perspective within Aboriginal culture is a high ground. In land-based cultures a perspective is valued not just for outlook, but for meetings, community, and a way of life. To see a situation from all sides implies wisdom and compassion.

The Aboriginal way of life is dependent upon sensitivity to the environment, to oneself, to others, and between different language groups. The artist becomes a scribe of mystical and profane events, the two interwoven. The paintings on rocks and cave walls become maps of experience. Flying over the Australian desert, looking down over an infinity of ochre-red expanses of colour, one sees Aboriginal paintings spontaneously coming to life.

The gesture an Aboriginal painter makes with his or her ochred brush has a life born from

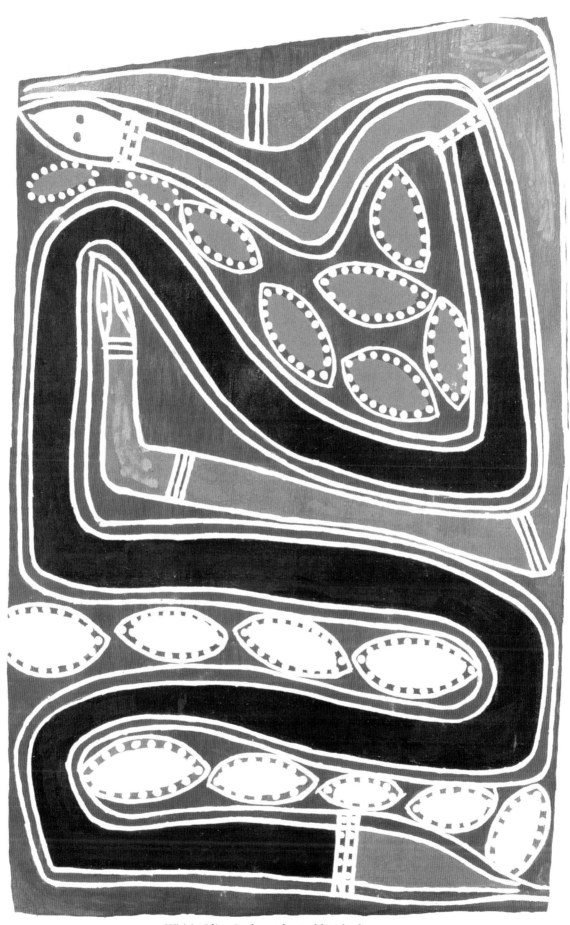

Wititj (Olive Pythons) by Paddy Dhathangu

13

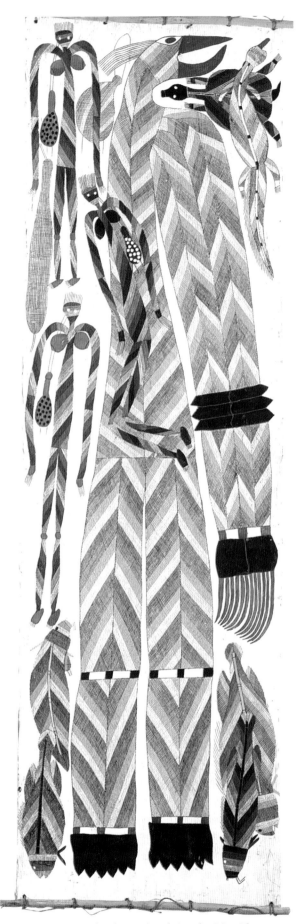

Nawora, the dreamtime being by Djawida

Dreamings, from their ancestors, from time immemorial. It is made literally on the land, the artist's homeland, a spiritual centre. The artist is enacting a ritual carried out at one time or another among peoples of all continents. It is direct. Here the doing and the being are one act.

The curator of the South Australian Museum, Peter Sutton, comments: "There is a very strong connection between the use of symmetry in Aboriginal art and the powerful commitment to the balance of reciprocity, exchange and equality in Aboriginal thought."

Aboriginal art appears abstract, yet is distinctly narrative. It is based on obligations to the land, to each other, and to the ancestors. The Dreaming symbols are by the artists who are connected with them, and these have been passed on to them by the elders of the community. The Dreaming is literally sung on to the canvas, bark or ground. These Dreaming songs are the essence of Aboriginal culture. The meaning, the cosmology and the art are one whole.

Dreamtime is a term used to express the Aboriginal cosmology of creation. It is an embodiment of the spiritual forces of the Universe. It links a natural and spiritual philosophy with the self and the land. While the Dreaming stories are sacred and particular, the individual artists are free to express their own interpretations, holding the original story as inspiration.

THE HISTORY OF THE modern Aboriginal acrylic dot painting movement began in 1970 in the government settlement of Papunya. Here a group of senior initiated Aboriginal men began making art from their own culture. From the rock paintings and rock engravings, the ceremonial adornment of the body with ochre designs and ritual sand paintings made of ochres, blood, feathers, twigs and seeds, an outpouring of thousands of years of experience flowed profusely into this new acrylic medium and has become an internationally recognized art movement.

Peter Sutton says: "You can know its visual aesthetic impact on you, but you need to approach the works on more than that narrow front if you are going to get into them deeply. If you know nothing about the Dreaming story involved, all you have done is colonize it, remove it from its context and turn it into a bit of wallpaper."

Rob Russell stated that fifty per cent of indigenous people in Australia refer to themselves as artists. With all of the introductions and intrusions of Western materialism into their culture, they have made a choice to continue to honour and celebrate that which is sacred to them through painting, printmaking, sculpture, dance, music and acting. •

14

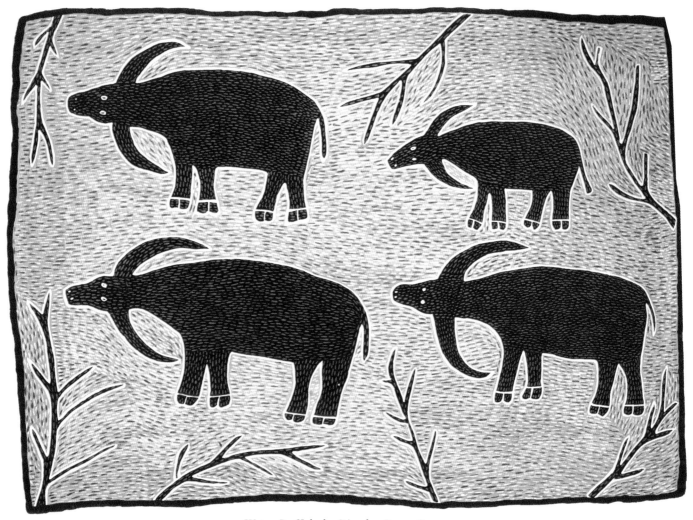

Water Buffalo by Djambu Barra Barra

ABORIGINAL ART
Art that Connects

Aboriginal art carries the viewer into the heart of a landscape
that is at once physical and spiritual, believes *Matthew Sturgis*

"OH, YES – ABORIGINAL Art; it's all those dots and circles, isn't it?" Many critics, when faced with the broad field of Aboriginal painting suffer from a foreshortened cultural perspective. They assume a homogeneity amongst the peoples and works of aboriginal Australia. Differences are flattened out and everything is merged together. Of course there are elements of shared belief and common iconography, but it is the differences that are more telling.

Australia is a continent, and the aboriginal peoples, who made it their home for over forty millennia before the arrival of European settlers, developed with all the diversity that might be found amongst the peoples of Europe or Asia. There are over 400 different aboriginal languages, and even more distinct peoples. Each group has its own cultural traditions, fostered over tens of thousands of years – traditions of music, dance, ceremony and painting. Each people evolved its own iconography, its own

forms of representation for paintings that were made on rock shelters, on bare torsos and on the shifting sands.

With the development of the contemporary Aboriginal Art Movement during the second half of the twentieth century, these traditions have found a new outlet and have developed a new vigour. Paintings are now made for sale and permanent display. They are made in multiple media – in paint on bark, board, canvas and paper.

THE WORK PRODUCED by contemporary aboriginal artists, far from conforming to a single style, reflects the diversity of the culture from which it springs. Over the course of summer 1999 there was a rare opportunity to see in London something of this strength and diversity. On show at the Rebecca Hossack Gallery there was work from three of these very different artistic traditions: bark paintings from Arnhem Land, dot-paintings from the Gibson Desert, and some of the richly idiosyncratic art from the wetlands of Ngukurr in central northern Australia.

Although it is a common assumption that bark painting is somehow the authentic mode of aboriginal artistic expression, this is not the case. The Yolnu people of Arnhem Land have, it is true, always decorated their bark shelters. But the great tradition of Arnhem Land bark painting is more recent. It has its origins only in the 1950s.

Their position on the wild yet fecund coast of central north Australia has given the Yolnu people both an enduringly strong sense of their own culture and a long tradition of interaction with outside peoples. It was the Yolnu who, several centuries before the arrival of European settlers, had come to an accommodation with the Malayan trepang-gatherers who made seasonal visits to their shores. As a result of such contacts Yolnu culture has long developed a sense of openness to outside influences.

The images and stories depicted in their bark paintings are drawn from their age-old traditions; the iconography and the method of painting are ancient too. The materials used are part of the mythic landscape they depict: the bark itself is cut from the Eucalyptus tetradonta, or stringybark tree; the pigments used are ground from the local earth; and they are fixed either with orchid juice or wood glue. But the impulse behind the work and the format adopted are inclusive. The pictures were made – and continue to be made – for sale or gift, as part of an ongoing dialogue between aboriginal and non-aboriginal worlds.

VERY DIFFERENT IN TONE, in style and in origin is the work of Warlimpirrnga and Walala Tjapaltjarri, two artists from a 'Lost Tribe' of aboriginals who lived – without white contact – in the Gibson Desert on the borders between Western Australia and the Northern Territory until 1984.

The two artists were born in the 'Bush' – probably in the late 1950s, or early 1960s – and while other aboriginals in the area were being forcibly settled on government stations further east, their small family group escaped the net. They continued to live the traditional aboriginal life of nomadic hunter-gatherers, travelling through their harsh but beautiful environment along their ancient 'songlines', observing the time-honoured rituals and ceremonies of their culture. They avoided all contact with twentieth-century Australia until 1984. It was then that they were 'found' by a party from a recently resettled aboriginal outstation at Kiwirrkuru.

The discovery created international headlines. It also created a new life for the wandering tribe. Needing to find wives from outside the limited family group, they moved to Kiwirrkuru, the tiny settlement of some 180 people, famed as 'the most isolated town in Australia'. It was at Kiwirrkuru that Warlimpirrnga and Walala began to paint on canvas for the first time, setting down the stories and images of an unbroken cultural tradition stretching back tens of thousands of years. Their work was, from the outset, distinguished by an extraordinary intensity and assurance. Using modern acrylic paints but the limited repertoire of symbols and the distinctive aerial perspective of most aboriginal 'desert artists', they created paintings of great power. The strength of the work was recognized at once. It carries the viewer into the heart of a landscape that is at once physical and spiritual.

This sense of interconnectedness not only between all the elements of the living landscape – plants, people, animals, rocks, skies, rivers and the firmament – but also between the living landscape and its origins in the great creation myths of the Dreamtime, is an element that lies behind all aboriginal art, no matter what its medium, or its outward form.

It is found in the paintings of Warlimpirrnga and Walala, in the barks and prints from Yirrkala, and also in the vivid, colourful canvases of Djambu Barra Barra. Stylistically, Barra Barra is one of the great originals of the Aboriginal Art Movement. His bold images of crocodiles, buffaloes, ant lizards and 'Devil Devil Men' are engaging and instantly recognizable.

Yet his originality is rooted in tradition. The animals and the stories he depicts are his totemic heritage, and the way he depicts them owes much to past practice. He trained as a bark painter, and he still employs the distinctive tropes of Arnhem Land bark-painting – cross-hatching, mixed perspective and 'x-ray vision'.

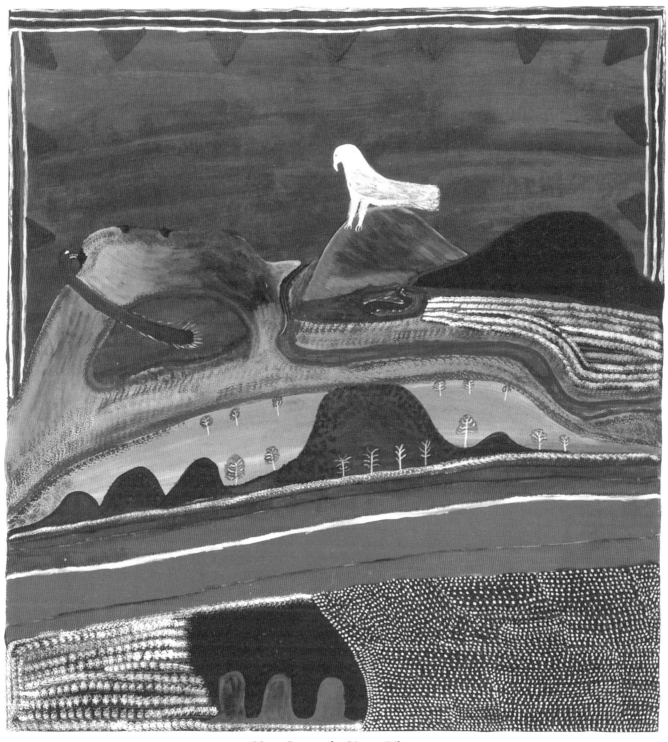

Mara Country by Ginger Riley

He has, however, combined this tradition with new media. Like most of the artists in his community at Ngukurr, he has adopted acrylic paint and canvas, and he uses them with extraordinary exuberance. His painting takes one to the heart of the great paradox of Aboriginal Art: it is at once the most ancient and the newest of artistic traditions. It draws on unbroken cultural tradition that still conceives of Land, Spirit and People as a connected and balanced whole, and it employs forms and symbols that have been sanctioned by millennia of unbroken use. And yet it constantly seeks new ways of combining its symbols and of expressing its truths. ●

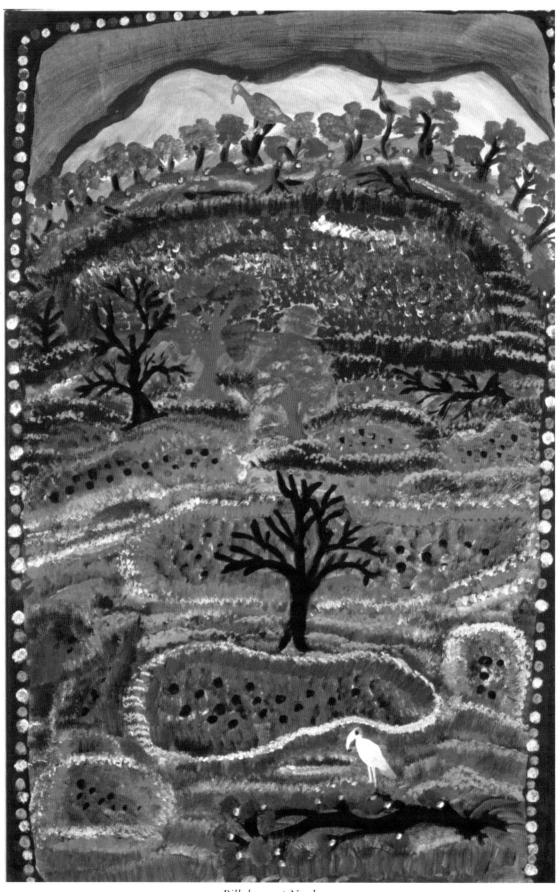

Billabong at Ngukurr

18

GERTIE HUDDLESTONE
Wonder of Oneness

In this art there is no battle of egos,
only a celebration of unity. *By Rebecca Hossack*

GERTIE HUDDLESTONE came to painting late, and had her first exhibition when in her sixties. An Australian aboriginal, Gertie was born at Ngukurr in the Northern Territory and still lives nearby. Her paintings, bursting with bright colours and clear forms, are perhaps more accessible than many of the non-representational 'dot-and-circle' pictures of the Western Desert aboriginal painters. Yet, they share many similar concerns.

Gertie's extraordinary appeal and power lie in her childhood. She was raised at the Roper River Mission, where her mother sewed clothes for children. Gertie attended the school at night and during the days she worked – gardening, looking after the goats and milking the cows.

Yet alongside this Christian education and farm work Gertie also imbibed the traditional stories of her people.

She learnt of the Dreamtime, which gives to every feature of the natural world a mythic and spiritual significance. And she learnt techniques of hunting and gathering food in the Bush. These two worlds come together in Gertie's art. Instinctively she has drawn from the two traditions of her upbringing a common theme – the unity of Creation.

Her pictures teem with life – with insects, birds, fishes, flowers, grasses, people, artefacts – the symbol of the Cross is also often present. She paints the landscapes around Ngukurr and describes her food-gathering expeditions to favourite sites.

She eschews, however, any conventional sense of scale or narrative. Butterflies are bigger than people, flowers are bulkier than birds. She holds this carnival of life and colour firmly in place with only her unforced sense of design and order. She grasps the pattern beneath the diversity – and she allows us to see both. The world she represents with such directness and vitality is truly holistic. Her vision is of the unity of all beings.

THE GLORIOUS FECUNDITY of nature has, of course, its corollary in the glorious fecundity of the artist's creative spirit. There is a harmony about Gertie Huddlestone's obvious delight in the richness of the natural world and the richness of her palette and her designs. But more striking than this is the place in this rich natural world that she finds for human beings. Their position is not privileged. They are merely a small part of the whole, no bigger and not more important than – say – a beetle.

This understanding is one of the abiding tenets of the Australian aboriginals' world-view. They set no boundary between people and the rest of the natural world. Nor do they arrange creation into obvious hierarchies. In part, no doubt, the aboriginals have preserved this world-view on account of the Australian environment and the way in which they have adapted themselves to it over the millennia.

Without crops or pastoral animals, they have always lived lightly in nature – as nomads, hunters and gatherers. Although they use fire sometimes to clear underbrush, they have no sense of control over the environment. For the aboriginals, human beings are a part of nature, and not its masters. The aboriginals know that they depend upon the gifts of nature. The essential humility of this vision is apparent throughout aboriginal culture and it is everywhere to be seen in Gertie Huddlestone's pictures.

Another aspect of humility is also evident in Gertie's work. Aboriginal culture, traditionally, is shared by the community – the stories, dances, body-painting motifs and earthdrawing patterns are preserved by the tribal elders and passed on to the young when the time is right. There is no tradition of personal authorship. Gertie Huddlestone often works with her sister Amelia George, each of them completing half the work as they discuss the events and places represented in the picture.

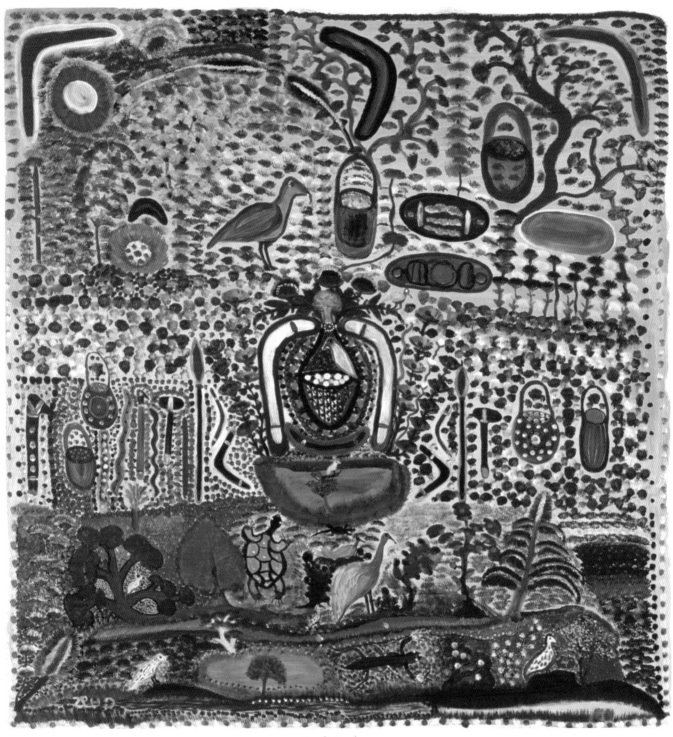

Bush Foods

One only has to imagine attempting this exercise with a friend to realize just how hard it would be both technically and emotionally. The sisters, however, are so sure of their common vision and understanding – so happy to sacrifice the insistent 'self' – that these collaborative compositions show no sign of strain or incoherence. There is no battle of egos, only a celebration of unity.

Gertie Huddlestone gives us a glimpse of the wholeness that aboriginal culture has managed to preserve. Her art offers a doorway into this world, which for all its specific topographical references – the carnival of curious birds, beasts and bugs – carries an unmistakable echo of the universal spirit. Her pictures inspire not only a sense of wonder but also a sense of oneness. ●

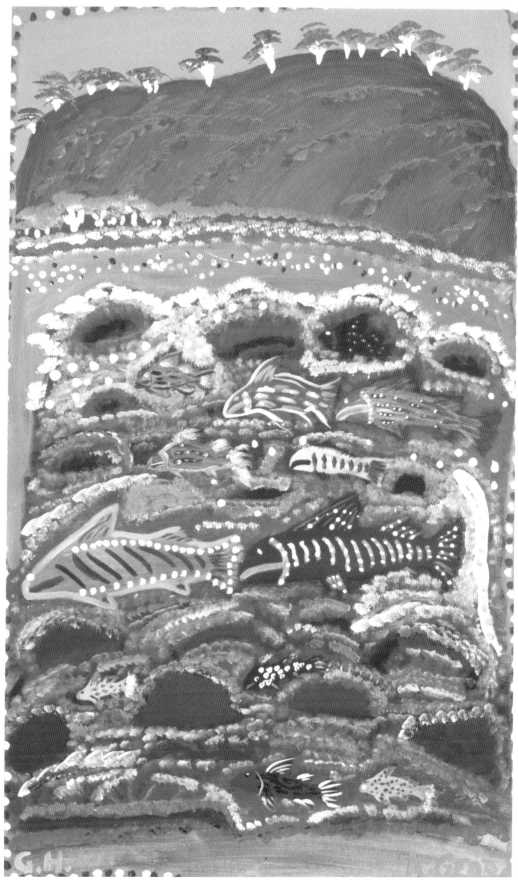

Fish

JANAKPUR ART
Peasant Beauty

The women of Janakpur may be illiterate, but they are great artists.
By Rebecca Hossack

I N MANY TRADITIONAL and tribal societies, the word 'art' did not exist. In Hindi, a major language spoken in north India and parts of Nepal, the word meaning 'art' is synonymous with 'skill', which means things well done or acts well performed. These include everything from cooking, dancing, building and singing to painting. There are eighty-four named skills. An art historian from Sri Lanka, Ananda Coomaraswamy, said, "In the Indian way of thinking, an artist is not a special kind of person, but every person is a special kind of artist." The women of Janakpur (a town on the plains of southern Nepal, near to the Indian border) do not consider themselves to be artists. Nevertheless, for many centuries they have been painting richly imagined and skilfully executed colourful pictures on the mud walls of their homes. This is part of their way of life, tradition and culture. These pictures relate to the seasons, festivals and myths. Though always beautifully worked, they were never meant to be permanent. They were either washed away in the rains, or painted over with fresh pictures at the next festival.

In recent years the women of Janakpur have

Paintings by Suhagbati Shah

been encouraged to paint pictures not just on the walls, but also on handmade paper. Thus people in wider India and in the West can enjoy and celebrate the beauty and simplicity of their art.

These women are peasant-artists who live in a very simple setting. Their material standard of living is low but the quality of life and family bonds remain very strong. Much of their time is devoted to domestic duties – farming their land, building homes, weaving – and taking care of guests, the elderly and children, and also taking part in the numerous festivals that form the Hindu calendar. This leaves little time for art, yet after having performed their daily duties, they are still able to decorate their homes and paint the pictures on paper in such an exquisite manner that outsiders are always amazed.

This artistic tradition has survived perhaps because of the lack of outside influences. The inability to afford mechanized and industrialized methods of making things and the lack of an academic education have kept them going on the path of simple techniques. In many other parts of India where modern methods have prevailed, artistic traditions

have vanished. This seems to be a great paradox; Under the shadow of poverty and illiteracy, this tradition of decorative art has flourished. The challenge for them is to keep the art alive whilst gaining improved living conditions. Unfortunately, the young who are going to school are being lured by the attractions of modern society and losing the skilful iconography. It is mostly the older and illiterate women who are producing these great works of art.

The women of Janakpur have come together and established the Janakpur Women's Development Centre so that they can sell some of their paintings, and achieve recognition and respect as well as an income from their art. Increasingly, urbanized people who have money and education but have lost their innocence are finding nourishment and joy in the beauty of Janakpur art. The scenes of landscapes, trees, animals and rivers presented in an uncomplicated manner highlight the serenity of the life of the Janakpur people.

These beautiful Janakpur paintings summon up a vivid and idiosyncratic world in all its splendid diversity. ●

MADHUBANI ART
Culture of Making

India unites arts and crafts. *By Satish Kumar and June Mitchell*

GUJARAT IS THE LAND of Lord Krishna and the Jains. Mahatma Gandhi, who was born in Gujarat, was influenced by both. Now there is a tremendous confluence of inspiration coming from Krishna, Jainism and Gandhi. Ultimately the message of Krishna, the Jains and Gandhi is one and the same. It is the message of simplicity, generosity and community – in one word, nonviolence. It is the guiding principle of all three traditions.

After six hours of driving from Mount Abu, we arrived in the city of Ahmedabad, the capital of Gujarat. The city used to be the textile capital of India, but now those industries have disappeared. The only thing left is the wonderful textiles collection at the Calico Museum.

The antique and modern textiles, rare tapestries, wall hangings, woven tents and canopies, embroidered coverings for elephants, embroidered chariots for pulling the images of the gods and goddesses, were all there, as were saris of every conceivable weave, warp, weft and colour. We were

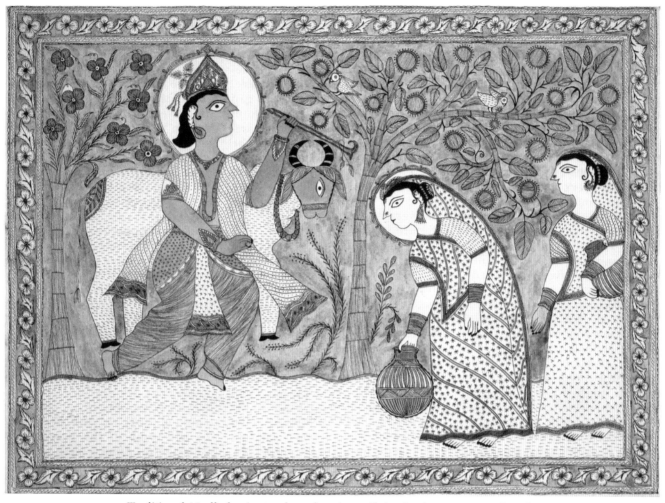

Traditional Madhubani art, where there is no distinction between art and craft

particularly struck by a thin white cloth, which seemed like a plain cloth until the guide lit a light behind it. Suddenly an amazing tapestry was revealed: trees, birds, animals, humans, all made of white thread, emerging like a whole universe out of a piece of white cloth, like Blake's poem:

"To see a world in a grain of sand
And a heaven in a wild flower
Hold infinity in the palm of your hand
And eternity in an hour."

The Calico Museum offers two guided tours every day from 10 a.m. to 12.30 p.m. and 2.30 to 5 p.m., and admission is free.

We stayed at Gujarat Vidya Peeth's guest house. This is a university which was established by Mahatma Gandhi in the thirties. By that time, much of India's formal education was Anglicized. The aim of British education was to create a class of Indians who were Indians in body but English in taste and mind. Such an educational system could not serve independent India, thought Mahatma Gandhi, so Gujarat Vidya Peeth was established to recover and reinvent an Indian system of education.

According to the Mahatma, British education was analytic while Indian education was based on synthesis. The purpose of British education was to oil the wheels of bureaucracy and commerce, whereas Indian education was founded to seek spiritual values. British education emphasized individualism and personal success whereas Indian education was meant to develop a sense of community and personal fulfilment through service to others. British education created a hierarchy of professions: an office worker, a bureaucrat and a banker were considered to be more valuable and therefore better paid, whereas a farmer, a weaver, a potter and a barber were nearer the bottom of the hierarchy and therefore less respected and less well-paid.

In Gandhi's view this was erroneous. The skills of a manual worker or a craftsperson must be equally valued. Furthermore, there should be no

division between the manual workers and office workers. Office workers need to learn to participate in manual work and vice-versa. Thus Gujarat Vidya Peeth was established to train young Indian men and women in manual skills as well as mental skills, and to teach social skills as well as spiritual skills. Knowledge is a way to learn humility, nonviolence and truth. Gandhi discarded the idea that 'knowledge is power'; he believed that knowledge should be an instrument of service. The knowledge that brings arrogance is not true knowledge.

At that time the medium of education in all Indian universities was English. This was the first university where learning took place in the native language, Gujarati, and also in Hindi. Teachers and students participated in cleaning, cooking, spinning and community service alongside academic training.

Alas, this is now history. After Independence the Indian government failed to change the British system. It took over the educational initiatives started by national leaders, such as Gandhi at Gujarat Vidya Peeth and Tagore at Shantiniketan, and corrupted them. The dead hand of bureaucracy came upon them together with the lure of money.

Nevertheless, some of the ideals of Gandhi still linger. We saw teachers sitting on cushions on the floor with students engaged in intimate conversations. This was the class in Jainism. This reminded us of traditional scenes where student participation, oral communication and deep questioning formed an essential ingredient for learning.

Hospitality, a friendly atmosphere, and courtyards with tall and mature trees made us feel that the spirit of Gandhi was still present.

Gandhi's ashram on the bank of the Sabarmathi river is just down the road. It is visited by large numbers of people every day. There is an excellent museum at the ashram, where Gandhi's life and times are depicted through photographs and charts. This pictorial record of the important events of Gandhi's life is inspiring. The ashram was founded in 1918 when Gandhi came back from South Africa, and it was from this ashram that the long struggle for India's independence began. When Gandhi left the ashram on his famous salt march he declared that he would never return to this ashram, his home, until India was free from British rule. However, many of his friends and colleagues continued to live there and still engage in handicrafts, gardening, education and, particularly, the spinning and weaving of handmade cloth (*khadi*).

At the time of Gandhi, Ahmedabad was India's most famous textile town, where cotton mills were taking away the livelihoods of spinners and weavers. Like William Blake and William Morris, Gandhi was against those 'satanic mills', and initiated a strong campaign to renew the craft traditions of India. His spinning-wheel became the symbol of the independence movement and was on the flag of the National Congress Party. Spinning was a metaphor for all village crafts and now, in spite of the fact that the Indian government treats handicraft as a poor relation, craftspeople of India are rising to claim their rightful place in Indian life.

IT GAVE US GREAT PLEASURE to visit the craft market, Dastkari Haat. Artisans were selling their wares of exquisite quality to the citizens of Ahmedabad: jewellery from Jaipur, pottery from the Punjab, bangles from Bihar, paintings from Bengal, shawls from Gujarat, blankets from Jaisalmer and hundreds of other items from all over India were on display. They combined Beauty, Utility and Durability. This was the BUD principle in action. The great craft tradition of India embodies the philosophy that when we make something it should be simultaneously Beautiful, Useful and Durable. These crafts also reduce the gap between art and craft, between form and function, between ethic and aesthetic. When work is done well, done with love and care, done with skill and spirit, then work is transformed into art.

There was another stall: the village artists from Madhubani in Bihar. By the time we bought two pictures from them, they had invited us to their homes and asked us to help them to restore respect for village artists. They said: "Our art is either ignored or turned into a commodity, and a few artists are isolated and promoted while others are ignored and undermined. This is not our way. For us art is not a business, it is a way of life. Together with farming, weaving and home-building, we also engage in singing, painting and storytelling. This is a continuum of life. Art is not a separate activity."

These sentiments are difficult to understand in the modern world, where commercialization of art is the dominant paradigm, where art is for the museums or to decorate the living-room walls of those who are privileged and powerful; but they themselves will never pick up a brush to paint.

The craft fair lifted our spirits – surely Mahatma Gandhi was smiling in heaven. If there is a way to save Indian culture from disintegration, people of India have to embrace crafts more seriously than they do now. The city of Ahmedabad in particular and Gujarat in general still keep a degree of faith with crafts. Gujarati shops are selling well-made and inexpensive craft goods and there are a number of other craft shops and centres able to compete with the mass-produced wares. Even the famous Sarabhai family is championing high quality clothes made by the hands of accomplished weavers, tailors and designers. ●

Ohanga 3

JOHN BEVAN FORD

All Pervasive Art

In pre-European days, Maoris had no word for art. It was part of life.

By John Bevan Ford

I WAS BORN in the South Island of New Zealand in 1930, to parents who were also born in New Zealand. In my culture, art was the centre of our identity. In pre-European days my ancestors had no word for art; it was all-pervasive.

By the 1930s, when I was a child, being Maori was no longer associated with grand, carved buildings or uniquely woven clothing. It took only a plaited belt, a stone ornament or a small carved utensil to make Maori identity vividly present. The tradi-

tional carved buildings and the clothing were still there, but the occasions to spend time in that sort of environment were few.

My mother's people lived in the North Island. During the depression of the 1930s, finances rarely allowed us to visit our relations in the North she so often mentioned. My mother sang the popular Maori songs which she had learnt when she was a teenager, and she often played and sang with Maori entertainment groups. My father, who was of

From the Navigator series

English and German descent, was radically pro-Maori and proud of my mother's ability to sing those songs. When we went to live in the North Island in the early 1940s, it was my father who dragged me from one Maori relation to another and encouraged me to become a Maori artist.

MY FINAL YEAR of secondary education was spent almost entirely in the art room, where a wise teacher made me realize that through art I could express my ideas and opinions in an imaginative way. Eventually, my education steered me into the Art and Craft branch of the New Zealand Department of Education where I spent almost twenty years as

an itinerant art adviser to schools. During this time the supervisor of the Art and Craft branch, Gordon Tovey, had accumulated a large number of Maori advisers. In the mid-1960s we were 'gathered together' to spend time with old traditional artists, learning our own Maori art so that such arts could enter the mainstream of New Zealand education.

In order to develop a deep understanding of its various tribal traditions as well as to be a part of its change and growth, it was suggested that we must first discover ourselves in the most complete cultural sense. Not just the visual arts, but dance, song, story and ancient explanations became part of this discovery. We also learned skills to bring the old

From the Navigator series

knowledge into the present culture for the benefit of our children.

From this exercise emerged the group of artists who created a renaissance of Maori art. Initially the new images and seemingly strange juxtaposition of old and new that emerged seemed a danger to our elders. Although the concept of *whakapapa* (genealogy), which is central to Maori art, requires one to respect individual identity, the relationship between genealogical identity and individual style had become weakened through years of cultural embattlement. As our people struggled to survive colonization, they became more conservative, in the fear that all might be lost.

That period had passed, and we had no such fear. We wished to pick up the creativity that lay behind whakapapa. For Maoris, whakapapa is not just a list of names in a family tree, but stretches back though the ancestors to the mythological sense of active space, emergent light, receding and advancing darkness, to an ambivalent beginning of a contradictory void: 'the nothing' and 'the not nothing'. In simple terms, whakapapa was a belief in eternal change.

Into that inheritance we would dip at random, not just in the near past, but wherever we felt was held the greatest creative potential for the present and future, maintaining the artistic integrity of that heritage.

IN MY OWN WORK the strands come out from the cloaks (realizing that the cloak is actually made from strands) and reach out into the spaces around it, activating those spaces and thus acknowledging the role of space in growth and change.

The cloaks themselves bring together some personal threads. My mother's grandfather used threads from the flax to make ropes for sailing ships. Her grandmother used flax threads to make cloaks. Fine cloaks identified great chiefs and promoted their dignity and power (*mana*). I now suspend these cloaks over land and sea to express the *mana* of those places and of the people who live and have lived there. These cloaks reach out to link people. Just as a cloak warms us physically, it can warm us spiritually. ●

29

Circles in the Sea

YNEZ JOHNSTON

World of Shapes

A cohesive, organic and magical vision. *Interview by Satish Kumar*

THE SMALL WINDING road took us to the top of Mount Washington in Los Angeles. This neighbourhood is unlike any other in the city; the city is built for cars, but the people who have chosen to live in the community on Mount Washington like walking. Houses are small and surrounded by trees. No wonder many artists and craftspeople live in this area; painter Ynez Johnston is one of them. Somehow Ynez had received a telepathic message of my coming. Of course, I had an appointment to see her, but how did she know the precise moment of my arrival? She was waiting for me out in the street in front of her house!

Ynez, a woman of eighty-two, is as agile and energetic as someone half her age. She wore casual clothes, short hair and a big smile on her face. She ushered me into the front garden, which was full of sculptured figures and images interspersed with flowers and trees. Moss and lichen had grown on the sculptures; the weather had given them a soft and friendly character.

"Who made these?" I asked. "My husband John Berry and I worked together to make them," said Ynez. "He was a poet, a writer and a very handy man. We much enjoyed working together on many practical projects." The interview had already begun while we were going around the garden and the house. Every bit of wall, every bit of floor space and every nook and corner of the house was filled with sculptures, ceramics, and of course paintings. Ynez is so prolific and active.

"What attracted you to the arts?" I asked. "Making comes naturally to me. It always has. I think through making, and images emerge. I find joy in being engaged with colours, shapes and forms," Ynez replied.

"What were the early years like?" I asked. Ynez spoke softly, quietly and slowly; it was clear that she was much more at ease with images than with words, but I listened to her with patience, and was rewarded. She replied, "I was born in 1920 in Berkeley, California. Climbing and walking in the hills of the Bay area, watching the water all around

me and seeing those boats with their sails coming and going was very inspiring. Spending my childhood in such surroundings, being brought up beside trees, water and boats, fed my imagination."

I asked her whether she had studied art. "Yes, I did," she answered, "and so I was also exposed to art galleries and museums. I was particularly drawn to oriental galleries. The works there spoke to my soul." "Then what happened? What did you do when you finished university?" I asked. "I was very fortunate: I won a scholarship in 1941 to go to Mexico. That was a turning point in my life: to see and experience a society where people, plants, animals, rivers, forests, land and architecture were a seamless whole was an eye-opener. It was so different from anything I had seen before then. Life was not divided into bits and pieces: everything was integrated into everything else. The magic of Mexico made a powerful impact on me and that started to be reflected in my work. I was there for three years and I have carried a bit of Mexico with me ever since."

"When you returned, where did you go?" I asked. "Oh, I kept drifting here and there. I was lucky again as I was awarded a grant by the Huntington Hartford Foundation. The Foundation had a residential centre in Los Angeles where writers, poets and artists were given a place to live and work. This was a god-sent gift to me. I had a room to live and studio to work in, and meals were provided. Moreover, I had a great opportunity to meet many creative talents there. For example, I met Christopher Isherwood, who introduced me to Indian spirituality and oriental philosophy in which I already had some interest from university days. I was there only six months, but it was a very intense period. I had peace and quiet and I had space and time. I was able to produce work that laid a firm foundation for my later paintings. There I also became attracted to perennial philosophy, which led me to the works of Aldous Huxley, Alan Watts, J. Krishnamurti, Coomaraswamy and Rilke."

"So, Mexico introduced you to the mythology and magic of life, whereas Huntington Hartford

Sunrise

brought philosophy and spirituality to your soul," I interjected. "You could say so," nodded Ynez. "At that time you also met Mark Rothko – what did you think of his work?" I asked. "I met him at Boulder, Colorado in 1955; his work is very different from mine. I work with figures and shapes, whereas Rothko has a gift to capture our attention without any figures and images. I find that amazing. He has a calmness of colours that is very spiritual. There is a sense of tranquillity, restfulness, stillness and silence in Rothko's works – yet he is so engaging. It was my good fortune to meet him."

"How did you meet your husband?" I asked. "In 1957, I managed to get a second residency at Huntington Hartford Foundation. John was there too. We started to see each other and work together on some sculptural projects. John was very keen on India. He had studied and taught at Shantiniketan, the university started by poet-philosopher Rabindranath Tagore. In 1964 he received a Fulbright grant, and that enabled us to

32

Sea Bridge

go to India and spend nine months there."

"How was that?" I asked. "Fantastic. John knew India well so he became a great guide for me and we travelled extensively. India is an art treasure. Life and art there are so integrated – just like Mexico, but even more so. People in India make so many things by hand to meet their everyday needs. They are simple and ordinary things, things that they use daily, and yet they are so beautiful. Their folk art, dance, music – everything fascinated me. The miniature paintings, erotic carvings, temple sculptures and architecture captivated me. And then I came across the Tibetan thanka paintings. Seeing these wonderful paintings changed my whole experience and outlook. I was totally mesmerized by them. I have tried some thanka techniques in my own work."

I observed that she had done a great deal of travelling in her life. "People say that life is a journey. It is. But journeying itself is also life," she replied. "In my many voyages I have discovered life, and discovered too that life itself is art." ●

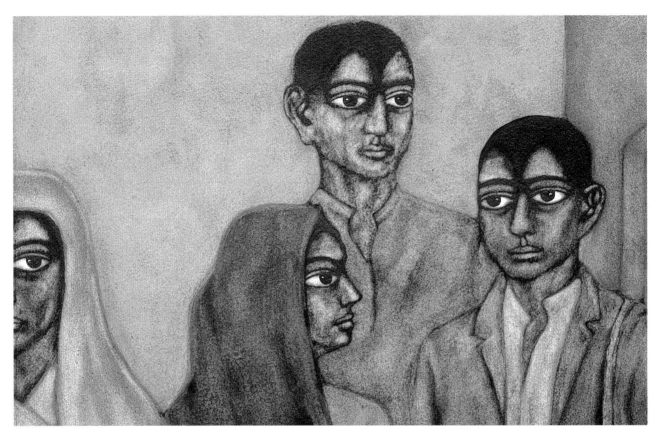

Departure, 1990 (detail)

SHANTI PANCHAL

Timeless Art

Painting is a meditative process. *Interview by Philip Vann*

WHAT WAS YOUR **village upbringing like? When did you first start to paint?**
The village I grew up in in northern Gujerat was like a large family, but it was very isolated. Even now it is not shown in local maps. It's very rural, in the true sense. It had no electricity; water was drawn from wells.

Art as we know of it in the West has no existence there at all. My mother made beautiful containers with papier maché and clay for daily use, but you would never call her a potter or sculptor. When I was 9 or 10, people used to ask me to decorate their mudwall houses, which they used to whitewash for wedding ceremonies. I used red clay as paint. There were no brushes. I used to get a thin branch from a neem tree, and hammer one end to make a brush. I painted simple images like birds and animals and flowers, and then gods and goddesses. The stunning visual experiences I remember from childhood were the puppet shows and beautiful plays performed by gypsies travelling from village to village.

I never actually wanted to do anything other than paint, ever since I was a child. I ran away to Bombay, about 350 miles away, when I was about 14, because I wanted to study. No one in the history of my family had moved away like this before. In 1978, I came to England on a British Council scholarship.

What were your first impressions of England?
I had an idea before that London was like heaven. I did actually feel it was like heaven in terms of being able to see the works of great artists. I also travelled in Europe and America and saw beautiful paintings that I could never have dreamt to see, like Turner's

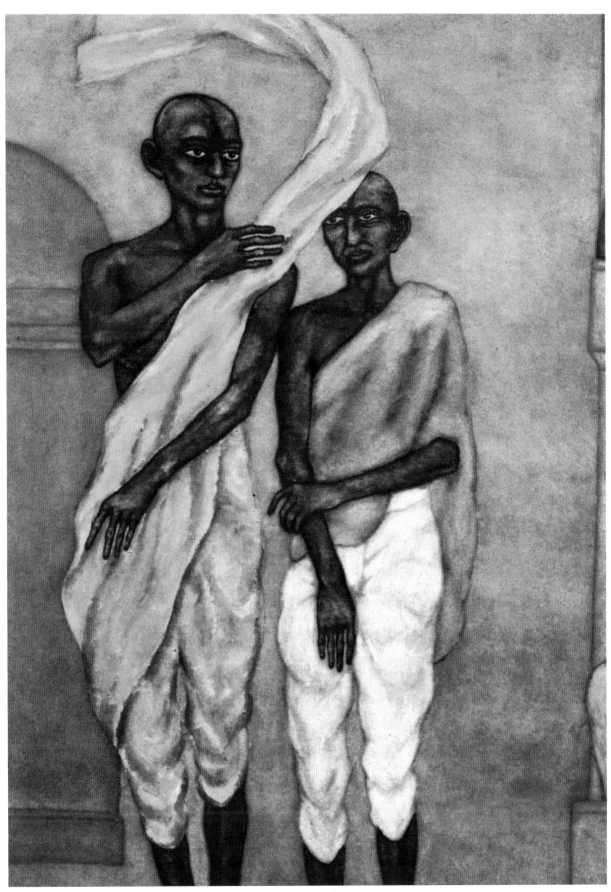

Saffron Robe

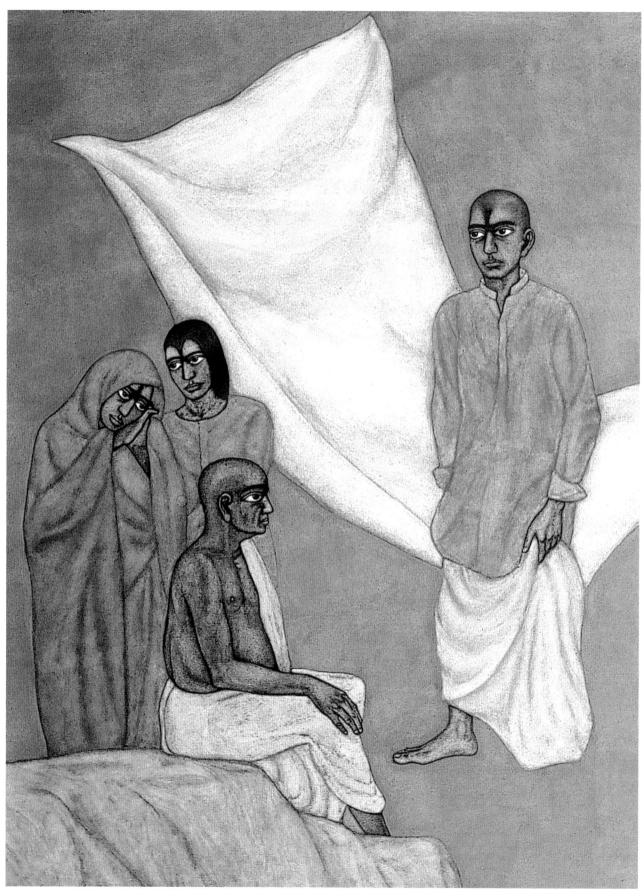

Resurrection

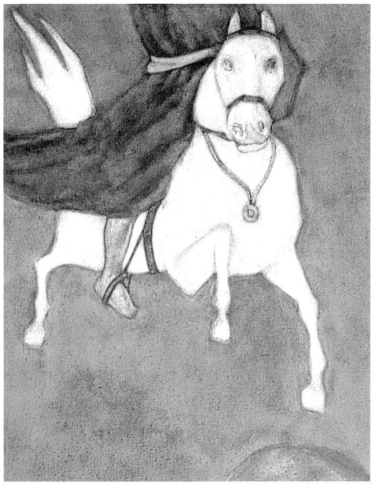

Sacred Verses (detail)

watercolours in the Tate. When one starts living here, I think it's altogether a different experience, but that's normally the case with most places.

Which Western artists do you most admire?
I find the medieval period fascinating. What I like mostly are the icons, which is connected with my interest in Indian miniatures. It's also to do with being close to nature and the spiritual aspect of human life. I find the same aspect reflected in El Greco, William Blake, even Cecil Collins. It's wonderful to have the opportunity here to admire these great souls. We have a conscious level in us and a tremendous unconscious faculty, the intuitive powers, about which it is very hard to verbalize.

Do processes of meditation learnt during your childhood remain important to you? Does that early knowledge resonate still in your art?
Focusing your mind and body on one specific thing is a tremendous help. The painting process, or even that of dance or music, is always a meditative process, because you are engaged mentally, spiritually, physically, in every way.

You have worked as Artist-in-Residence in various London schools. How do you compare your childhood experiences with those of contemporary British youth?
As children, we never had any ready-made toys. We had to make our own from clay or wood. My grandfather made me a beautiful wooden camel with four wheels. Hindu philosophy nurtured the use of natural materials, developing sensitivity as a child. Often when I see youngsters here, I sense a lot of wasted energy.

One Residency I did, through Whitechapel Art Gallery, lasted six months, working two days a week. They did a mural in the very noisy playground. The theme was peace, growth and renewal. It was good to make children realize that there are times when one wants to be quiet, just to do nothing, read a book or look at a painting. They painted flying swans, bees, deer, using high-quality materials. It was very successful. I appreciate these enriching opportunities in this country. ●

HAKU SHAH

In Tune with Nature

Art is a way of life. *By Satish Kumar*

HAKU SHAH IS a born artist, and for him anything made well, with imagination and skill, is art. But unfortunately our utilitarian and industrial civilization has taken the arts out of everyday life. Painting, drawing, dancing, singing, acting, building and all manner of making have become 'unnecessary' luxuries. In the wake of mass-production and mass-consumption, the arts have become a hobby rather than a way of life.

For Haku Shah, art is neither a hobby nor a luxury, but an essential ingredient of living and being. In his view, "The work of true artists is to be found not so much in museums and art galleries but in the rural and tribal communities of India. These people may appear to be uncivilized and illiterate, but in their arts and crafts of everyday need they have a profound sense of unselfconscious aesthetics."

A humble man, Haku Shah was born in a village in western India. He was educated at a Gandhian school where he learnt spinning, cleaning, drawing and other manual skills. The ideals of Mahatma Gandhi such as simplicity, solidarity and service made a lasting impression on him. He went through many struggles. When he was at college, he had very little money. Once, he did not have enough money to buy rice, so instead he bought an inexpensive snack, but the moment he opened the packet, a kite flew over him and took away his snack. Only the wrapper remained in his hand! He had very few clothes, so he would wash his underpants in the evening and wear the same pair the next day. With such a simple upbringing, he knows and understands the plight of the poor artists of village India, and respects their integrity deeply.

Haku Shah sees as much beauty and elegance in the pictures on the mud walls of rural dwellings as in classic carvings in temples. So much so, that he has become a spokesman for the unknown and unrecognized artists of indigenous communities. He says, "These artists seek neither fame nor wealth, but simply wish to be respected for their traditions."

As a painter in the traditional mode, Haku Shah uses exquisite colours to convey a sense of continuity, calm and contemplation. A tree, a cow and a flute appear and reappear in his paintings as a constant theme. They evoke the ancient mythology of India. A human figure plays the flute, standing under a tree beside a cow; he is totally in tune with nature, at ease with himself and in harmony with the animal kingdom. "The purpose of the arts is to connect," says Haku Shah. "We need to connect with our intimate selves as well as with the entire universe. Music represented by the flute is the bridge which connects. Sound is sacred and divine; it feeds the soul and the imagination." "Art is a combination of love, skill and attention," he says. "Love is the quality of surrender; no holding back, but letting go and allowing something to come through you. Skill comes through regular practice; day after day you have to devote yourself to it. And art also requires you to pay attention – it is like meditation. Your mind has to be fully present."

Haku Shah sees art as a way of celebrating life, community, nature and the divine, through the handiwork of a painter or an artisan. For him there is neither hierarchy nor divide between arts and crafts.

He takes leave of modernity at the juncture of conceptual 'art', where 'the artist' becomes more important than the act of making and creating. In the Middle Ages art was for 'God's sake', then in the age of humanism art came to be practised for 'man's sake'. The modern age promoted the idea of 'art for art's sake'. Now, in post-modern times, when conceptual art rules, art is presented for the 'artist's sake'. Haku Shah has difficulty in calling something a piece of art if it involves no skill, no beauty, and not much making. "Why not call it just 'concept' rather than corrupt the much-loved notion of art?" wonders Haku. For him, art cannot be divorced from integrity, from simplicity, from truth and from life. In fact, he believes that "art is not a concept, it is a way of life." ●

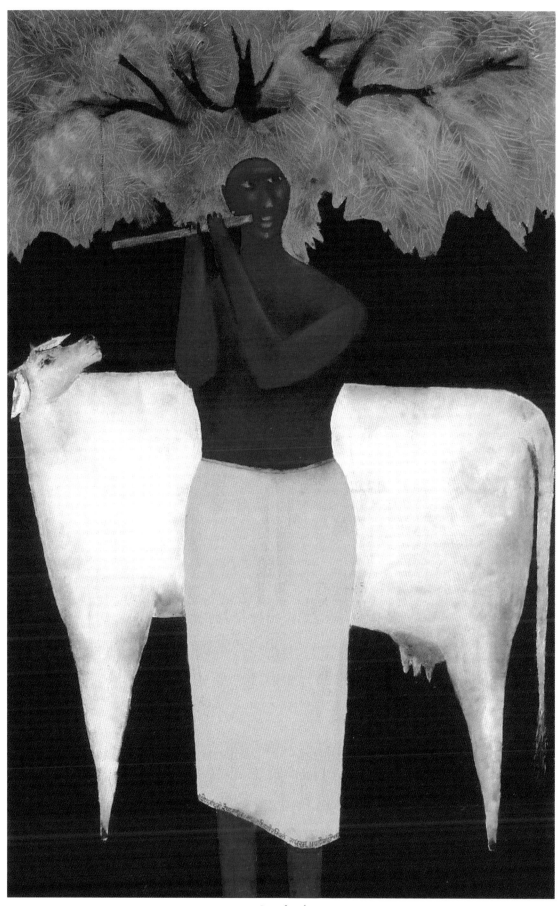

Cow herd

39

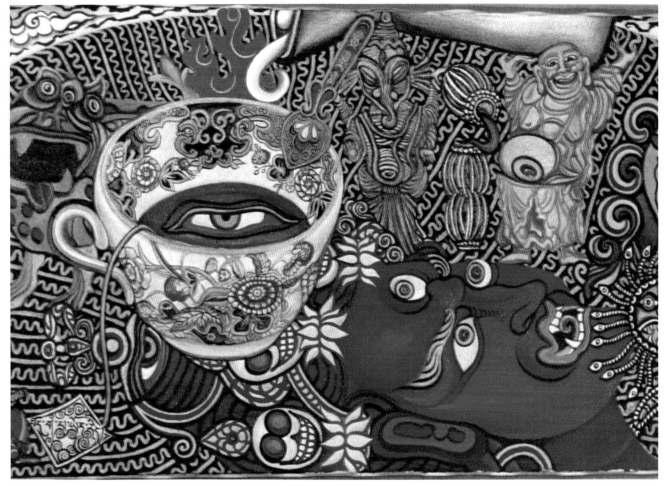

Dakini Tea (detail)

JANE SIEGLE
Painting the World

The cohesive, organic and magical vision. *Interview by Suzi Gablik*

A S SOMEONE WHO has written extensively about contemporary art and the role of artists in society today, I have been engaged for many years with certain issues. Can art make a difference to the welfare of communities, and even to the welfare of societies? What is the true measure of success? Does it depend on external achievement, money, and an impressive list of exhibitions – all signalling a conditioned allegiance to art-world approval – as we have been taught to believe? Or is it something else?

The conclusion I have drawn is that true success is manifested through a certain quality of spiritual awareness and an ability to live in an interconnected way, with compassion and responsibility. So imagine my sublime astonishment when I first discovered that just such an artist was living only a few miles from my own front door. Jane Siegle is an individual who more than fulfils these criteria: in both her life and her art, she really puts the great spiritual teachings into action.

Born in 1958 and raised in Greensboro, North Carolina, Jane now resides with her two children in

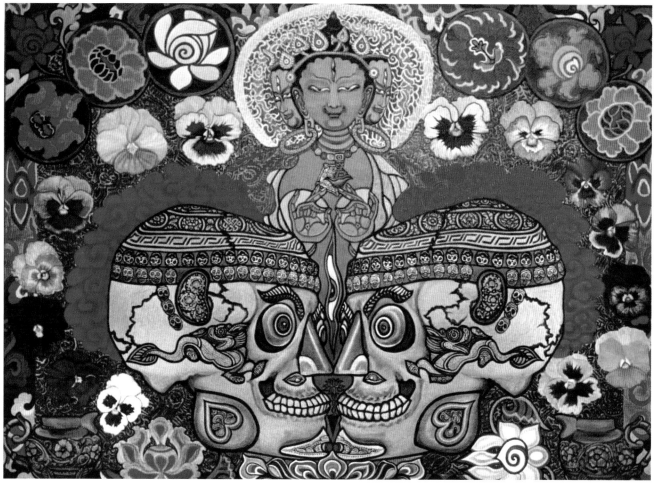

The Future and the Present

Blacksburg, Virginia. Her artistic credentials have not been acquired from the postmodern culture of academic formalism, but rather from her own ongoing personal dialogues and interactions with Rajasthani hand-painters, Sri Lankan clothdyers, South Asian jewellers, potters, metal- and stone-workers, taxi-cab drivers, cremation assistants, monk-artists, the camel saddle-makers of Pushkar, Nepalese carpet weavers and Tibetan thangka painters. In her own paintings, everything is woven together: a heady, cross-cultural mix of forms and ideas that creates a powerful cultural and spiritual bridge between East and West, as well as between tradition and modernity.

Jane is able to weave the experience of others into the process of her own art through mutual recognition and respect, and her most unusual ability to make friends and build trust. Jane Siegle's work speaks of immersion. It speaks of participation with the whole heart. To my mind, a consciousness of this order is the only thing that can lead us away from old patterns of mind based on radical individualism and the culture of separation.

Suzi Gablik: When did Tibetan imagery first enter your life, and how?
Jane Siegle: I started going to India in 1985, but in 1990 I visited Nepal where I saw Tibetan refugees and Tibetan art for the first time, and I didn't know what I was seeing. I started reading about it in books and I remember knowing enough about it to start painting some of the iconography.

So initially you began by integrating this imagery with other kinds of painting you were doing? And then it became increasingly the central focus?
Exactly. It's like being blind, and being in a room and feeling out the right path, even though you can't see the ground or the walls or the colour. I was in fact even distrustful to begin with – of the enormous hybridization, or multiplicity, or endless number of Tibetan deities. I thought it was unnecessary and disorganized, and I put up some contest to it all and resisted it – but it later became clear to me.

If this was your initial response, how did it transition into no longer being the case?

41

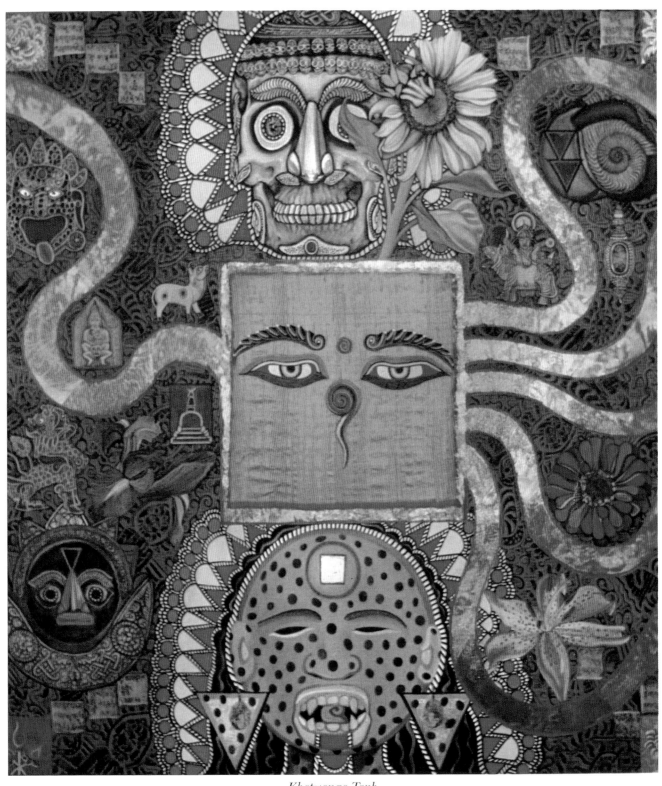

Khatwanga Tank

It wasn't reading about Tibetan art that did that. It was studying the imagery right there in Kathmandu, in the valley, and realizing that these images were growing up like plants. Each of them was a valid form in a different context, and every one like a door. So the excess and profusion shifted for me into something more like fertility and abundance. I met people who didn't know each other's particular form of worship, but I saw that those forms were functioning similarly, and I saw how the people accepted each other's forms.

Did you lean towards the philosophy of Buddhism while you were in South Asia, or has it always been more of a painter's approach?

I'll never forget a moment when our lama friend Tsampa was taking my friend and me through some of the old monasteries in the west of Nepal. At one point he saw one of the monks there who was still training. The monk became very intrigued that two Western women were with this high lama, and that the lama was explaining all the images on the walls to us. Well, the monk said to Tsampa at one point, "Is she Buddhist?" And Tsampa said, "Yes, she's Buddhist." And that's as close as I've come to the evidence. In that context, I am a Buddhist. I do not practise in a morning time separate from my life. But to the extent that this iconography means a certain way of understanding the connection between things, I am a Buddhist.

I was reading Chogyam Trungpa Rinpoche's book *Dharma Art*. Trungpa says, for instance, that "Art refers to all the activities of our life. . . . It is not an occupation: it is our whole being." That seems to sum up my feelings about your relationship with your art.

I've always loved the idea that art can make the world more beautiful, and it's worth it to do that. And you don't know to whom you contribute, but you contribute, assuming that there will be people whose paths intersect at some point, who will take benefit from what you do. That's a kind of faith, a way of living.

When Trungpa talks about "seed syllables that contain the essence of the power and magic of the teachings", he's making a distinction between symbols that have certain fixed meanings and symbols that somehow embody the essence and magic of the tradition. Is that true of your work?

When there is an icon in South Asian art, it is a seed syllable; it is not a symbol. It is not a thing that is meant to be decoded mathematically or algebraically. And it will not fit into the next equation and perform similarly. In my painting 'Khatwanga Tank', for example, the khatwanga is a tantric staff carried by practitioners, or imagined by them, that always

contains at least one skull. It's a kind of shish kebab of stages of consciousness – so you can see in this painting a stacked composition with a skull on the top. A khatwanga alludes to the different degrees of clarity that you will pass through.

I've also presented two ornamented skulls facing each other in 'The Future and the Present'. They are ritual objects in which priests would place powder, and from this open-lidded skull a priest might bless you on your third eye, the spot which sees through time and space and does not miss what is beautiful. If you read this in our Western way from left to right, then it's really the present looking into the future, and what we are really seeing is the future in the eyes of the present. I like this optical illusion that the future and the present are part of one design, almost like the wings of a butterfly, and that they depend on one another.

Then, in 'Dakini Tea', I wanted to make a painting about saturation – the idea that your moments are saturated by a daily texture rich with what is sacred. Not even a cup of tea, not anything that you take into yourself, is without extreme significance. And so there is an old, cheap, aluminium tea-kettle at the top, beginning the action of the painting, and pouring into this sumptuous cup something that is not just water, not just tea, because it floats the eye of the Buddha.

I remember a time walking down a single street in India and thinking, wow, this man is working as if in the Bronze Age; ah, this is pre-history; here's a cyber-café; here's the eighteenth century; here's colonial England. There were all these simultaneous moments in history, not to mention races and religions, tolerating each other very well, without judgement, without condescension, and with some understanding of each other's talents and traditions. Those layers, co-existing in one place, have always seemed to me like healthy bio-diversity, and are represented in my paintings in the *mélange* and sheer profusion of imagery.

Do you think of your paintings as narrative?

I do, but I trouble over the word 'narrative'. When you look at Hieronymus Bosch's paintings, they take place in a space, and you can travel through them, but it's not strictly narrative. It's more like fireworks exploding in many places simultaneously rather than a road that leads somewhere. So it's not linear narrative. But because my paintings are not just replicating Tibetan images – they're bringing them into contact with the West – there is a story there. You know, you're fortunate when you can do some kind of suturing, or some kind of congregating. Or be a catalyst for something else that begins to happen. To that extent when you matter, it's so glorious, because you were there and it was good that you were. ●

43

SEEING SACRED

I often ask myself whether or not
it is the inconspicuous things that had
the real and decisive influence on my
development and work;
my time with a dog, the hours spent
watching a rope maker in Rome, who
in his craft repeated one of the oldest
actions in the world and, in the same way,
a potter in a small village on the Nile.
To watch him at his wheel was an
inspiration to me, in a very mysterious
sense and impossible to put into words.

Rainer Maria Rilke

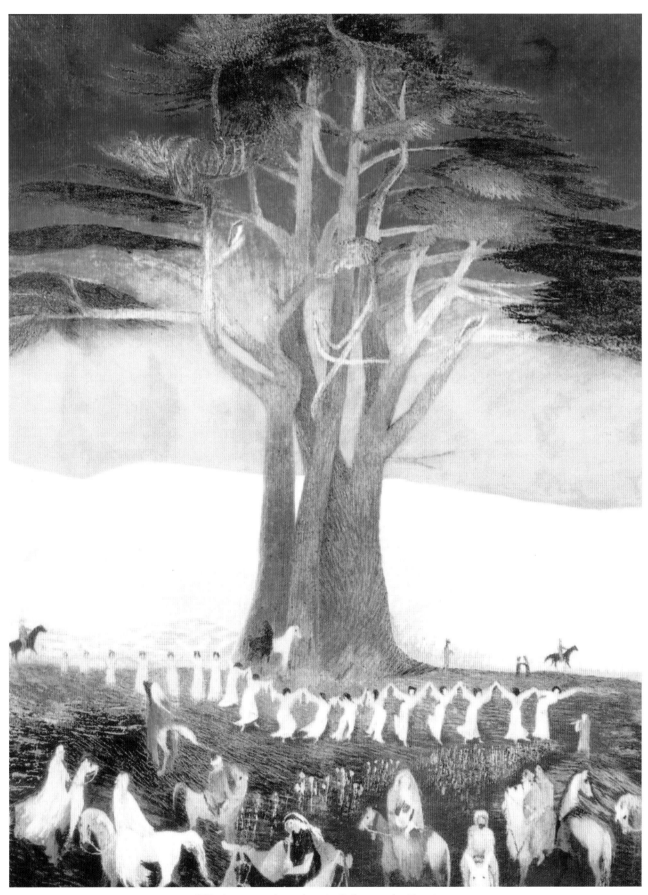

Pilgrimage to the cedars in Lebanon, by Csontvary

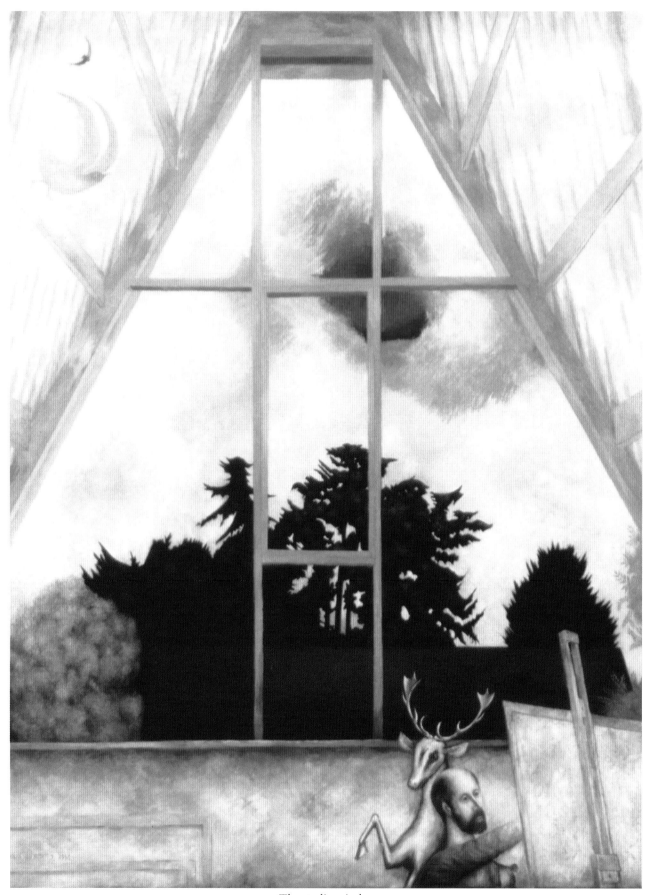

The studio window

ROBIN BARING

Images for the Soul

Paintings of mystical vision. By John Lane

AT ALL TIMES THERE have been the contemplatives, the Desert Fathers, the Celtic saints; in Japan, Ryokan; in America, Thomas Merton; in India, Bede Griffiths; and countless others in all ages and countries, anonymous and devoted. Today, that devotion can still be found not only amongst nuns and monks but amongst a few artists – poets, painters and writers of all kinds. Naturally, the noisiest, the circus performers – the Picassos and Warhols – succeed in attracting the most attention, but there are others, the forgotten ones, the ones who dedicate their lives in pursuit of a visionary quest, who offer us the greatest inspiration.

Of these I'd like to celebrate but one: Robin Baring. This painter is in fact barely known, largely on account of his indifference to the business of exhibiting and, I should add, his disregard of any interest in positioning himself for the purposes of career in the very decadent court of 'Modern Art'. As a man he could never be described as a natural marketeer, nor one, like Mr. Saatchi, with a genius for public relations. In contemporary terms he is virtually invisible. Nonetheless, there is nothing quiet about his 'stand-off': in fact, there is great activism about Robin Baring, dedicated as he is to a commitment that 'his' kind of imagery and its underlying philosophy might one day contribute its own healing to the aridities of our mechanistic culture.

ROBIN BARING WAS born in 1931 and painted from the earliest age. He trained first as a farmer, then served in the Royal Navy, then worked for Christie's the auctioneers, before deciding at the age of twenty-five that what he really wanted to do was to paint. He therefore took the next necessary step by enrolling at the Central School of Art in London, where he studied for three years under the now well-known painters Keith Vaughan, Mervyn Peake, Merlyn Evans and Cecil Collins. The latter soon became and remains a powerful influence: "From the start I felt I was on a similar

wavelength with Cecil, a wavelength about the inner world, the world of transcendent realities."

Here we touch on a major heresy: in our culture the artist of consequence must be an innovator, must be at the cutting edge, must be breaking new ground, must be original. To paint in another's style is, quite simply, unacceptable. Baring feels that the idea of novelty in relation to the arts needs to be re-examined. New flavours, however tasty, are not necessarily a sign of excellence, and may even be a substitute for real vision.

In justification he points to the duration of cave painting (a mere 20,000 years), the duration of Russian icon painting (not as long, but undeniably lengthy), and the carving of the sculpture of the Hindu gods and goddesses (still being carved today after many centuries). "One thinks of the thousands of times that Christ was painted by generations of artists, yet none of them was told that this was invalid because it had already been done." He also points to the timeless nature of traditional images in which the concept of progress has no validity. No, the symbols and archetypes of the inner world, the world of visionary insight, are by their nature both permanent and timeless. They can and should be re-expressed in a contemporary idiom, but must never be distorted or trivialized by the twin distractions of fashion and ego. "Although interesting work is currently being created, especially perhaps among the younger sculptors, an undue proportion of contemporary art is obsessed with psychopathology and much more with superficialities. In this sense, much of what we see is another form of pollution, this time of the mind."

To put it that way can make Baring sound a trifle doctrinaire and preachy. Yet he is a well-mannered and deeply courteous man. Many of his paintings are closer to magic. They are poetry and illumination in one. His is a vision of the numinous inner world that lies at the heart of both art and religion.

For some thirty years he has been exploring that world through the mysterious, poetic and richly

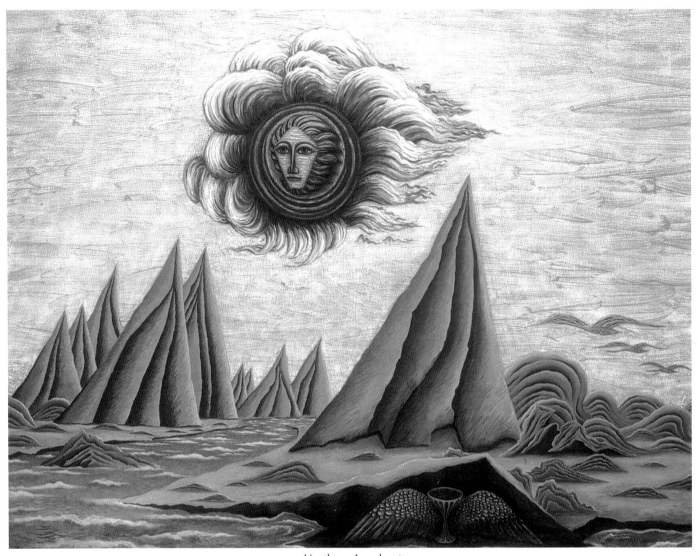

Northern Landscape

suggestive vocabulary of symbols out of which his work has been composed. He has been painting mountain caps, flaming suns, horses in flight, angels, chalices and landscapes that are as old as Eden and even older. These are slowly meditated works (he produces only three or four canvasses a year), icons of contemplation that are both strangely healing and at the same time never comfortable. Yes, they are often closely related to the images that Cecil Collins used. "I don't believe that archetypal imagery can ever be owned by an individual since the archetype belongs to all, the collective," says Baring; but at the same time they possess their own naked energy; they come from deep places in the psyche. "As a whole," he confesses, "I do not analyse the images from the point of view of iconography. I let them come. I let them open like flowers. I like to see them as possessing their own life: mysterious and evocative images that work on the soul of the viewer."

If this is so, one can understand Robin Baring's extraordinary claim that it could be artists like Rembrandt, van Gogh, Duccio or even the Symbolists of the late nineteenth century who kept alive images of the Dream in a time of increasing rationalism, that could help to 'save' our endangered culture. In other words, those artists in whom the faculty of oracular consciousness has penetrated the numinous forces beyond the personal self, could act as pathfinders and guardians of the soul of our society. It is they who have retained the divinity at the root of life. ●

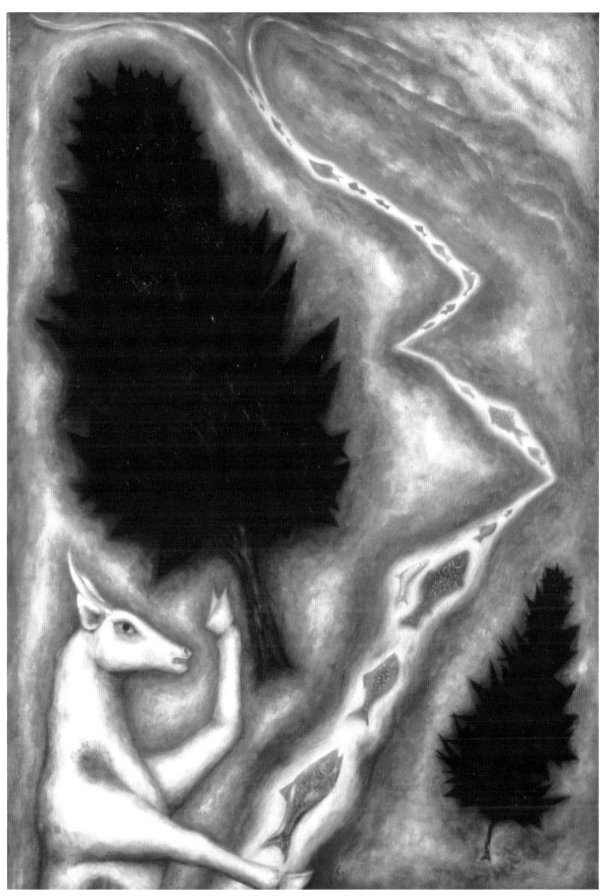

Pastorale: Returning to the Source

49

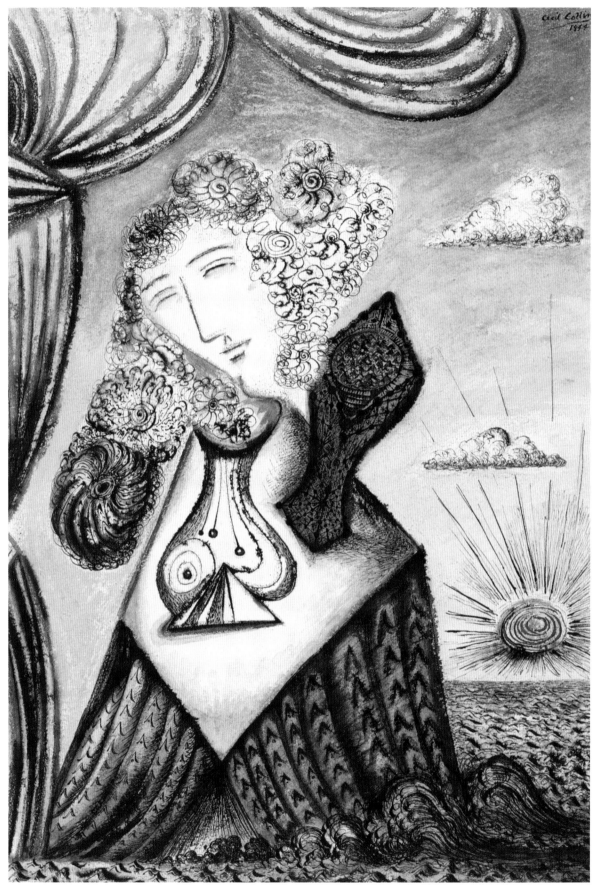

The Coming of the day

CECIL COLLINS – 1

The Singing Sea

A manifestation of the spirit and the imagination.
By William Anderson

THE ARTIST CECIL COLLINS was born and brought up in the West Country. He studied at the Royal College of Art in London, where he met his future wife Elisabeth, a fellow student and herself a fine artist. Inspired by his love for her, from the age of twenty-five onwards he began to paint a series of visionary works (such as 'The Eternal Journey') which – with many developments of style and theme – he added to, with undiminished energy, throughout his life.

In the course of his life there have been several successes, followed by long periods of neglect. His first London exhibitions, one in 1935 and the next not for another nine years, were both great successes. In a way the neglect has been because he has distrusted success and run away from it. Much of those nine years were spent at Dartington, where he began his most famous series of works, the cycle of the Fool. Another, deeper reason is that he has often been far ahead of his time in the themes and emotions he has expressed. For example, his vision of the unity of life and consciousness within the spiritual dimension which he was portraying as early as 1938 has far more connections now with various aspects of the holistic movement than with almost any earlier currents of thought in the course of his lifetime. He is now coming into his own as one of the greatest artists of the twentieth century, and it is indicative both of the strength and inner truth of his vision and of his courage and persistence that he always trusted to his vision and never allowed himself to be deflected from it. Another reason for the neglect, made obvious to me by reading the reviews of his exhibitions from the fifties onwards – or by finding no reviews – has been the embargo on the discussion of spiritual ideas and values that extended from the fifties into the seventies. It is comparable to the embargo on the consideration of environmental and ecological problems that I used to meet among some of the scientists I worked with in the sixties. To them the problems either did not exist or should not be mentioned. Similarly, Collins's work was ignored, or he was told

not to paint in the way he did. Also, in Collins's case, it has meant that, apart from courageous backing at the Tate Gallery, there is little of his work to be seen in public collections.

When Clive Hicks was photographing Cecil Collins's painting 'Fool and Angel entering a City' (1969) in the course of collecting the pictures for my book on the artist, it seemed to us as though the painting was hungry for light. The stronger the light that was turned on it, the stronger grew its colour contrasts and the deeper the eye was carried into the city in the distance. This is an image of my own experience over the past two years in having to study Cecil Collins's work and his creative processes for this book. The more I saw his works and the harder I concentrated, the more it seemed as though the paintings and drawings were hungry to be seen, and as though there would never be any disappointment or any end to the emotional journey on which they would lead me.

Every book has its own life story – its biobibliography, to coin a word. This book originally was made possible by a chance meeting with Cecil Collins at a conference of the Centre for Spiritual and Psychological Studies. The late Glen Schaefer, the ecological physicist, was so inspired by Cecil Collins's talk and the showing of the Arts Council Film on Collins's work that he went off to get a copy of Collins's book *The Vision of the Fool*, published in 1947 and long out of print. He was outraged at having to pay £40 for a second-hand copy of a book he felt should be on everyone's bookshelf. I was then with three friends starting a small publishing venture: Glen Schaefer persuaded us to bring out a new edition of *The Vision of the Fool*. Our sales force was ourselves, and we managed to bring the book out in time for the Tate Gallery exhibition of Collins's prints in 1981 and to sell out our printing in about a year.

ONE OF THE BEST WAYS for a friendship to grow is from a working relationship. This is how my friendship with Cecil Collins was first formed. Although I admired his work, its special qualities did

CECIL COLLINS - 2

To the Gates of the Sun

Embodying innocence, purity and freedom.
Interview by John Lane

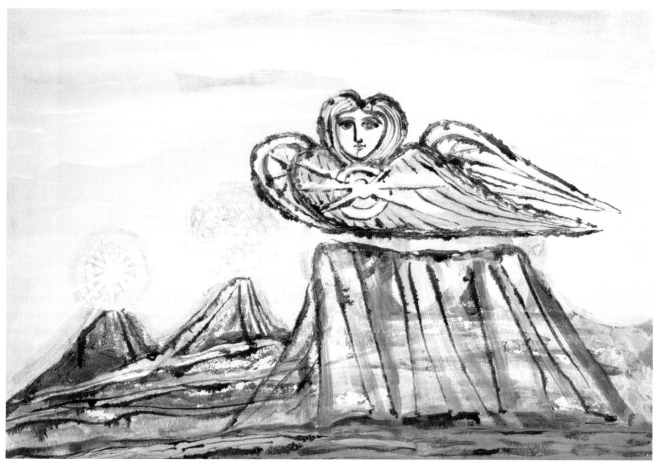

The Divine Land

UNLIKE MANY of his younger contemporaries, the painter Cecil Collins is not a household name. Yet the disparity between the relatively small extent to which his work is known and its importance has one advantage: we may still discover it for ourselves without the prejudice of preconceived notions.

To begin our discussion I asked him to clarify the difference between self-expression and true creativity. "There is a major difference between the two," he said. "Self-expression is actually relieving yourself of emotions and tensions. It is largely therapeutic. The

true nature of creativity is not therapeutic because instead of expressing and relieving oneself it is concerned with the transformation of the raw material of the emotions.

"The problem of creativity is the transformation of the raw material of the lower world in us so that it becomes a contribution to the world's harmony, not a reflection of the world's condition. We don't need the artist for that; every newspaper will do that for us."

Cecil Collins regards painting as a metaphysical activity whose function – far from mere aesthetics – is the almost impersonal, certainly ego-less, expression

of imaginative knowledge, the knowledge of the soul. In this sense his art is more closely allied to the traditional sacred masters than that of his contemporaries; closer, say, to Chartres than the Tate. It is a Hymnery rather than an Opus. "In my view," he pointed out, "it is the metaphysical that is the most vital issue in art today – not eros, but the metaphysical. It is the most potent reality there is." In consequence, the kind of knowledge we have today lacks equilibrium. There is, however, another kind of knowledge, inner knowledge, which remains one of the most urgent needs of modern life, especially modern education. Cecil has no doubts of this.

"The contemplative life means a concern with being and the psychology of being. The psychology of coming into contact with the essence of an experience. This means not being educated to manipulate and exploit experience or to possess it, which is mostly what our modern education is concerned with because of its reduction to utility. That is why I believe the soul today is such an anachronism. It cannot be traded with utility, and contact with the psyche is with the wholeness of man. Unless this takes place in education it will lead undoubtedly to disintegration. I don't think this is realized in general by those who still see the concern of education as the rational business of educating the external man. But until the soul is satisfied and nourished by ideas of harmony, the world will not know peace."

Having touched upon the arts, I invited Cecil to say something about his own work.

"Music is really the clue to my painting because my experience of a symbol is not a kind of code language which, when cracked, everything is explained Really the images that I use are like notes of music which I group together in chords. These chords have the function of evoking a fresh atmosphere of life, a kind of climate or fragrance of the life of the soul, beyond the world of concepts. Each of these groups of images or chords are a kind of poem or beautiful music in an open field of experience. This is different from the orthodox traditionalists, who have a fixed language which crystallizes into formulae so that it becomes a mechanism; the existential reality goes out of it.

"It's not an accident that now the Church seldom commissions works of art from artists, and that the latter are now finding it more and more difficult to paint for example, the standard subjects of formal religion. Even the most devoted artists and followers of a religion find it more and more difficult. It's because symbols get used up and have to be returned to the unconscious to be refreshed.

"The Holy Spirit is the renewer of all culture and civilization. In my view this is now the Age of the Holy Spirit: the Reality that does not divide men and women, that enables every human being to stand in the presence of Divine Reality. It is for this reason that a formal sectarian religion cannot be affirmed now, because it will divide mankind immediately, and what divides the spiritual unity of men and women, and therefore prevents the birth of a universal world culture and civilization, is against the Divine Spirit of Reality."

Fearing that we might be moving into open waters, I decided we should remain, at least for the moment on dry land. I asked him to say something about the relationship of technique and materials – colour in particular – to the climate or fragrance of life of the Soul which he was continually seeking to embody in his work.

"Colour is the realm of intuition," he replied. "Colour is vibrations. As an artist I am not concerned with conscious colour symbolism, which is academic. Colour is a most beautiful and mysterious element. At the moment I tend more towards the more classical view of colour, which is to reduce the harmony to a few colours and to avoid kaleidoscopic harmony. It is in this that I find the serenity and harmony that I am interested in, the harmony which contributes to the serenity of the world.

The technique that I use in my later paintings is a very complex one involving working in layers, and it requires great patience. Perhaps it could be said to be a kind of meditation. I like every painting to live on its own as an object of contemplation. I like to paint pictures which can be looked right into. I don't like painting which gives a certain effect at a certain distance but when you look into it gets coarser and coarser and coarser. People ought to be able to go right into a painting, so that they enter a world in which more and more experiences are unfolded."

It was in the thirties (whilst working at Dartington) that Cecil Collins first as we say 'found himself', found beneath the surface vividness of life a deepseated, holy source – the inner world of vision. In consequence, the paintings of those and later years have a charged, an almost burnished primitivism: icon-like, ritualistic, both magical and bitter sweet, with something of that blend of gaiety and pain, humour and sadness that we find in Watteau.

There, too, he not only worked out his own metaphysic but a small cast of archetypal figures and symbolic objects with which to give it expression. These he has called a theatre of the Soul.

In virtually every one of his subsequent works, Cecil Collins has portrayed this cast of personages – Angel and Fool, in particular – to conjure up a world complete and coherent in itself, which also presents a commentary on contemporary life. "Certainly, the soul suffers from isolation and forgetfulness. But the Angel is a great reminder, it is an image of freedom. The wings, for example, are made for the sky. Angels belong to the open sky of eternity. They live in the oxygen of God, the only

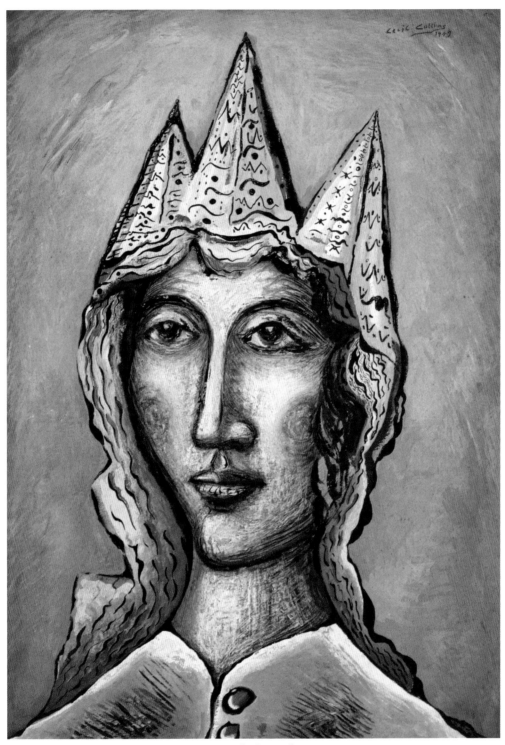

Head of a Fool

reality which keeps us alive. They are also images of what is the highest in us. Our consciousness has to grow wings in the sense that it has to transform; the wings are an image of transformation, and the world can be seen as a kind of battlefield of transformation. Angels come into the world to help this transformation, they take part in this battle and some of them get wounded and have to rest on the floor of paradise. This is the experience of my painting 'The Wounded Angel'. It is like a butterfly that has had its wings damaged. The painting 'The Angel of the Flowing Light' also shows the world of the angel. It appears walking on mountains, it glides over the mountains, which are symbols of the transformation of consciousness. It is dawn, the dawn light is behind this angel and out

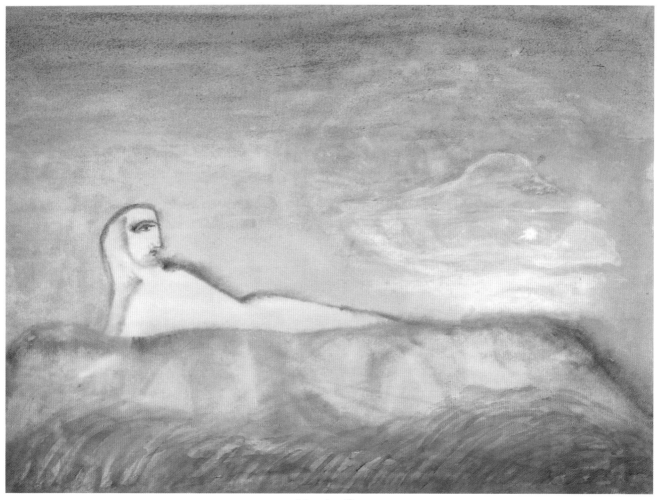

Morning Star

of its side comes this flowing river of light."

For Cecil Collins, poetic vision has been a central preoccupation. Of no less consequence has been the concern for education of the inner life. What Cecil calls "a reviving of creative innocence, a virginity of spirit, a purity of consciousness, a way of seeing directly as we once did as a child", is all contained in the seed. The theme is developed with passion.

"The seed is a potential. I believe we all have great potential for transformation. The seed needs the warmth of the divine rays. It needs light. We need the spiritual education of the whole human being. That this is not given is the real crime of modern education."

If critical of most modern 'education', Cecil Collins shows no fear or distaste for the modern world itself. Nonetheless, he remains a devastating critic of a society founded, to quote Jacques Maritain, on "the two unnatural principles of the fecundity of money and the finality of the useful". What did he think then, I asked him, about the compatibility of industrialization and the Spirit, technology and the soul?

"The machine," he replied, "raises a big problem:

we are released from the more mechanical levels, yet left high and dry with a big vacuum to fill. Everybody now knows that very soon, eventually half the civilized community will be out of work through computer technology, leaving a vast vacuum. This vacuum could be the most disastrous thing ever to occur. Alternatively, it could be the most wonderful chance ever presented for man to develop the contemplative life. But that would imply educationalists capable of teaching the psychology of the contemplative life. And the obsolete sectarianism and disintegration of the formal religions of the world taking place everywhere; all this is around us, and living in a disintegrating culture is a very difficult challenge. The end of the classical world was exactly the same.

"The new civilization was hidden underneath in the catacombs. Today we don't have physical catacombs, we have mental catacombs that we live in – small groups of people who think and feel, who feel these seeds in themselves. It is these cells which are eventually going to determine the contours of a new civilization – a world civilization, for this is what the creative spirit of life is manifesting." ●

ALAN DAVIE

Art of Coherence

The celebrated Scottish painter talks about art, spirit and nature.
Interview by John Lane

ALAN, YOU HAVE SAID: "Painting for me is a continual process of gaining communion with God." Could you expand on that?
Perhaps I am trying to make excuses for what I am doing. I paint from inner necessity, but then I say, "Why am I doing this, and what is happening to me?" When working I often feel that I am in touch with something beyond understanding. The concept of God is an expression of this basic feeling. The origin of all religions comes from this basic need to somehow get in touch with inexpressible creative forces.

Do you think what might be called the poetic way of understanding spirit may always be difficult for people?
People often fail to understand this way because they believe it is something difficult, something intellectual. Yet all people feel this, and they all have experiences in life of strange things happening beyond understanding; but they dismiss them as coincidence or illusion. I don't think the artist is particularly different from anyone else; perhaps more sensitive to the magic in life. One point is that a lot of art is basically unfamiliar. It is unrecognizable, or can't be pigeonholed. People say "Modern art, I can't stand this." This, I feel, is perhaps an animal reaction. If a stranger comes into the house, my dog runs away and hides; there is a threat to his security and he puts up a barrier against it. The same happens with art. If people come across a work with which they don't identify, they put up a barrier immediately. Curiously enough, even I feel this when I find myself faced with forms which are unfamiliar – only later might I realize that I am faced with something infinitely marvellous and fresh which grows with intimacy.

But this nervousness about new art is a fairly new phenomenon, two or three hundred years old. Surely the palaeolithic artist who drew bison on the wall of a cave was understood because he was working for his community?
The artist then was an integral part of the community – a Shaman – and as a Shaman he made these images out of his intimate association with the spirit world. He was able to enter this mysterious world which is beyond comprehension and make images which would express it. He was a central person in the tribe. In a materialistic civilization, people feel that spiritual things don't live up to their material ambitions. Anything that isn't beneficial from a material point of view is disregarded as being of no value: but I am certain that initially human beings made marks and images for no reason, until they realized that the images they were making were somehow magical, and had an inner meaning. Only then did they begin to use these in religious rites.

What is the function of the symbols? What do they do? Why have human beings made use of them?
Jung had this idea of archetypal symbols being deep in the human unconscious, but it doesn't account for where they came from in the first place. If they weren't 'invented' by humans they must have been present at the origin of the creation, which doesn't make sense. A symbol is a purely human thing. There certainly seem to be certain forms which are recognized as having significance over and above any logical representation. When people have hallucinations they actually see these symbols – people who wouldn't normally recognize them – and often these are the same symbols which appear again and again in primitive cultures in different parts of the world and in different periods of history.

The fact that you get the same symbols in diverse civilizations seems to indicate that there is something that appeals to all human beings regardless of race.

Do you use symbols as a form of evocation?
I don't consciously use them for any purpose at all. I don't use art for any purpose either. The same way that a bird makes music and sings for no purpose. People say it is for territorial reasons, or to attract a mate. I don't believe any of that, I think they do it for no reason. I used to watch the seagulls soaring on the coast, and it is amazing that they obviously don't do it for any utilitarian reason at all. I have

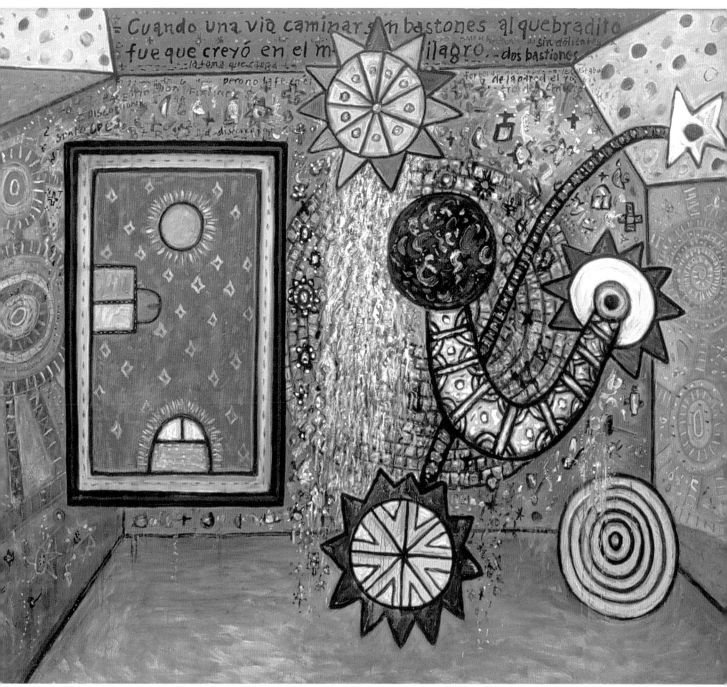

Room of the Cosmic Signaler no. 1

seen seagulls go up to about 6,000 feet, where I have joined their spirals in my sailplane, far above a height where they could recognize anything on the ground, so obviously they do it for the sheer joy of it. I feel I do painting the same way. I find certain symbols exciting and wonderful, and I incorporate them into my work. I feel obsessed by these images. I find myself making these archetypal symbols without even thinking about it. I am not trying to convey a message. Life itself has no particular reason,

but it is infinitely magical. Great art is also magical and needs no justification.

Here is another paradox. You say that art is gratuitous, and yet you also say you are driven to it. Isn't it odd to be driven to do what is gratuitous?
In the way that one is driven to make love, one is also driven to make art. Basically, you don't indulge in sexual experience for any reason. You don't do it for any purpose. We have this inner drive. It is the

Entrance for a red temple no.1

Mystical landscape, flying serpent

same inner drive that creates art and can reach the same ecstasy – the losing of the me in total unity and rapturous wonder.

So you think the instinct to make art is universal, shared by every human being? But frustrated in the majority somehow?
People experience it in different ways. People experience it in fishing, for example. I don't think that for the person who goes fishing the catching of fish is so important: he or she goes there for a kind of meditation. People who go fishing have this rod, and this thread with a hook on the end. Through the thread they have intimate contact with mysterious forces of the waters. If they catch a fish, that is a miraculous contact with the living mystery of the waters from which evolved all life. We underestimate the ordinary human being. Ordinary human beings have a great need for the mystical experience. Also, we should not think that mystical experience is limited to so-called art or religion. Some of this could be found in games when, for example, a

team, working together, becomes one unit, one being with one single mind, free from ego or individual achievement. When the spectators are seeing this miraculous transformation of the individuals into some unified organism, they too are in contact with the same creative force: they could have a joyous experience of oneness. This is only one of the ways that ordinary people can be in touch with this spiritual dimension without realizing it. The artist is different only in as much as he or she feels the need to make something visually permanent out of the experience.

Part of the drive in me for making art is that I feel I must make something to give my life coherence. One of the disturbing things about having a big exhibition of choice masterpieces, chosen from a lifetime's work, is that one comes away from it thinking, "My God, I am a great painter." Then I go into the studio full of confidence and discover that I am not so capable. It is very disturbing, and I have to go back to square one; to the inevitable struggle to free myself from my ego. In a funny way art is

Room of the cosmic signaler no. 2

something which happens to me. Art happens in spite of me rather than because of me. When I try to practise it consciously I realize that it is impossible. If you start with the aim of making a great work of art, you will never succeed and success comes only when one relinquishes all desire for success. Then what is success? Isn't it an illusion?

Would you say that in general the art of the twentieth century is about spiritual communion?
I don't think so. There was a short spell of revival of spiritual feeling in art but, on the whole, twentieth-century art is very materialistic. The recognition of primitive art by Picasso and Matisse was a turning-point. They were amongst the first to recognize the spiritual qualities in primitive art. The recognition of the necessity of spirituality in art caused a kind of renaissance but that also led to the modern move-

ment. Like all movements, 'the modern' has tended to go to seed and revert to academic and materialistic decadence. There has been a gradual downhill slide until we got where we are now, a conceptual art which, to my mind, is rock bottom. These conceptual constructions are often not even made by the artist. The actual human touch which makes a work of art is absent in this dry intellectual exercise. The concept might be an exciting 'idea', but it does not necessarily produce a work of art of lasting significance. Yet, at the same time, more and more people seem to be interested in spiritual matters, and the revived interest in conserving nature is encouraging. People are beginning to realize that nature is not something separate from us. In the materialist generations people thought of nature as being entirely different from humans, whereas in primitive societies nature and humans were one unity, completely

Cosmic signals no. 5

in tune each with the other. This, to my mind, is a spiritual approach. It is very encouraging that people are beginning to get back to realizing that we are part of nature, that what we do is reflected in nature and that our materialist culture is leading to the complete destruction of the universe.

There is also so much greed amongst humans for material gain and possession, for 'development' and 'progress'. Take, for example, the Australian aborigines, once considered to be animals or savages with no intelligence. Now, at long last, we are beginning to realize that these people had a very high civilization. The Australian aborigines were one of the high points of human civilization. They were completely in tune with their environment, had no greed and no awful urge to improve. The Australian aborigines are now known to have come to Australia at least 50,000 years before the white man came. The remains left from the earliest settlements show that their tools did not change in 50,000 years. They did not develop; they did not need to, they had reached a perfection. They had a tremendous instinct about nature, they knew where to find things and how to cure themselves. When gathering food they only took what they needed. They had such a wealth of culture and religious ceremony, dancing, singing, painting, poetry – a very high culture indeed.

Are you reasonably optimistic about the future?
I have come to the conclusion that it is completely impossible to say. There are infinite possibilities which are beyond our ability to imagine. A hundred years ago if you said to someone that people would fly they would have thought you were insane. We tend to predict according to our experiences of the past: the future is limitless and eternal. ●

63

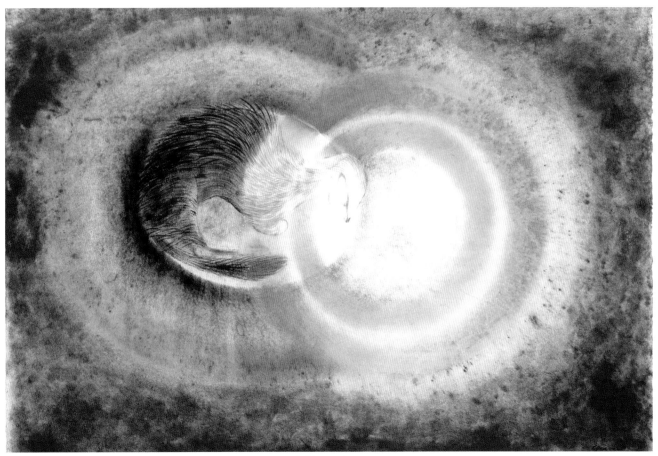

Hibernation

MORRIS GRAVES

A Dream of the Earthly Paradise

Paintings which catch the essence of the very soul of America.
By Kathleen Raine

I FIRST SAW WORK by Morris Graves in the 1940s in the house of Nancy Wilson Ross, who was born in Washington State, where Morris Graves has lived hermit-like for many years. Nancy was also one of the earliest supporters of Buddhism in the United States, and had herself a fine collection of Japanese Buddhist art. Morris Graves has been a lifelong student of Oriental philosophy, both Buddhist and Hindu. A strong Oriental current of thought has flowed into America from the time of Emerson and the Transcendentalists to the present day. Not all the seeds scattered in the virgin soil of the New World, carried from ancient civilizations,

have fallen on stony ground, and I think of Morris Graves's work as an example of the new beauty attainable when that union is authentic and profound. While the American population has largely abandoned the land for the inner cities, the American imagination remains rooted in the dream of the earthly paradise earlier generations discovered with wonder and recognition in that most beautiful of continents. Thoreau lived the American dream, and a pure current of poetry has flowed on to Robert Frost and Wendell Berry, Robert Bly and Gary Snyder in the present century. What I saw in Graves's work with such delight was that his "joyous

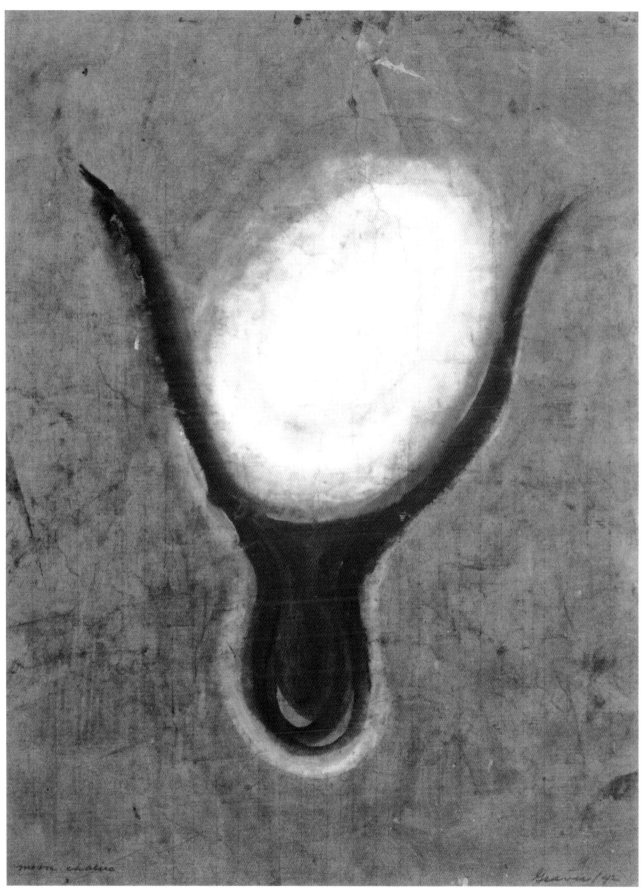

Moon Chalice

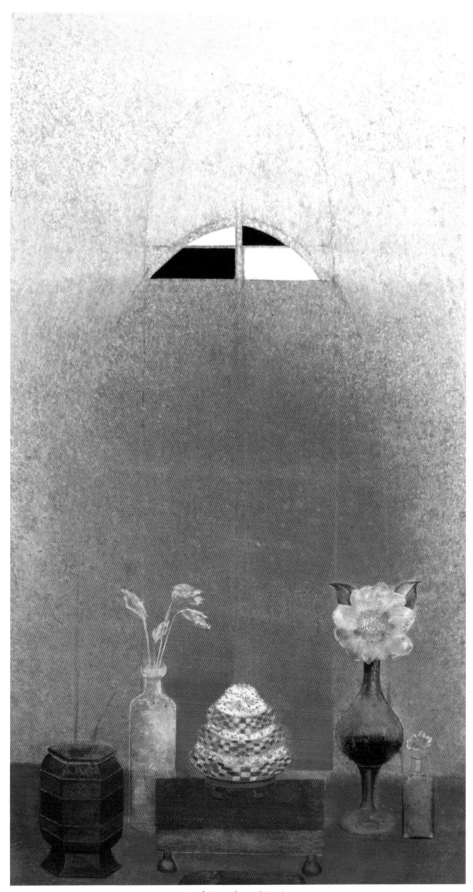

Red Powder of Puja

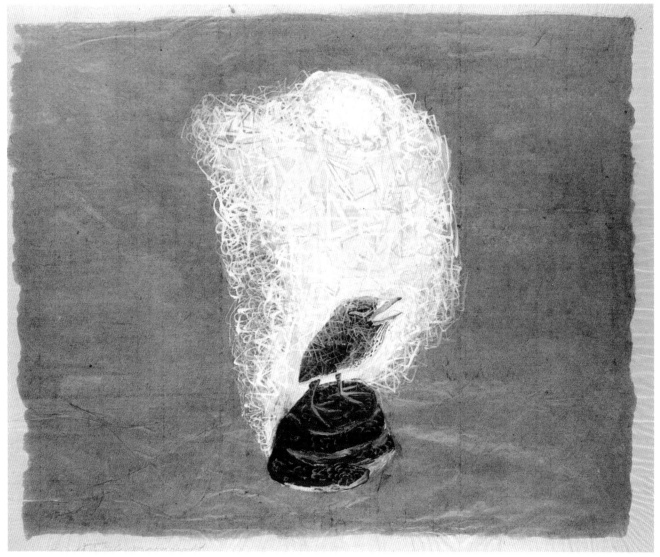

Bird singing in the moonlight

young pines", his hibernating mustelines, his hatching chicks, his solitary birds enwoven in their song or in the motion of a flock, catch the essence of the very soul of America. They were like no other nature painting I had seen. Although the strident world of Warhol may strike the eye, Graves's paintings touch the depths. Such responses are immediate and sure, one's hair has stood up, before one has formed an 'opinion', a judgment not comparative but absolute.

I WAS FORTUNATE enough to be in Washington DC in 1983 at the time of Graves's exhibition at the Phillips Gallery, the first time I had seen flower-paintings by him. These were of breathtaking beauty, a seeming simplicity that is the product of consummate virtuosity.

The comparison that springs to mind for this painter who sees the natural world through the eyes of a mystic is Odilon Redon, whose flower

paintings are of such magical beauty. Two English painters are in the same rare world, David Jones and Winifred Nicholson. Jones's flowers are epiphanic and sacramental, his *flora dea* garlanded with the flowers of his native Wales. Winifred Nicholson, as she grew older, increasingly saw her flowers not as coloured objects but as colour itself, the self-luminous colours of the rainbow. "It is the world into which we will go when we leave the body," she used to say.

In the course of his long journey Graves has explored the strange abstract worlds of modern science, and his mastery of pictorial rhythm and space seems to reflect this exploration, as does the Far Eastern understanding of the relation of objects to the Void as understood in the Buddhist philosophy.

The visual influence of Japanese flower-paintings, of those screens where cherry-blossom or chrysanthemum is painted on gold leaf, is evident in

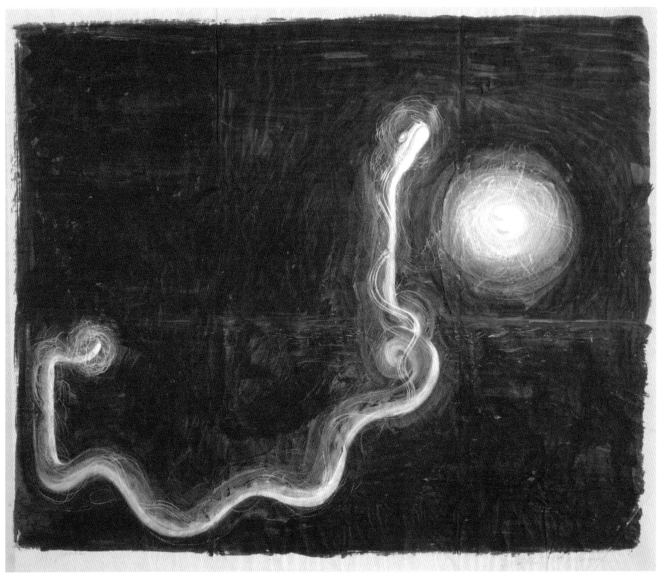

Snake and Moon

'Bramble 1970'. The theme of these chaste bouquets of two or three wildflowers reminds us of the sudden wonder of the haiku, as existence – flower or bird or insect – takes place in the void from which they emerge and into which they will again pass, their brief reality so poignant in its transience, yet so perfect. Of this living void the Buddhist landscape painters of China, and the flower-painters of Japan were ever aware.

I SEE THESE late flower paintings as metaphysical, and the 'reality' of Graves's late paintings the transparence of the eternal seen 'in and through the temporal', the reality of the epiphanic transience of 'nature' ever before our eyes. Cezanne preferred to paint paper flowers because the real ones wither: Graves, by contrast, is not a painter of 'still life' – *nature morte* – but of the continuous miracle of life. As with his earlier animals, Graves comes so close to

the life of those hedgerow flowers – as he does to snake and bird and some curled-up animal withdrawn into its own state of blissful dreamless sleep – as almost to paint them from within: inner and outer, seer and seen become indistinguishably one.

As with Redon, Jones and Winifred Nicholson, one can use the word 'beauty' of Graves's work. The word is meaningless in terms of the scientific materialism of the modern West, nor is it used in the vocabulary of art critics. But for the Oriental philosophy, whether Zen Buddhism, Tao or Vedanta, beauty is, as for Plato, the signature of the harmony of truth. Hence the timelessness of only those works on which the transparence of spiritual vision confers immortality. To quote the painter-poet Jan le Wit:

"It was more than one flower, I believe,
That Rilke hammered into gold leaf." ●

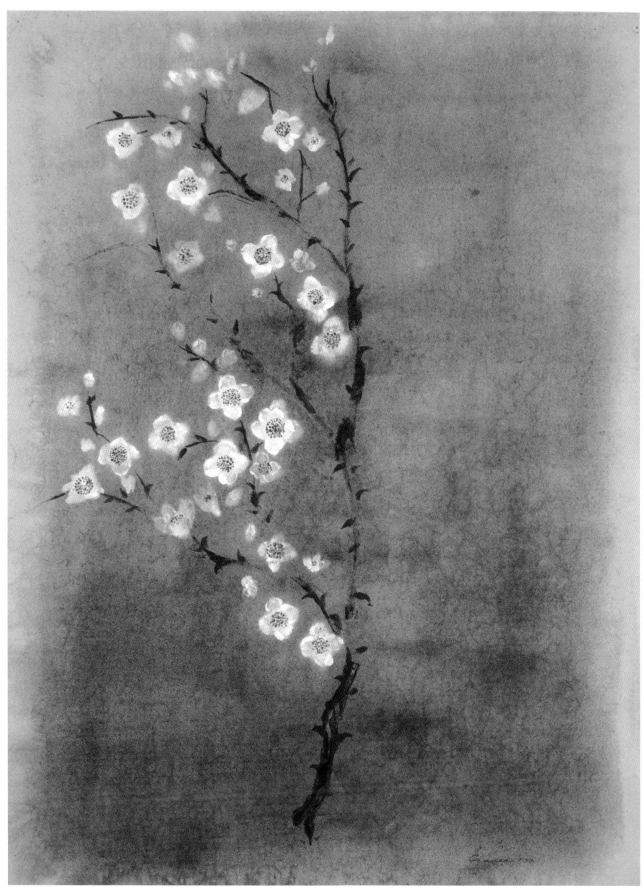

Bramble No. 18

JOAN HANLEY

The Presence of Spirits

Connecting spirit and art. *By Thomas Moore*

IF YOU WERE TO WALK into the living-room of our home, you would see, leaning rather informally against a wall, a luminescent green image seven feet high and four feet wide, painted on a door panel. It is an interpretation of the ever-compelling ancient idols from the Cyclades islands off Greece. It has a presence the way a statue of the Buddha does or a crucifixion. It is not a painting of something, but rather a presencing of a spirit. If that sounds too precious or New Age, let me try to explain.

In the 1480s Marsilio Ficino, writing about magic and images, said that a piece of material inscribed with an image carefully made and chosen could house a spirit or a radiance having a particular quality absorbed from the stars and planets. In India, workers take great care following ancient traditions as they gather materials and make their holy images and adorn them, adding special rituals at each step of the way. Again, the idea is to make a habitation for a spirit. Ficino says that an artist lures the spirit into the well-made piece, while Indian scriptures say that the spirit can't help but make a home in a suitable art object.

Joan Hanley is the painter of the green Cycladic figure. She and I have been married for over a decade and are raising two children who have been painting and drawing strong images almost from birth. Our home is dominated by religion, art and music. We have a third-floor attic, where Joan meditates and continues the yoga practice she began almost thirty years ago. On a typical day, she meditates upstairs while I play the piano downstairs, and then she gets to work painting and I to writing books about the soul.

I can't speak for Joan, but I believe that her painting and her spiritual practice are so closely connected to each other that it is not always easy to see where one leaves off and the other begins. She is a serious, trained, thoughtful painter, as disappointed as I am by much of what passes as religious or sacred art these days. But we also feel cut off from the rationalistic, ultra-realistic, and art-with-an-agenda we see in many galleries. In a museum, whenever I spy from afar a painting I crave to see, it almost always turns out to have been made in the 1400s. Joan is much more sophisticated than I about

the history of painting and especially about modern works. Every time I try to express in words the relationship in her work between her spiritual interests and her images, she tells me that I don't quite have it. But there is one thing of which I am certain: she makes images that invite passing spirits to take notice and often take up residence.

A FEW YEARS AGO I HAD a contract to write a book on spiritual depth, but as I wrote, other little essays kept coming to me at odd moments of the day. I wrote them out quickly and tried to get back to the business at hand, and after a few months I discovered that I had a book's worth of pages. They were two-page essays, for the most part, beginning with a quotation from a favourite author. I thought, 'Wouldn't it be good to publish these with a lot of space around them and perhaps a visual image or two?' I asked Joan if she'd like to do something for this unauthorized (but authored, of course) book. She set to work making fifty woodcuts, using Japanese equipment and materials. I was amazed to see her produce several prints each week – strong images that didn't really illustrate my themes but presented them completely through her own imagination. I now see my essays as appendages to her prints.

In the room where I write I have three of Joan's paintings on the walls. One is a reclining Buddha, bright and vivid, just twelve inches square – a perfect painting. To me, it shows that we can still make icons and sacred images without literally copying them or translating them into our own fashionable ideas. I told Joan that I would like to live with this image for the rest of my life, and she has agreed.

In front of me in my writing room is another painting of a dark-haired woman, with articulation only in the head and pubic areas. She is a presence that day by day offers me the kind of company I need to put words on paper. Near my desk is another style altogether. Two years ago Joan took a course on landscape painting and couldn't bear the literalism of reproducing mountain scenes. So she went into the forest next to our home and began to paint the leafy floor, which is soft and colourful with pine cones and needles and roots of birch and white

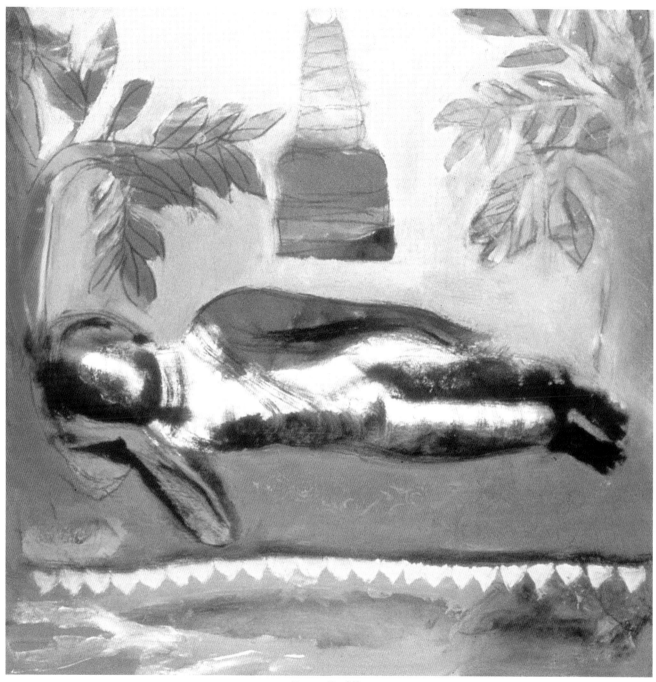

Easter Buddha

pine. The painting is warm and intimate, though it, too, is not literal.

Joan's work is not abstract, not realistic, not conceptual. It celebrates the female body and various feminine spirits without being defensively feminist. She dares to strive for beauty at a time when many artists, I hear, are embarrassed to use the word. She paints from a deep place that, in my view, is spiritual the way the spirit of a holy well is spiritual. You know from her painting that she spends time with the eternal every day but at the same time loves the particulars of this life. Indeed, she sees the eternal in the slightest hint of form and colour, and I suspect that this is the secret to the power of her images.

Sometimes we teach together, and then I go on and on verbally about my pet ideas while she places maddening trust in the imaginations of her students. With exhausting patience she invites them to let their images come forward. She offers little guidance and almost no instruction. Meanwhile, I am restraining myself from more actively defining, describing, etymologizing, rhapsodizing, and even interpreting. She and I both abhor interpretations of art, but I am much less able to avoid the deed itself.

71

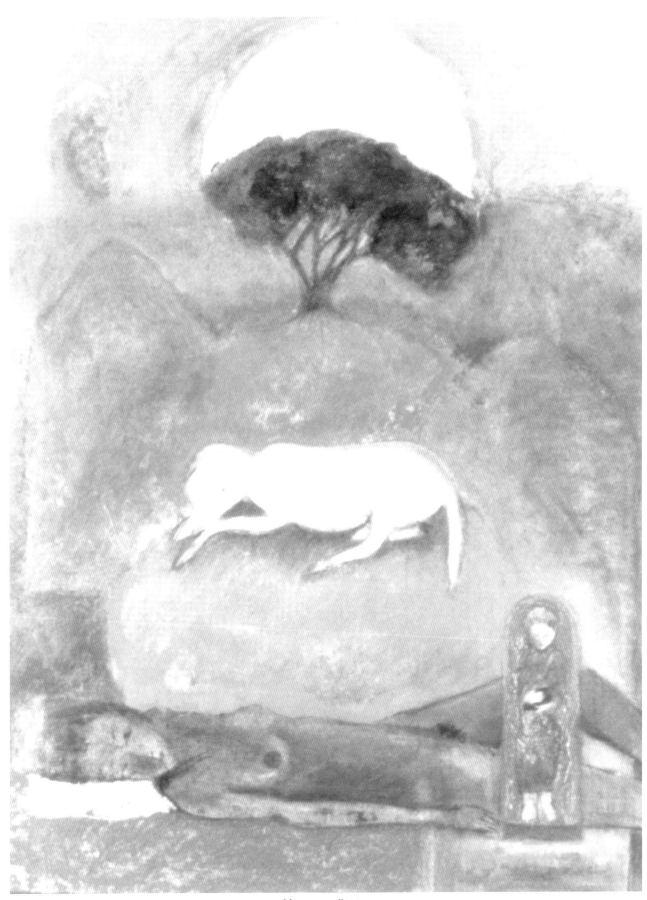

Nazarena Stupa

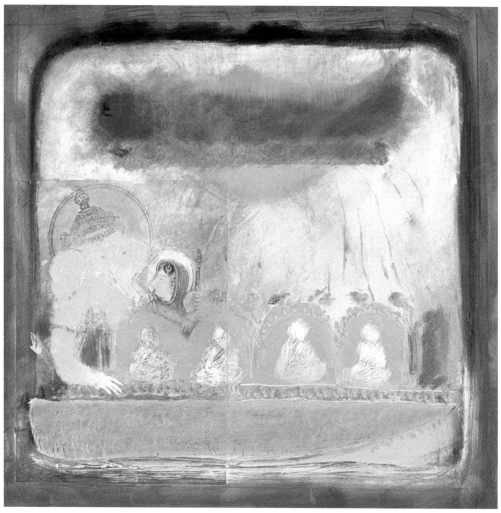

Ganesha

IT IS MY CONVICTION that one reason we treat nature and the commons of our public life so badly is that we have lost our appreciation for beauty. We believe we should live productively rather than beautifully, the former cancelling out the latter. How can we protect that which we don't love, and how can we love that which we don't find beautiful? Yet beauty always has a religious aura, because, as Thomas Aquinas said, it is a sign of divinity's presence.

Beauty is not prettiness but rather a loved presence. I see the beauty in my daughter, but I can't separate it from the love I feel for her. The beauty of nature is not only in its form and colour but in its vivid presence and is inseparable from our love for it. I don't know which comes first, the love or the beauty, but I do know that the two together make what I understand by the word 'ecology', which means (you see my failure to write a few paragraphs without etymologizing, a process that the early psychoanalyst Sandor Ferenczi explains as a continuing concern about the origin of children) the mystery of dwelling, of being at home. It is a deep form of love and attachment.

Art has a place in culture only when it is religious – not that it must portray a conventionally religious theme, but it needs to reach deep enough into the artist and the viewer as to stir the spirit. Art can be secular and yet still reach these depths, because in the best of circumstances religion and secularity nurture each other. In this grouping, dogmatism and secularism are the opposites. So I find hope in Joan Hanley's art, knowing that it arises from an unsentimental, undogmatic spirituality that indulges in the beauty of colour and line and figure.

Sometimes in her art a holy figure will appear, but always the eternal can be felt there. Sometimes I'm tempted to think that the shaman is the best model for the work of the artist, because she goes down so far and so far away from this reality, or perhaps so deeply into it, and then emerges damp with images that don't fit neatly into our dry rationality. These are the images that restore us and give us new imagination and therefore new life. They keep us vital and rooted. This is what Joan Hanley's paintings do for me. They are not really paintings, but presences invoked by colour and image. ●

JOHN LANE

A Hymn of Being

Integrating art with life *Interview by Satish Kumar*

To begin our conversation, let's talk about your background: How were you brought up?

I was brought up in the suburbs of South London, in Croydon, for very nearly all the formative period of my life. The family – my mother, father and sister – lived in a semi-detached in a road like thousands of others; it was wartime and we slept in our Anderson shelter in the small back garden. I can still hear the throbbing sound of German engines, and the sound of bombs, near and far, exploding in the night.

On the face of it an extremely unpromising beginning: a waste land. Yet I cannot remember a time when in spite of, even because of, this desolation, I wasn't attracted to and enraptured by the experience of beauty. Why that should be so I can't tell you.

Did you start to make things at school?

I can vividly remember being given a water-colour box – in fact it's the one I still use – on my thirteenth birthday, and going into the garden, and the thrill of that moment when I used it for the first time. The possibilities ahead.

I was painting and drawing a lot in those days. I was also making lots of other things, including puppets. I was always inventing plays. And writing. I wrote poems and illustrated them. Before I was about ten I can't remember anything particularly exceptional but from then onwards I was either discovering or actively involved in many of the ideas and things I am still interested in.

Was there a teacher who was an inspiration to you?

School was appalling. I can't begin to describe my abhorrence. I think the majority of my contemporaries enjoyed school, the majority had quite a normal, conventional experience; they accepted what they found as 'normal'. But for some reason I found it painful. Perhaps because I sensed a contradiction, an unacceptable conflict, between mainstream, conventional experience and my own secret inner knowledge of what I already knew. Of what was right. There was, however, one teacher, the art teacher, who spoke of a culture, a climate of feeling, to which I intuitively responded. I don't suppose he was an exceptional teacher, but he provided the only food that nourished me at that time.

When you got to the Slade, was that in any way an experience of coming home?

That's a difficult question to answer; I think one could say both yes and no. In one sense however it was a homecoming: I had arrived in a land where at last I was speaking the same language as other people. But I also sensed that most of them were using it to say inappropriate things – irrelevant things, things born of matter not of heart. Like a lot of painters, I discovered what I had to discover only subsequently, and for myself. That was the true homecoming.

Can you give me an illustration of that?

I went to the Slade soon after William Coldstream had been appointed Professor. Coldstream subscribed to what is called the Euston Road School of Painting where the emphasis is on the object; on the subjugation of personal experience in the interest of an almost impersonal 'scientific' objectivity. For example, we were taught to draw by measurement, to observe with detachment in order to realize an exact representation of an external object – perhaps a dingy street of houses somewhere. Now in a way, that was a useful discipline; it was certainly egoless. On the other hand the procedure denied whole dimensions of experience – the symbolic dimensions, the metaphysical dimension, the dimension which gives images due recognition as the true voice of meaning. Images move the psyche, work within the psyche, bear fruit, ripen into meaning. But the Euston Road method, a perfect example of Blake's single vision, was one-eyed. It took me years to find the confidence to paint in the pure way I knew as a child.

When you left the Slade did you have clear ambitions of how you wanted to pursue your life?

I had a plan. I knew what I wanted to do. For a while, in fact, for three years, I taught art in a Grammar School in Ripon in Yorkshire so as to save up money in order to give up paid work and paint. From the earliest age I had experienced this yearning, this need, to live and work in the coun-

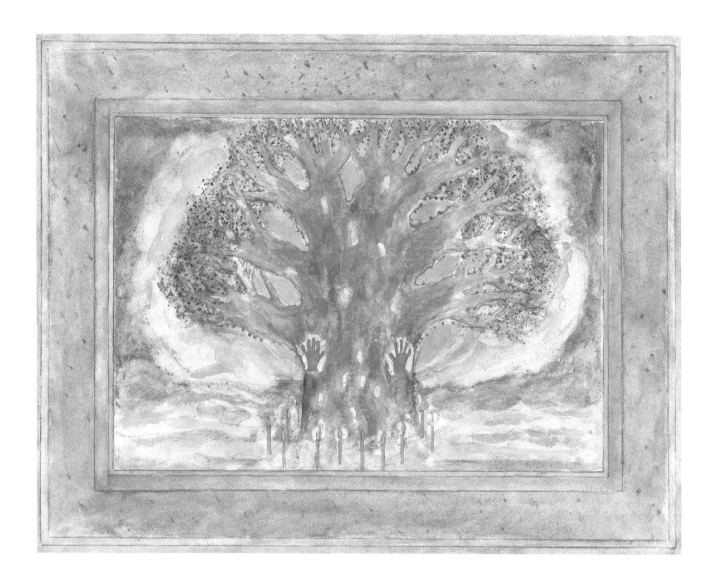

try; this was something that I first realized at about the age of 23.

So did you manage to paint full-time?
Yes, I didn't do any painting while I was teaching at the school; my own creative needs were temporarily met through teaching. But soon enough I achieved my ambition to live alone in the country and paint. It was a marvellous, fecund period. For about two years I lived in a shed in an orchard on a farm in South Devon painting all day, every day of the week; a delirious obsession.

Which must bring us to the point of your decision to take on the totally consuming challenge of setting up the Beaford Centre in North Devon. Did you come to that with preconceived ideas?
Well, we moved to Devonshire because having seen this job advertized we were attracted to the idea of not only living in the countryside but, like a vet, making a contribution to its life. I did, too, have a

vision of the kind of thing that such a rural arts centre should explore, which was the extent to which the arts, interpreted in the broadest sense of the word, could revitalize a declining culture. My concern was not only to make available a huge range of performances but to create no less widespread opportunities for participation. In the mid-sixties the latter concept was far less familiar than it is now. Today it has become the conventional wisdom of arts centre activity.

I remember in the last couple of years seeing you referred to as the guru of arts centres. Did this take you away from your central life as a painter?
In a sense it did, though there is no way in which I can accept my life as something chopped into bits: like anything organic, it has been a seamless web. I have subsequently wondered if I threw myself into this work as a counterbalance to the private, isolated nature of painting, which has something too much about it of the monk in his cell. Recently I

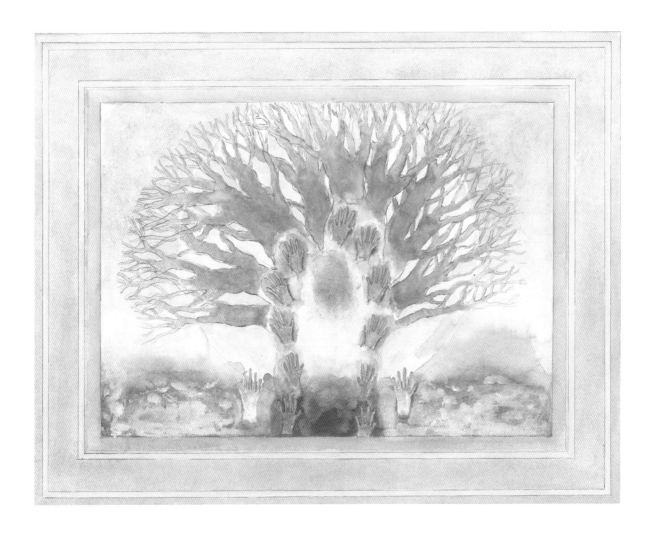

have been reading about Mahler whose life was, I have learnt, divided between composition – he had only six weeks of every year available for uninterrupted concentration – and the intensely demanding, extrovert administration of a large opera house. That kind of oscillation between public and private, inner and outer, is something my nature also desires. Part of me is in flight from society; part seeks involvement But the question remains: How can I be in the world but not of it?

Was it then in a state of exhaustion that you made the decision to accept the offer of becoming a Trustee of the Dartington Hall Trust?
No, not at all – I had had a sabbatical year during which I did a lot of reading, writing, travelling and self-exploration. I really felt the need to rinse out a lot of muddle and mud, to clarify where I stood. And just at the point when I was about to go back to the Beaford Centre I was asked if I would like to work at Dartington in South Devon. It was a difficult decision because it really was a choice between two different futures.

Were there any specific ambitions you wished to achieve when you went to Dartington?
Two or three perhaps. But primarily I wished at that time to cease to be a specialist -– an 'artist' – preoccupied in a fragmented way with one kind or another of expertise. I wanted to experience a wider field of activities; to sense the wholeness of things; I wanted to know about and be involved with different ways of life; the way of the gardener, the printer, the accountant, the boat builder. I wanted, above all, to discover the extent to which the aesthetic could be returned to all spheres of life and in particular to the world of work, from which it has been tragically extracted. Soon enough our civilization will be annihilated unless we can discover the vision of men and women engaged in creative, joyful labour, in union with nature, and at peace with each other and the world.

And in the last years, finally, you are back with your painting.
Yes indeed, I work at it consistently. It gives me much pleasure – and pain. But what I enjoy is the

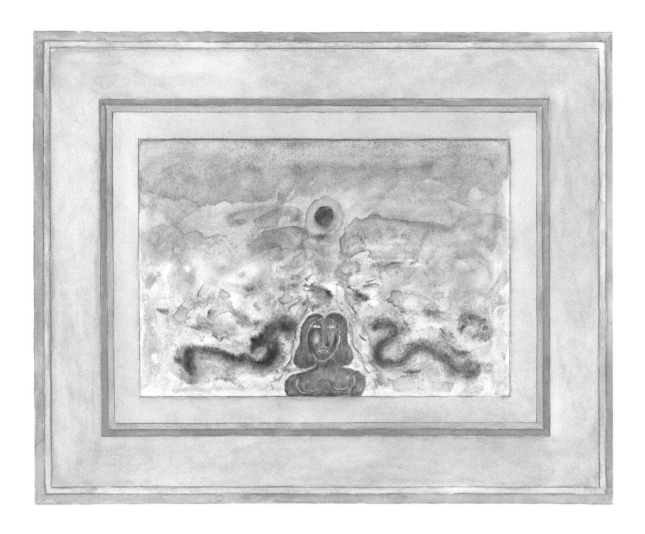

knowledge that this work is only part of a larger pattern, the pattern of experience: of family, friends, other work, walking, reading, cooking, laughter, and so forth. It's not a closet activity unintegrated with the rest of life. I see a rainbow, I paint a picture, I greet a friend: all one.

Can you say something more about that philosophy?
I find it difficult, without complete pretension, to stuff so many experiences into the time we have left. But I will say one thing, perhaps arbitrarily, and it is this: the external world is, and always has been, one of the keys to revelation, the immediate living experience of the sacred life I sense around me in a star and a mountain, a tree and a blade of grass. It is the signature of the Mystery. It is a hymn of being and, as Blake said, "one continuous vision of imagination".

In your pamphlet you seem to advocate a move to a more, perhaps less specialized form of artistic expression. But at the same time you yourself enjoy the opera and exhibit your paintings in galleries. Do you feel this is a discomfort, or is it something you can accommodate?
I am not unaware of these contradictions which are so closely related to what we have been discussing. But, you see, although it may be intellectually reprehensible, I'm not a purist, a person of unbending principle. On the one hand I do believe that life will only be whole again when there is a proper regard for skills in making, when, that is, 'art' bears on everything, on all the simple daily things: the daily rubric. But like Coomaraswamy, who argued there were two paradigms for the work of art – the icon and the useful object – I also believe there is room for that which reminds us of another world more real than daily life, eternal and indestructible.

I see my own paintings like little icons: attempted fragments of grace. Surely we will need these reminders. We will need both falcon and falconer. So I don't think I'm living a life of total contradiction. Some contradictions if you like. But ambiguity, paradox, the unknown, the inexpressible, contradiction never repel; they attract. Their potential mystery is limitless. ●

JOHN MOAT
A Moment's Grace

Painting is born of a deep love of life. *By John Moat*

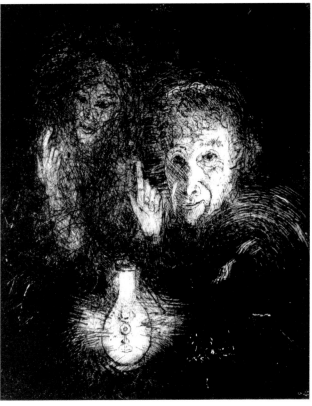

The end of the Opus

The Hunter

THE PAINTER/NARRATOR in Russell Hoban's novel *Amaryllis Night and Day* remarks, "There are many talented people who never will become painters, writers, or composers: the talent is in them but not the empty spaces where art happens."

My experience says Yes to that. These empty spaces: they're not quite the same as the Buddhist emptiness (that emptiness that is form), but they're related. This is a unique subjective emptiness that is identified by a thing looking to come into being. It is an emptiness that registers as a torment, a torment one can only heal by opening the space to the thing intent on filling it. And in every case it is a unique torment, because in every case something unique has touched a unique sensibility with its matching determination to have been expressed.

If that sounds pretentious, I can't have said it right. Mysterious yes; but absolutely not pretentious. In fact, for me, it is evidence of a basic worka-day dynamic. There are the emptinesses that relate to writing, but they're different – they are empty spaces abhorred by a particular type of problem thought, the issue of a toiling coitus of feeling and demonic meaning.

But with painting, the business is less of a problem. Something is seen in the mind's eye, in the actual eye – shape and colour and a feeling. For me, two categories: one the imagery that startles from within, quite often material unused in a piece of writing, which to claim an available emptiness magically switches medium and appears as image; the other, the external image, a flower say that leaps out and hijacks a little emptiness whose existence, or non-existence, I'd never suspected.

So what are these empty places? The way they ache seems important. Each a little torment until it has been filled thus, and thus, and THUS. And then for a moment's grace I feel complete. That, I'd say, is painting, more or less. ●

80

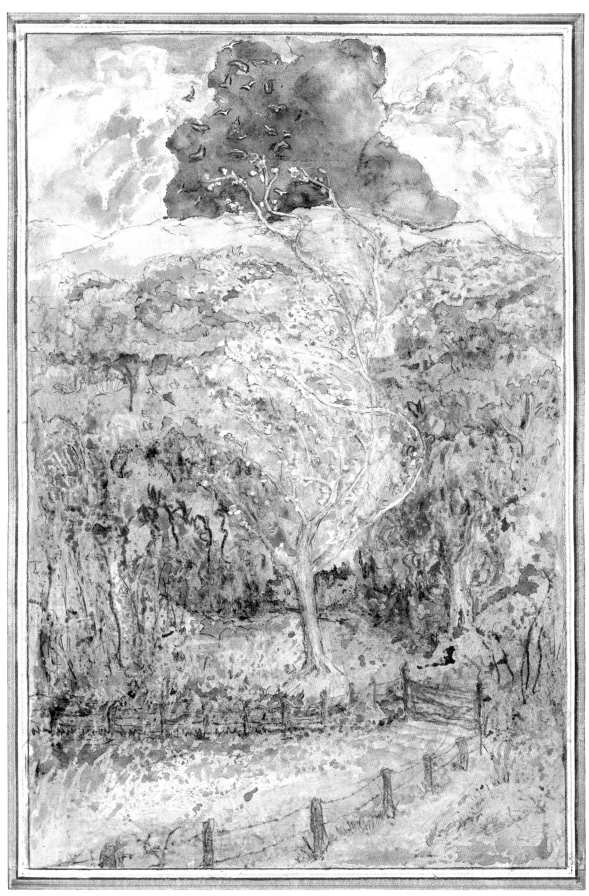

Poplar

81

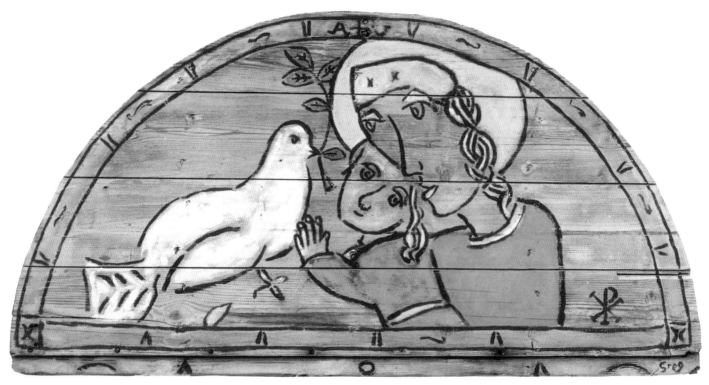

Mother and child

GREG TRICKER

Eternity Now

All my work has been converging towards a point of threshold, a doorway to freedom.

By Greg Tricker

S A CHILD I FELT HIDDEN. Through art I found a way of touching and expressing different emotions, a doorway to freedom. I felt very close to Van Gogh's inner struggles and alienation from the world. In his early years at The Hague and with the peasants you feel this deep struggle and burrowing into the darkness and the soul of people; you see this in his potato eaters and his painting of his boots. He touches a deep reality and truth. A spark in the darkness of his early work later becomes light-filled with the glorious sun of Arles; you feel this as a kind of resurrection in the paintings like the olive trees, the sunflowers and the red vineyard. Van Gogh was a kind of catalyst for us all, who expressed the struggle for reality and truth, for humanity, the beautiful wheat fields, for mother Earth. I felt deeply moved by his life and work.

From the age of ten I made many copies of his work, mixing colours with feeling and working sometimes into the night. Later, I found my own direction painting with *batik*, the beautiful Indonesian cloth dyeing medium. Various themes began to unfold. One was based on the moving life of Anne Frank. I was touched by her spirit to overcome the horrendous inhumanity that surrounded her. A series of twenty-one paintings unfolded. Later still, a series of paintings on 'Lady Lyre' emerged. They had a Greek feeling, with lustre colours of gold and bronze. The Lady touched the lyre strings and the sound carried her on a mythological journey traversing sea and time back to a hidden temple; she rekindles and finds her higher selfhood.

Then I embarked on a biblical theme of Jonah and the Whale. It is interesting that to the ancient people the large fish was seen mythologically as mother Earth, that when you walked on the surface of the world you were really walking on the back of a fish that swam in a cosmic ocean. This connection to mother Earth as a living being becomes signifi-

82

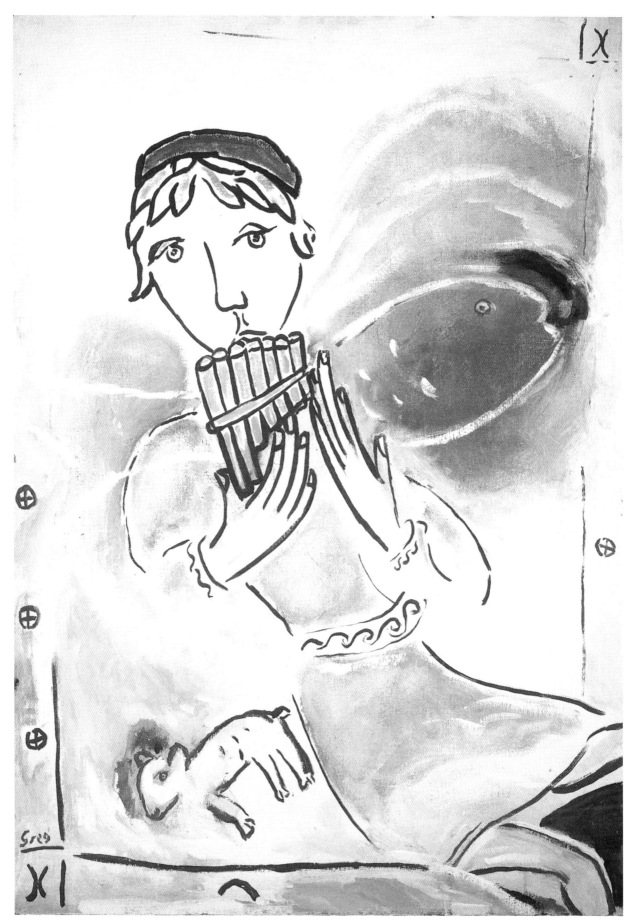

David shepherd boy

83

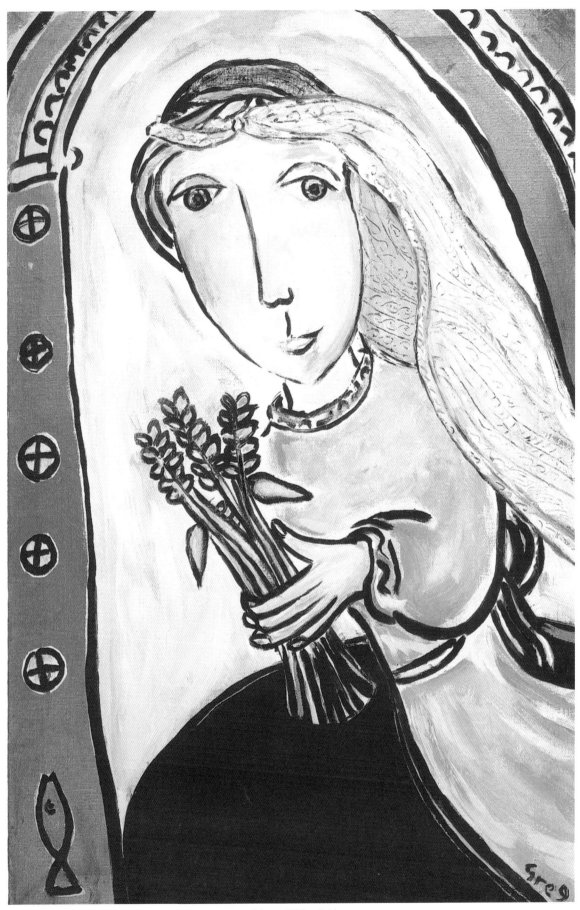

'Natura' Wheatbride

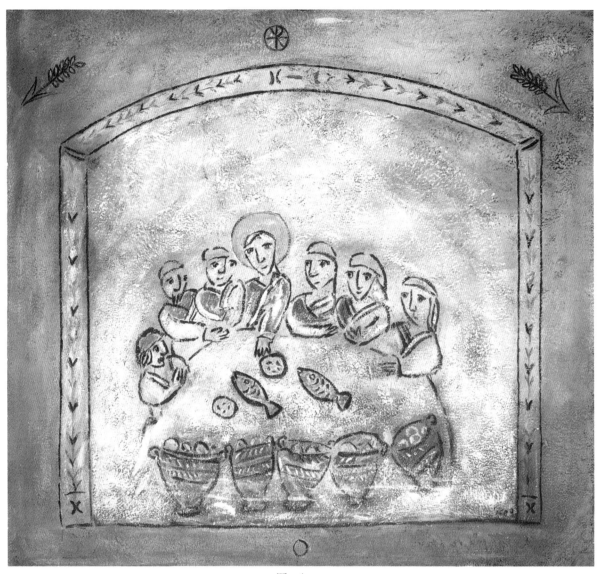

The Agape

cant when we see later in the 'catacombs' that the early Christians scratched in stone the fish symbol as the secret and sacred word for Christ.

It became clearer to me that all these themes interrelated, were weaving with one another like a symphony on a deeper level. The question arose: how can I bridge, span time so that in one brush-stroke there could be present a rich Greek mood, a feeling of Jewish history and a Byzantine art; like one golden ball that could roll, so my art would achieve a unity of expression, a wholeness?

It was at this point that I made a visit to the cata-combs of Rome where the early Christians were buried deep below the ground. I walked down the darkened steps through a labyrinth of passageways and entered a chapel-like room. I discovered a pro-found silence. I could see the sign of the fish and the dove scratched into the ancient walls. Nearby I found a painting of the last supper. Although it was faded with age, it was still possible to see the disci-

ples gathered around the table with baskets of loaves. I reached out and touched the subtle colours of the bread and felt beneath my fingers the delicate texture of time reaching back towards the early Christians. I sensed the nearness of Christ. Other chambers had faded paintings of Helios and Jonah on the walls. These paintings resonated deeply with all my previous artwork. A closer weaving and har-mony between the themes was now clear. A golden ball was being created. There is a profound meeting point at the catacombs, a coming together of pagan mysteries and early Christianity, old and new testa-ments, east and west – a cosmic secret.

With great passion I created a series of paintings and stone carvings centred round this theme, cele-brating not only the early Christians' wall paintings, but also Greek myths, ancient mysteries, Byzantium, Romanesque and contemporary art. Art has the potential to transcend time and space, a resonating back and forth from now – Eternity now. ●

HYMNS TO NATURE

I strove with none;

for none was worth my strife;

nature I loved

and next to nature, art.

Walter Savage Landor

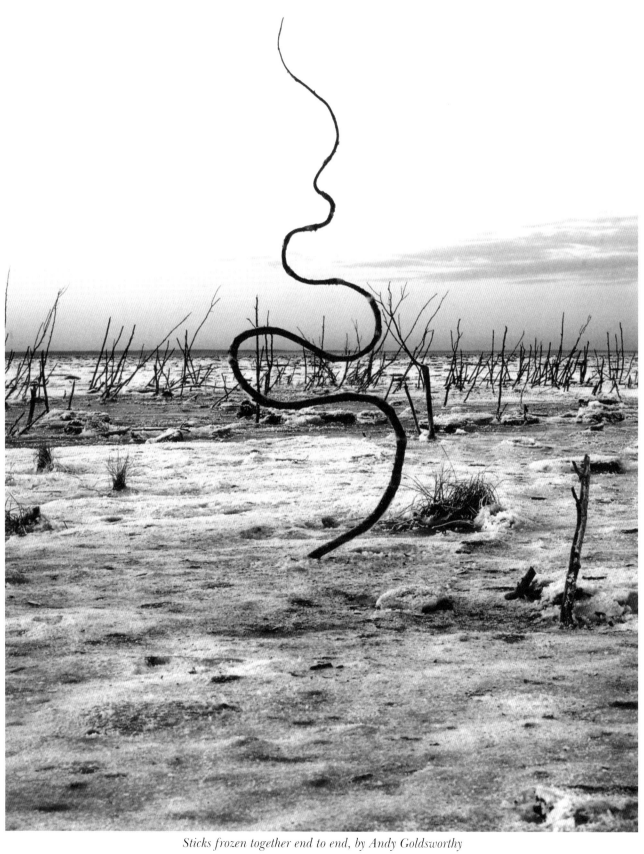

Sticks frozen together end to end, by Andy Goldsworthy

CHRIS DRURY
Art in Form and in Silence

"In my work, culture and nature are no longer separate," *says Chris Drury*

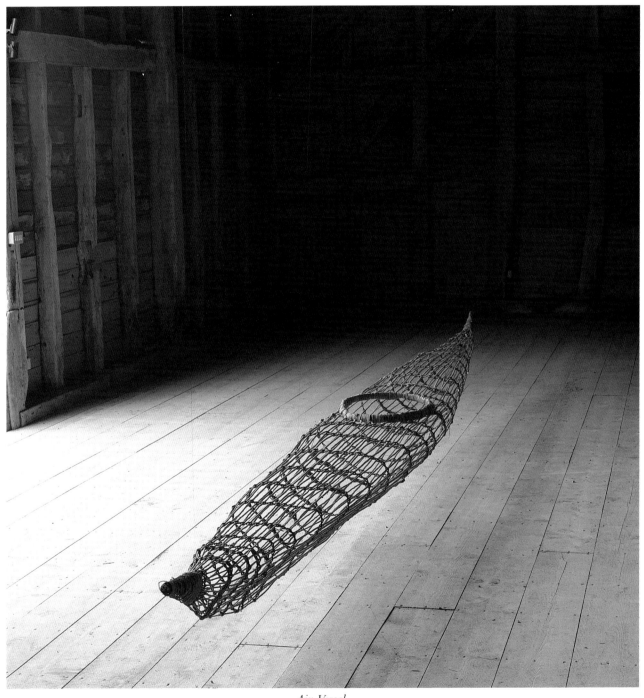

Air Vessel

Chris Drury makes shelters and cairns in landscapes; he uses the materials of the land to make baskets, vessels and stick bundles. He creates objects both during and in response to the journeys he makes, using a camera to record work which is ephemeral and transitory. Chris discusses three works that crystallize the particularity of his relationship with nature.

AIR VESSEL – 1995: When I was a child my father made a kayak from a kit. It was carefully constructed from a skeleton of wooden struts on to which canvas was stretched and painted. This beautiful craft accompanied us on all our holidays and provided hours of fun. A few years ago, I saw a genuine Inuit kayak at the Museum of Mankind which literally took my breath away. The shape was utterly precise, beautiful and delicate. This kayak, I realized, must have taken hours of painstaking work during the storms of the winter, the struts pieced together from small strips of driftwood and tied with raw hide. Something of the intense concentration of attention in the making of an object for use and survival imbues this object with great spirit. It is a hunting tool of precision. Amazing that something so fragile was designed to negotiate some of the most hostile seas. Its lightness and shape seem to me to be as much about flying as floating.

With this in mind I wanted to make a similar vessel which appeared to fly, whose sheer lightness mirrored many moments of exhilaration in extraordinary landscapes and mountains I have visited. I wanted to use my continuing practice of woven baskets and vessels, so the air vessel was to be a three-dimensional drawing in willow.

I drew out in actual size the length and shape of the vessel in chalk on the floor. I exaggerated the length (eighteen feet), and marked in where the transverse struts were to come. The shape of those struts I then cut out in plywood and notched around the edge where the willow struts were to lie. Starting at one end with a bundle of tightly bound long willow, I inserted the first small ply strut, fitting the parallel willows into the notches, then twinning with two red willows at right angles, following the line of the strut. When the twinning has circled the cross-section, the ply strut is removed and the next one placed, and so on. So the vessel is made over several days of concentrated attention using the same body and hand movements, starting from one end and working through to the other. The final work is suspended by thin nylon thread so it floats in the space of a room.

In some strange way the concentrated attention required to make something, especially something woven with repeated body, arm and hand movements, is very close to the act of walking over long distances for several days. In both activities, the body is in movement while the mind is concentrated (on rain, weather, or in making the correct shape) but at the same time alert to what is happening on the outside and to the thoughts passing through on the inside.

COVERED CAIRN Tickon 1993: The cairns I make mark a special time and place. They are an acknowledgment of something unnameable. They are not sculptures; they are simply pointing to something which is outside the self and changing. These cairns are built very simply, photographed, knocked down, and then I walk on.

At Tickon (Denmark) my intention was to contain a cairn and to mark what is within. The cairn points to inner nature. My work is interactive. From the outside, dome and cairn are a unified, defined object, but when you enter the dome, the outside (the trees, sky, sounds, smells) is allowed in through the openweave and enhanced. It is like looking out at nature from the position of a secure inner core.

Rather than make a work which points to something in nature, I decided to mirror the process of nature. The dome is built in marshland and is made by pushing alternate hazel and willow wands into the ground. The willow is living and growing; the hazel is decaying. The work is allowed to go its own way. I imposed order which will revert to chaos, which in nature is the true order.

WAVE CHAMBER – Kielder Reservoir, Northumberland 1996: The shelter has been a preoccupation in my work. I like simple, basic dwellings that sit within a landscape, just as I like to see birds' nests and animal lairs, sheep resting places and rabbit warrens. I like the idea of taking refuge from the bigness of open spaces in a small cocooned and enclosed shelter. Such spaces pull you inside yourself, in opposition to the way that mountains stretch you outside yourself beyond the next horizon.

When I stumbled across the idea of a camera obscura, all these interests came together. By means of a dark space, a light floor and a small hole in the roof, the cloud chamber breaks down this division between inside and outside. You can at one and the same time be cocooned in a dim subterranean space while watching the clouds in the sky drift across your feet, as if heaven and earth are brought together in one space. The cloud chambers are still, silent, meditative and mysterious spaces. They are spaces of movement within stillness. Sometimes on dark, grey days, nothing is visible – the chamber is then a dark space of stillness within the broader, moving, changing landscape.

To make the Wave Chamber I worked with two local dry stone wallers and others, transporting seventy-five tonnes of rock to the site by barge, in high winds that created five-foot waves which crashed

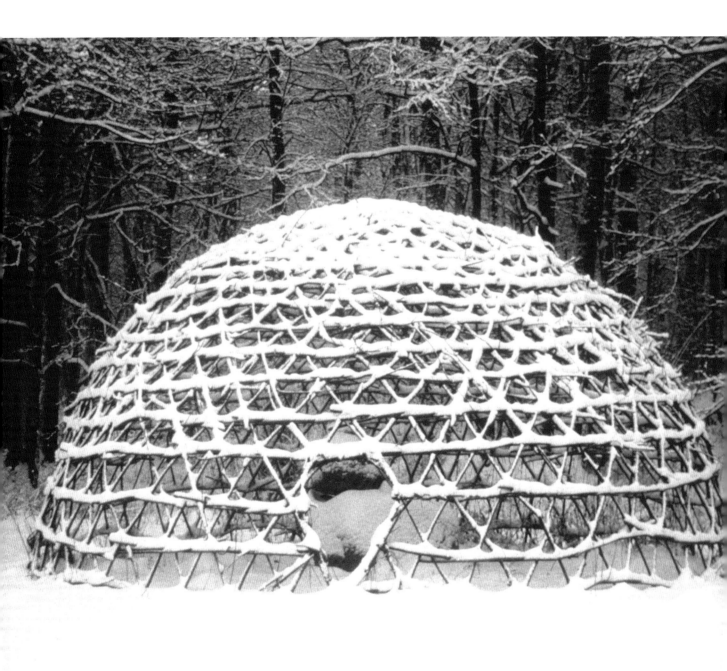

Covered Cairn, Tickon

over us. By the use of a lens combined with an angled mirror in a periscope built into the top of the chamber, I was able to project the image of moving waves on to the floor. When the stonework was finished but before the door went on, I was impatient to see if the camera obscura would work, so we rigged up a tarpaulin over the door at a time in the afternoon when the sun was bright with rippling light. Inside the shelter it looked like a thousand silver coins were dancing on the floor.

At times during the day the image is ghostly subtle, and you can get the weird sensation that you are standing on liquid. There are other times when it is blowing a gale and rain is lashing outside; then the mirror or lens will mist over and no image is visible. At such times the chamber reverts to a simple shelter which echoes inside to the sound of waves breaking on the rocks below it: a still space within the greater movement of the landscape.

There is also something here about change, which is the only constant in nature. Thirty years ago the reservoir was a valley with two villages, fields and forest. The Belling Crags were a local climbing spot. Earlier there was much coal-mining

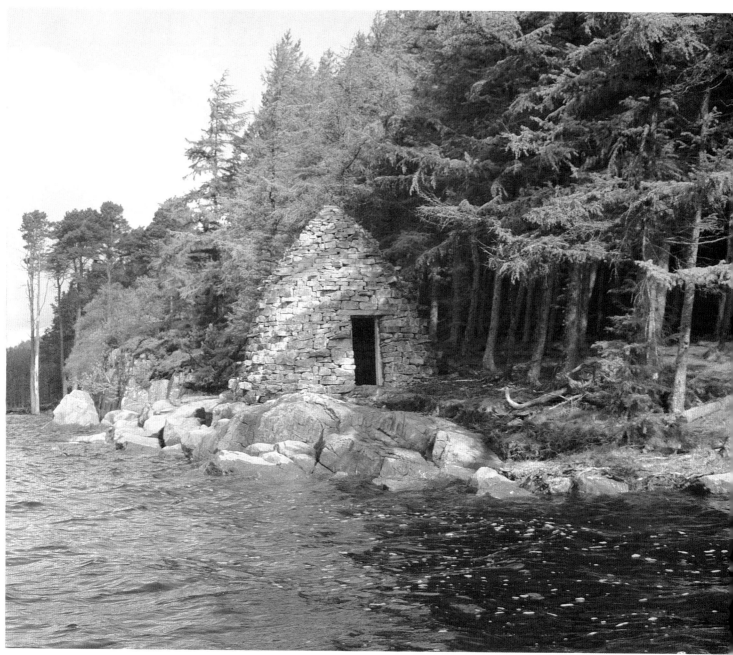

Wave Chamber, Kielder Reservoir

in the valley. Now all that is covered by water and forest; the rocks seem permanent but only relatively so. The wave chamber appears solid and permanent against the constant change of the rippling wave image. In reality everything is in movement and changing. With the wave chamber, then, movement is in the labour of making. The intense hard physical work produces a space of stillness and meditation, within which there still remains the echo of the greater movement outside.

With the activity of walking, the stillness is in the mind, which after several days becomes relaxed but focussed, alert and observant to what passes inside and outside. Works made during or from these experiences are pauses in the greater movement; objects at rest. In both cases the divisions between inner and outer, movement and stillness, are blurred – culture and nature are no longer separate. ●

Wave Chamber is located at Kielder Water and Forest Park, Northumberland. To reach the sculpture drive across the dam and park at Hawkhope car park. Follow the north shore waymarking to the Belling. The work is situated just east of the crags near a trig point and information board.

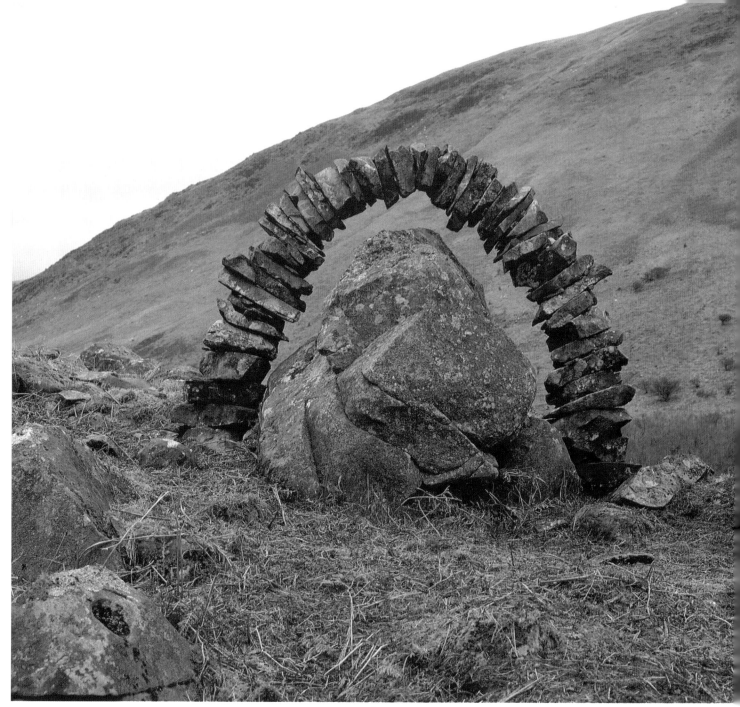

Over the stone

the work of art. He often works under strenuous conditions in isolated, harsh wintry country. He spent four weeks making sculptures in an Inuit Indian village of the High Arctic Islands of the north-west territories of Canada, and at the North Pole.

Andy Goldsworthy, why did you go there?
North has always held a fascination for me: it is a strong element in the landscape. For me, going north was following feelings that I've discovered in working with snow and ice. I wanted to follow north to its source. I wanted to go to the place that generated the cold that made winter. It was a way of understanding where I live. North is made visible in the snow and ice of the winter. The north side of a

mountain is different from the south side – there's a kind of northness about it.

When I first started working outside, winter was a test for me; a test of my commitment to the landscape: whether I could manage to work all year round. I wanted to work all year round because I wanted to have a complete understanding of the landscape, and that meant seeing it not only on the sunny nice days, but also the wet, snowy cold days. Not only have I managed to work through the winter but I have found that I need it; I need the stimulus of winter. I can't explain to you the effect, the excitement of the first snow fall and going out and working with it, the dark earth turning white – that was a very potent lesson for me. There is something

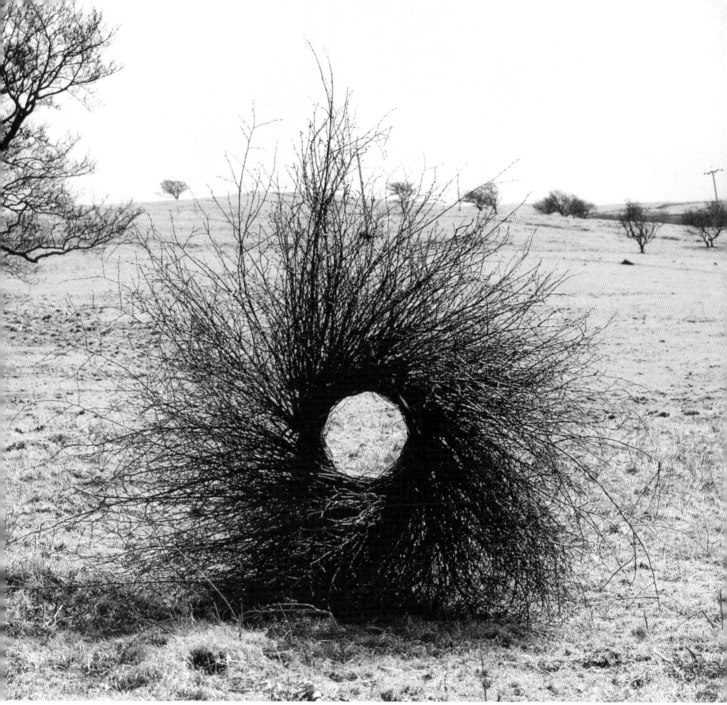

Woven silver birch

there that is fundamental to the way the earth works. It was by following these feelings that the Arctic project was originated.

On the Pole you constructed four over-life-size upright circles using blocks of snow, and then positioned them to form a large square area. This is I think the most formal piece of sculpture you have ever made. How did this come about?
Its formality I think was a response to the regular rhythm of the sun going round at the same height – the sun never went down, it never went up, it stayed in the same place and just circled. It is a very strong sense of a circular motion and that was the strongest indication that you were at the North Pole. So the

work had to be equal on all sides, to work the equal light conditions up there. I've never used that before; the light for me has always been changing, whichever direction it has come from. So the formality came out of that. I also wanted to enclose an area up there so you felt that you were at the centre of something. All points from there face south, so to make work that made you aware of looking towards somewhere required certain qualities which I was trying to work into the piece.

When you arrive at a spot, how do you begin the process of making the sculpture?
When I arrived at Grise Fiord I started working immediately. There was no acclimatizing before I

started work, there was no resting. I wanted all those problems to be resolved in work. For example, coming to terms with the cold: I wanted to do that whilst I was working and making things, so that pieces became an expression of that. That is the best way I can come to terms with a new place, through my work. I don't really know what I am going to make until I arrive. I like to go open-eyed and until I actually get there I don't know what I will make because I don't know what the materials are like. As soon as I stood on the snow I realized it was hard, and I realized that I could work with it, but until that moment I had no idea; it could have been soft, very powdery snow that would have produced very different work.

The snow that I am used to is a wet snow. The Arctic is very dry. The hardness is brought about by the wind; it is not wet snow which has been frozen. So it's a totally different snow to anything I have ever experienced.

So the process is very intuitive on the spot. I know you draw. What part does drawing play in the creative process?
I have kept a diary, which is very important. I make a short, quick drawing of the work. But I began to feel about some of the snow works as drawings. The walls of snow we made were like sheets of paper that I worked into each day. They were blank walls of snow, and it's difficult to put drawing into a small category in my work – I have drawn lines in the sand and on the snow.

How did your interest in nature begin? Did it start when you were a child?
The things I remember most from my childhood are those that are related to messing about in woods. I began working outside in the first year of my degree at Lancaster. I became very disillusioned with working inside. It didn't seem important, there was no meaning in that, whereas when I started working outside I learnt about the weather, the materials. And through touching materials and working with them I get an understanding of those materials which you can only get through touch. I understand snow, leaves, feathers, mud, sticks and stones around. I started pushing them into the pebbles. That lead to a feeling of the way a carpenter understands wood, because he works with it.

You worked as a farm labourer when you were young; that must have opened up all sorts of possibilities?
Working on the farm was far more important to me than art college. It gave me an understanding of how to work the land, how you can affect the land. It gave me an ability to work, physically, quite hard. It also made me very angry about the way the indus-trial farmers abused the land. I did many things – from stone walling, hedge laying and sheep shearing to driving tractors.

Working outside makes me more aware of how I affect the land. For me ecological issues are very important and creative. This is a very exciting time to live in, because we are reassessing our relationship with the land. For me it is a time of celebration, a time when we can find a very personal way of establishing relationship with the land.

In 1988-89 you made a series of sculptures using various leaves, in the garden of a museum in the south of France. Now I find these works over-delicate. You once said that sometimes a work is at its best when most threatened by the weather. Do you feel you work more successfully in a hostile environment?
The works in France were made in a tiny garden in the middle of a small town, surrounded by buildings and traffic. In that garden I found such a marvellous wilderness. It too was one of the most difficult environments in which to work; it was a very small area, so that was a challenge. I feel a strong commitment to find riches in what appear to be very humble places. In that garden, the first day I worked, there was this brilliant intense sun, the light was beautiful. There was a brilliant clarity in the light and I had to work that light in a relatively dark situation where there were tall buildings around. I found that the light hits certain trees two or three times a day. That garden had a kind of natural clock to it which regulated how it worked, and I began to hang leaves from these trees to catch the light. I would get there before the sun had even got up and work in the cool dark morning. I would hang the work on the tree and wait. The sun would gradually come round and activate these leaves and it was fantastic. I would just see that happening and then the sun would pass over them and the work would be finished.

So for me it was an extraordinary situation and in its own way as extraordinary as going to the Arctic. I wouldn't like to think that I had to go to places like the Arctic to find extraordinary things. In many ways my trip to the Arctic emphasized my commitment to the small and the local. I went to the Arctic to follow and pursue things that I'd felt very strongly in Scotland. But I don't need to have these exotic trips. I am not an artist who can only work in that way. I like to have a wider view of the world that the trips give me; the places that I have worked in, Japan and France, I have a strong feeling of those within me and I like to think of the trees that I have worked there. I think of them when I am working with a tree in Penpont, it gives me a feeling that a stone turned in Penpont is a stone turned on the world.

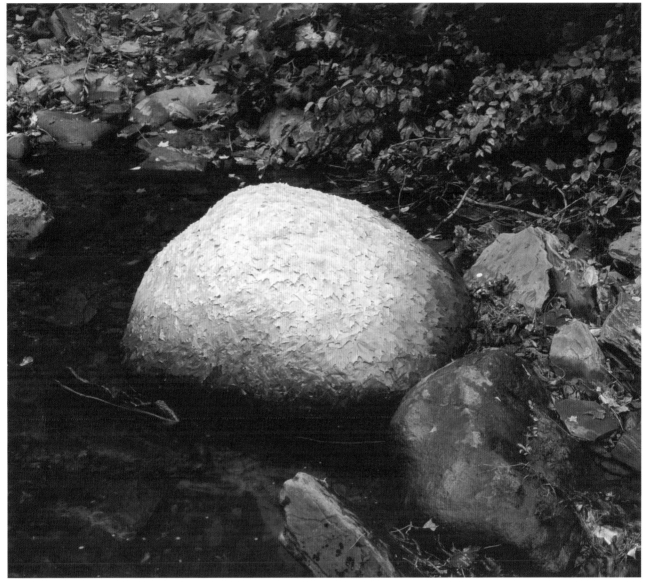

Leaves laid on a river boulder

Do you find that colour is an important aspect of your work? Is Japanese colour in nature different from English colour in nature?

When you first arrive at a place your perception is very new, your eyes are fresh in the way you only have when first seeing a place. When I arrived in the Arctic the thing that struck me most strongly was how deep blue the snow was. Any snow that we come across normally is brilliant white in comparison. That initial discovery dictated a lot of the work that I made there. Everybody thinks snow is white or the grass is green and that conception of colour sometimes blinds us to what that colour really is. Sometimes I would have to shake my eyes up, look again and then realize that it wasn't white, it was many colours. The colour in the Arctic is the sky, so I am working with the sky. When I work with the land I work with the sky, when I work with water I

work with clouds. The colour in the Arctic is a kind of atmospheric colour. It is different from, say, in Japan, where the colour is embodied in the leaves and in the mountains. The red of the Japanese Maple held, for me, the spirit of that place. Understanding that colour was understanding that place, and touching that colour is what I try to do in my work, yet touching something as elusive as colour is very difficult. When I saw those red trees up in the mountains and I walked up to them, by the time I reached them, the colour had gone. It had disappeared because the colour I'd viewed from down in the valley was a concentration of leaves, lit up from behind by the sun, and it had gone. I had to try to find that colour and I discovered that colour by putting the leaves in water. That was the key to discovering the energy of that red.

When I make a good piece of work, it's like touch-

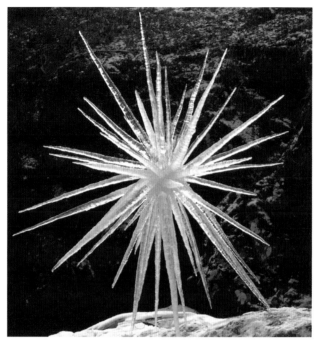

Icicles frozen together

ing a rainbow. Try touching a rainbow and it moves. It's always moving. It's always elusive. Working in the Arctic, with that cold, was like being able to touch a rainbow all the time!

Are you saying that the atmosphere in Japan produced a particular type of work and the atmosphere in the Arctic produced a different sort of work? Is it the atmosphere that is the key to what is produced in your sculpture?

The atmosphere of any place produces a specific work. The space that a material occupies is made visible by the weather and the light. It's that space that I am trying to understand. I am not just trying to understand a rock as if it has been delivered to my studio. I have to understand why that rock is there, the time it has spent there and the way it has affected that place. It's a window into the processes that have gone on around that rock. Those are the things that I am trying to learn about. That's why I work with the materials in their place, where they have come from. I try to see them at their source. When I work with a leaf I am working with the sun, rain and the growth of the tree, the space of the tree, the shadow of the tree; it's not just three inches of leaf; it's the entire growth and process that I am interested in.

When you arrive at a spot, do you spend quite a bit of time wondering and thinking about that space, exploring it before you actually start making objects?

I can probably best explain that by the Japanese work that I made: the bamboo screen. Firstly I don't always work in places I feel are special; the day I arrived there I thought: this is terrible – what can I make here? I remember that first day, there were small grey pebbles on the beach and that was it, as far as I could see. But I have faith in my work, for it to open my eyes to a place. That is what it does. I found some dead bamboo lengths scattered, creating something between me and the mountains over at the other side of the sea. So, they began to get involved in the work. Then it began to rain. Dark purple clouds started to come over from the other side of the estuary and that began to become a part of the work. So, things evolve as I go along; they start reacting and responding to place and weather.

In the Arctic when I arrived it was calm and I was very apprehensive about the wind. I knew how severely it could affect me. The first day we had a strong wind, I said to Looty, 'We'll go and work where it's strongest.' We went right out on to the ice. I didn't know what to do. I had no idea what I would make. I didn't know how I would be able to handle the wind but I had to come to terms with it by going straight into it. Rather than trying to find a sheltered spot I went to work with it directly. It was just extraordinary. The whole surface was moving. The snow would disappear, then come and then go again. I was so excited about the wind that I began to make work that needed the wind. Then the wind died down. I was left with all these feelings that I wanted to explore with the wind and I couldn't do it. So I was then looking forward to the wind. I made one or two pieces of work that touched the wind. Seeing the snow moving made the wind visible. The wind was something you could touch then. The cold was so cold that I could touch it. It was almost as if I could see the cold, see the wind, make works that were using the wind, were about the wind.

In your description of working at the Pole, you referred to Looty. Tell me something about him.

Looty Pijamini worked with me for four weeks. He was my guide, teacher, helper and companion. I have never worked with anybody who understood snow more than I do. His knowledge and skill were a big contribution. We worked together in a way that only my wife has been able to do before. At the end of my stay there, we built a store house, an igloo. I realized how many of the things I had learnt from Looty were in his tradition of snow house making and that his needs of snow were the same as mine: he needs to explore it, use it and understand it.

What part does the photograph play in the work?
The photograph gives an independent, visual life to my work which is outside my own head. If you can imagine that after working all day, I am tired, sometimes I don't know what I've made. It's difficult to assess the day. When the photographs come back that is the time I can assess the piece of work. Often I can see things that I didn't realize at the time. I re-discover my work in the photograph. It is also a way of communicating with other people.

My work decays because nature decays. The work that I do with my hands, with thorns and leaves or snow that doesn't last very long, is the heart of what I do. That's the source from which I draw all the other aspects of my art. The photograph is only a record of the work. There are many qualities left out. In that sense the photographs work as a sort of invitation to feel how the work might have been. My art is and will always be a reflection of my way of life. ●

This interview was conducted by Terry Friedman and first broadcast by the BBC. It is reproduced here with their kind permission.

Slate crack line

KEITH GRANT

A Marriage of Vision and Reality

The works of Keith Grant are prayers as well as paintings.
He is a landscape painter and, at the same time, a painter of the
inscape of the soul. *By Peter Abbs*

CEREBRAL installations in the city; sentimental paintings in the province. We live in an age when the dominant art seldom addresses our immediate feelings or activates our imagination. Shaped by the power of international investment and, to a lesser extent, art colleges and journalists, fashions come and go, but the majority of people no longer care who is in or who is out or who is about to come in or who is about to go out – for, invariably, the work hailed or harangued is devoid of human interest and has little intrinsic value. Humanity looks at it and says: so what? And the artists, instead of answering, rush back to their clubs for justification and social approval. So the official world of art becomes more and more enclosed, sterile and narcissistic. Artists confer with artists, trend-setters and agents; and the general public stays at home.

At such a time one would expect to find the serious artist – the artist committed to the exploration and illumination of experience – on the very edges of the great art-game and largely outside its frame of reference. One would expect him or her to be building up a substantial body of work directly challenging the imagination, and one would anticipate that such work would be widely admired by the discerning members of the public when and if they had the opportunity to see it. There must be a number of such gifted painters scattered across Britain. Keith Grant, I believe, is one of them.

Over the last four decades Keith Grant has created an extraordinary opus: hundreds of paintings, drawings, sketches – ranging from the miniature to the vast: as well as murals, stained glass work, illustrations and stage sets. Driven by a compelling inner necessity, the work has poured out of him. In my view the best of this formidable output has sought to express and illuminate the landscapes, seascapes and skyscapes of the far North. Keith Grant, from a working class background in Liverpool, discovered as an adolescent that he was a painter and then, as a comparatively young man of twenty-seven, that his task was to become the painter of the austere and extreme beauty of the North. "It is in the North," he once wrote in his journal, "and only in the North that I sense the value of my life." The painter has worked elsewhere. He has taught in various parts of England; he has travelled widely, painting in Israel and South America. Yet, continually, the North has called him back, as if to remind him that his major task was to articulate its language and to throw its severe geometry on the screen of the collective imagination.

KEITH GRANT'S WORK requires the closest attention. If one examines the Northern paintings, one becomes aware of two crucial elements so fused in the act of composition that it is difficult to separate them. The first of these elements is a telling representation of the object seen: a volcano erupts, a vast sun sinks into the horizontal sea, a mountain peak rears up out of a bleak tundra, the steep sides of a fjord are reflected in its still water. We recognize the objects instantly. There is no puzzle. They are made visible before us: rocks, water, clouds, stars, mountains, ice-caps. They stand in their own dramatic right, startling in their apparent objectivity. It is as if the painter has stood relentlessly before them and using all his acquired skill captured their immediate physical nature. In his canvasses the immense flux of nature stills, allowing us to contemplate the symmetry of the ephemeral.

And yet, the more we look, the more we realize that the object so adroitly grasped is also shot through with the soul of the artist looking, with his mood, his aspirations, his inner spirit, his unconscious. It is precisely this that gives the paintings their mesmerizing spiritual character. The many sun paintings depict not only the natural sun, but also act as mandalas, prayer wheels, numinous circles affirming the unity of all living things. They are, one is tempted to say, prayers as well as paintings.

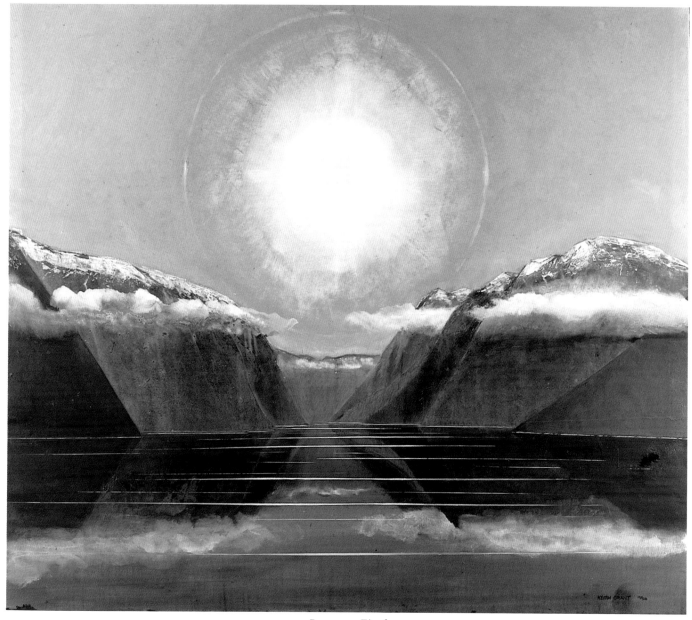

Sun over Fjord

Similarly, in other paintings, clouds come to possess an almost musical quality of abstract movement, while reflections of an island in water stand suspended like archaic memories.

As in the paintings of Paul Nash, a major influence on Grant's vision and technique – landscape forms – can often come to resemble slumbering bodies prefiguring consciousness. They lie there, half-human presences casting a magical, sometimes uncanny, atmosphere across the landscape – as if within the manifold of nature itself consciousness is about to break forth. Out of matter emerges the eye. Thus the phenomenal world (loved for itself) comes to house the resonant symbolic world of the human mind.

IN BRIEF, a spiritual energy suffuses what is precisely seen and the outcome is an act of embodied vision. Grant is a landscape painter and, at the very same moment, a painter of the inscape of the soul. He has been called a visionary realist. As far as tags can take us – which is never very far – this seems an apt description. The work joins together what has so often been broken apart. Here in the arena of his work seeming opposites come together and animate each other: object and subject, perception and dream, description and evocation, science and symbol. Not surprising, then, that Jacquetta Hawkes has called him: "the master of the Yin and the Yang".

Yet, through indirect allusion and explicit hom-

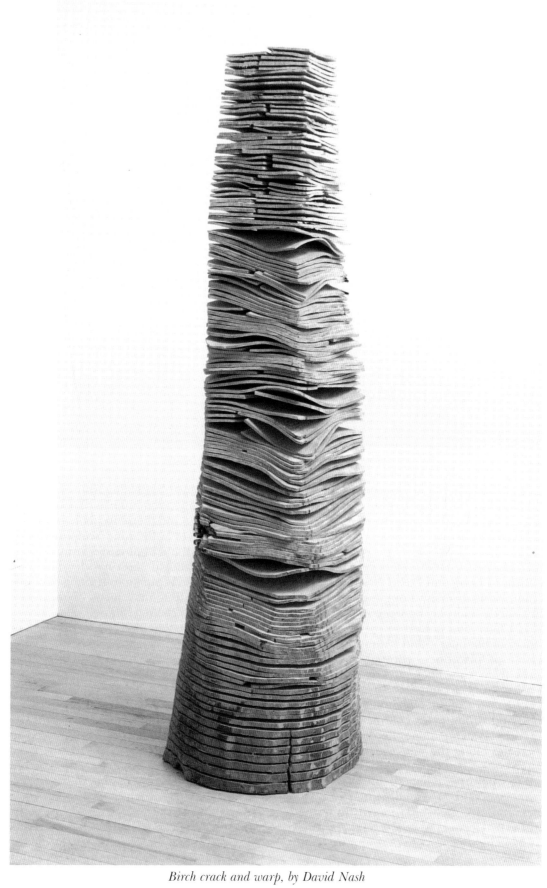

Birch crack and warp, by David Nash

106

Square and Branch, by David Nash

over a thirty-year period into a living tree dome. This circle of ash is planted on Nash's land in Wales where he cuts down the wood he needs, or finds green or dead wood. It is an expression of making life and art one, and a meditation on making place central to that life.

WHITHER THIS TRAJECTORY in and beyond the art world today? Land Art, if we are to call it that, could be said to be at a crossroads. Widely accepted by the general public, more radical detractors point to how the movement has been coopted into the mainstream, with its hitherto radical edge becoming artistically meaningless: the equivalent of wallpaper in the woods. The art market never went away, and as artists become established, their artefacts become just another product in this culture industry. Also, at times, the work, although particularly its packaging, is susceptible to being thought of, in David Reason's words, as "art that stresses the harmonious and accessible prettiness of the natural world (which) flirts with eco-kitsch." This may be nothing to do with the artists, who do not desire to romanticize nature in itself.

Signs of its further establishment can be seen by the planned opening of a Centre of the Contemporary Arts and the Natural World, near Exeter in Devon. Conversely, Grizedale Forest, the original artists' residency centre, is undergoing a major rethink, which so far has moved it far from the original energies and towards a fully-fledged post-modern apprehension of how the rural, and its relationship to the natural, is constructed.

From there the new Grizedale artists seek ways to comment on and critique this. There are of course other younger artists working, though the most forward-looking appear to be thinking of how in the spirit of convergences, elements of Land Art's original energies can be combined with other strands, be it performance or new media. It is difficult to imagine how effective new moves, as radical as Long's and Nash's once were, might be made. This said, with an increasing ecological sensibility pervading modern societies, along with the perennial human preoccupation with making marks in the ground and on rocks, from Lascaux and Stonehenge on, it seems likely that these forms of artmaking will continue far into the future. ●

107

JOHN NAPPER

Seeing the World by Heart

His last paintings. *By Ian Skelly*

Sheep at night

IT WAS IN 1971, at that magic time of Whitsuntide, that John Napper moved into Steadvallets, the house that for the rest of his life was such a powerful source of inspiration. Here in this isolated farmhouse, after nearly fifty years of living a peripatetic existence in London and Paris, the Far East and America, his work finally found stability. For the next thirty years in a continuous stream of pictures he embarked upon what was essentially a spiritual journey, exploring the interrelatedness of the whole of creation, seeking to capture the harmony that exists between all things in their natural state.

The paintings featured here are from his last years, by which time he had delved deep. They are thought-provoking as often as they are beautiful, and depend upon the timeless geometric principles of balance and harmony for their construction. Their vocabulary is drawn exclusively from the magical landscape of his home.

This 18th century farmhouse is tucked away from the teeming world in a velvet fold of the South Shropshire countryside. Below the house a river carves its way out of a steep-sided gorge to cascade in rapids over boulders and storm-felled trees, then

more peacefully into dense and twittering woodland. Birds abound. Kingfishers and dippers dart along the banks, finches fluster in the hedgerows, field fares and redwings cloud the ploughed earth, and in the orchard the partridge and the pheasant patrol. The majestic outline of Titterstone Clee dominates this tranquil scene. This vast island of earth is smooth-sided like a volcano, with a long back that rises to a summit of solid rock squared off at the crown to resemble the head of a sleeping lion. It has a magnetic effect upon the senses, and John used it many times in his paintings, placing it on the far horizon to imply a sense of ultimate permanence and quiet wisdom; a calm symbol of hope and certainty; the still centre keeping its peace.

John would often joke that while his friends accused him of removing himself from the world, he had in fact found the centre of the universe. He enjoyed an encyclopaedic knowledge of Indian mythology and philosophy, and was deeply aware of the paramount Hindu principle that one need not travel far in search of treasure. True treasure may be found where one IS, here and now. And so it was at Steadvallets. His endless wandering came to a halt, allowing his journey to deepen into the active process of knowing one place by heart, to the extent that near the end of his life he told me he could understand every word that nature spoke to him, every nuance of its meaning, so he could participate in nature rather than act as its observer. In his memoirs, on which he was still working when he died in the March of 2001, and which I hope one day will be published, he wrote of this 'understanding':

"Eden is an archetypal human world, a world that was made to be Man's home. The garden that Adam and Eve lost was nature itself and we have sought at Steadvallets to restore it, to reunite ourselves to the best of our abilities with that place of paradise. A flower or a bee can have cosmic importance to those who have a sense of interior life. If one admits to the supernatural reality of nature, that aspect which can only be expressed by means of the arts, one finds that it heightens the sense of spiritual awareness. The candles burning on the dining table are of the same material as those that light the altar."

John Napper was born in 1916 and from the beginning was on the move. By the time he was 18 he had lived in as many houses. He studied at the Royal Academy and by the 1940s, after service as War Artist to Ceylon Command, he had established a reputation as a society portrait painter, somewhat by accident. Lady Churchill was among his many sitters and in 1952 he was commissioned to paint the first official portrait of the new Queen. But by the late fifties it was all too much. He left Britain for France, where he began the painful process of stripping away the formality of his training and an excessive romanticism in his work, unloading what the French call 'cooking'. They were fifteen difficult years. Eventually he returned to England via a professorship in America, and so to Shropshire, where all his hard work finally began to bear fruit.

A first series of kitchen interiors gave preference only to colour. There was little or no modelling of faces or objects as he boiled down the thing seen to its very essence, exploring the texture of the apparent world in increasingly balanced compositions. Huge watercolour interiors followed, with vast washes of rich colour filling the paper, and in the 1980s several important series setting mythological, classical and Biblical legends in contemporary scenes. Many depicted a violent world gone mad with materialism, a society de-humanised by the industrial process and a natural love of life blighted and soured by inner-city isolation and despair. They were peopled by a race of lost souls, gimlet-eyed creatures constantly on the lookout for the fast buck or the quick thrill. This was all part of the process that led to these last intimate pictures. Here he was attempting to capture the awe of nature, and to put Man firmly in his place.

For example, in 'Landscape with Figures', rocks pepper a stream, in the distance an orchard is dotted with sheep, and beyond, the dark outline of Clee Hill keeps its counsel. Above the stream a group of people greet a curious cat, while in the foreground a holly tree glows with an intense blue light. The eye is apt to linger long on the holly tree. Then, suddenly, two other figures become apparent; a boy and a girl, hidden beneath the tumbling rose bush. But they only emerge so far, never to dominate the picture as the tree does, and this is deliberate. "They are no more important than the smallest leaf on the tree," John told me. "I'm trying to create harmony. Everything intimately balanced one thing to another."

Light plays subtle roles in these pictures. In 'Sheep in September', where another holly tree sings a more lonely song, the light does not come from outside. The red and gold are magnified by an indwelling light. Meanwhile in 'Sheep at Night', light is used to set up a subtle contrast between two rival subjects: the bridge, a stark white and man-made thing, and the leaves of the young tree; delicate, silver blue and glistening in the gloom. Why does the frail tree again hold the eye for longer? Is it because of its humility and innocence, or because of its vulnerability, being of no 'useful' purpose next to the bridge?

All these images are of the 'ordinary,' the everyday, but in each case these utilitarian scenes are transmuted into something which far transcends them, depicting the world as it is; a magical wonder. This was John's vision. These pictures should not be seen as mere observations of 'a scene'. They are deeply resonant experiences. Out of the rich taste of the earth

Landscape with figures

Shropshire landscape

comes a glimpse of the pure light of Heaven.

Alas, he had to break off from this series in the last weeks of his life to work feverishly on a very exciting new commission. Early in 2001 the Prince of Wales asked him to design a stained glass window for the Chapel Royal in St. James's Palace. Sadly John only lived to complete the enormous quarter-size designs, which he produced at great speed, drawing them freehand in watercolour. It was the efforts of his friends and the Prince's own care and determination that ensured the window was completed, and retained all the subtlety and simple frankness of John's original watercolours.

How apt it was that the last thing John Napper ever painted was the ultimate source of light in the world, and to do so for a stained glass window; painting light with light. He had devoted his life to an inner search for the light and, I believe, had found it in his intense study of the natural world within and around him. In his very last watercolour, called simply 'Shropshire Landscape', he addresses the light directly in a great sweeping panorama, painted with astonishing control of the medium. It is a striking departure from the usual view of his beloved hill. We are no longer looking up at Titterstone Clee, contemplating its mysteries from afar. We have climbed to the top and are looking down on to the phosphorescent world we have left behind. The earth sleeps in a half light between night and day, while in the broad sky a pure luminosity shimmers around a suspended disc of light. John would not be drawn as to whether this was the sun or the moon, but I know the view. We are looking to the East. Despite the fact he died within a month of completing this picture, this is not a painting of the setting sun.

Here was a painter who had suffered many setbacks and struggles in his life but who had followed his calling faithfully, diligently tracing his path up the mountain to find the peace he had been searching for. He trusted in the journey, allowing it to take the time it took, letting it unfold at its own pace, and in so doing discovering the magic of harmony, the wisdom of balance and the hidden treasure to be found in simplicity. His body weakened in those last months but his spirit soared on, ever more serenely towards the sacred heights. At the end he felt he was painting better than ever, and doing so to greet in a wide and open sky the light which endures and animates the whole of the universe. There is nothing complex about it. His message is simple. This is the light which edges each of our horizons. ●

MARGARET NEVE

The Power of Nature

Magical visions. *By Emma Crichton-Miller*

Winter blossom

HOW WOULD Margaret Neve explain *The Fall of Man*?

"The painting isn't built round the subject. The subject is added later. I started with those trees and the landscape, which I saw in Austria. I was well on with that before I thought to put figures coming in. One paints like an abstract painter really; one paints form. And then I thought I would like to add the figures and the movement down. Then the sheep in front could be right and would link with the movement. It's rather banal to explain that that is what one did – but I certainly didn't set out to paint the Fall of Man."

So how did the painting get a subject?

"The *shape* is the Expulsion. The drama *down*."

Adam and Eve are chunky, tragically clumsy and earthbound; the glistering moonlight rains down and the angel is unmistakably a sword of fire, painted with the only flowing, thin strokes on a panel otherwise completely built up and encrusted with tiny dots of brilliant colour.

Margaret Neve is small and fine-boned, and has very open, intent eyes. She moves quietly, is very thoughtful in conversation, and prone to delighted laughter. Her speech is precise and measured, but immediately emphatic about anything that matters to her. In the same way, her craft is exact, modest and sumptuous. She is herself modest to the point of dismissing her extraordinary, particular talent, not in a spirit of self-denigration, but one of certainty about who and where she is.

"I know I am narrow. I've got a small talent, and I'm hoeing a very narrow, small furrow really, and I've got to keep within it."

To others it seems a furrow in a field that no one else has ploughed. These paintings are not naive, nor primitive. The dots are not pointillism. How did she arrive at this technique?

"I think it probably started when I was doing children's book illustrations for Macmillans. Some of them were done with a lot of little circles – as decoration – and when I started to paint again, I carried on with dots and then realized that the great advantage was that it kept the painting fresh. You could dot on Monday, dot on Tuesday, and you could dot on Wednesday. You never had to scrape off and you never had to start again – you could always alter and add. That's the advantage to me – because I don't change the drawing but I do alter the tone. The colour looks after itself in a way, but the tone is the thing I fight with. I use pure colours to get vibrancy. With a brush it would be too crude, but when I work in tiny dots I can grade it. I like fiddling with that kind of thing: to grade and heighten and pale and bleach out is really what I do and the dots are ideal because you can go on for months on the same painting."

She speaks reflectively about the pleasure and the work of her craft, about the physical involvement of painting. Does the theory of pointillism come into it? "The splitting of colours? No. Not at all. It doesn't work for me."

WHAT SHE ACHIEVES with these dots is an inner glow, a sensual precision, and a masterful control of form, depth, movement and light all within the shimmer of pure pigment. The technique has developed over the last fifteen years, and the effects are increasingly ambitious, yet she arrived at it quite suddenly. Her student years were spent at Wolverhampton, Birmingham and the Royal Academy Schools, and she won a scholarship to travel to Italy. At this time she painted industrial landscapes that have little in common with her present work except a certain self-contained sensuality. "The Black Country then really was flames from furnaces; now it's all electrified and cleaned up and deadly dull."

She married, had children, and started to work as an illustrator, so that when she started painting again, around 1974, "I had become a different person. Really the painting I'm doing now links with the painting I was doing in adolescence."

The link is partly geographical. As a child, family holidays had been in Wales, and in the early sixties she returned to a farmhouse there with her two sons. The place inspired her, but not in any romantic way. "You can't call that 'spirit of place': it's because of the forms it's so good. I used to feel that the only colour I saw was the flowers on the graves: it was so green and so grey (though you did sometimes get a lovely bit of blue sky). I longed to see colour. Maybe it was very good to be in that landscape, deprived of colour. I love beautiful colours – I respond very much to colours, to certain colours. Why else is one a painter?"

She saw the mountains and the trees with the same intense, painterly vision. "I suppose I like these forms because I'm very keen on structure, keen on design, the abstract qualities that hold a painting together."

And the more she looks at the abstract, the more her eyes open to nature. For *The Cliffs and The Downs*, for instance, she says, "I went down for one night to Cornwall and saw this cliff and it was simply the solution I wanted. But I would love to be able to get my paintings more like the natural world. It's so marvellous: that's what sets me off in the natural world, some particular thing I see."

The natural world of her painting is hills, woods, fields, and, above all, sheep. Why sheep?

"There is absolutely nothing else at Gelli – plus the fact that they are alive and moving. The eye goes to them, it's as simple as that. I spent a great deal of time there, on my own with the boys, and I used to draw the sheep; I suppose this was before I

Burrow Stone

PETER RANDALL-PAGE

Vessels of Life

Communicating subjective feelings through making objects.

Interview by Roger Ash Wheeler

PETER RANDALL-PAGE received his professional training in Sculpture at Bath Academy of Art. He has been much inspired by the work of Constantin Brancusi and Isamu Noguchi. He worked at Wells Cathedral and became a Winston Churchill Fellow. Since then, Peter Randall-Page's process of sculpture production has been remarkably constant. He sees each sculpture as 'a vessel of life'. The most challenging project Randall-Page has yet undertaken came in 1989 as a response to Common Ground's Local Distinctiveness campaign which intends to 'help people to hold on to what is valued in the old, to demand the best of the new and to increase local identity.' Working with farmers, landowners, parish officials and craftspeople in the vicinity, Randall-Page has been enabled over an extended period to make sculpture for the locality.

In the words of Marina Warner, "Peter Randall-Page's sculpture, creating bridges between art and ecology, nature and people, countryside and artifact, individual imagination and common experience, secular and metaphysical consciousness, responds to certain needs of our time and engages with our problems in an evolving language of form; this language is not concerned with representing outer appearance, but with expressing the potency of all matter, including stone, and passing beyond questions of appetitive or aesthetic taste to seep into the nervous system where human identity itself lies coiled."

Why do you feel your work is gaining so much attention at the moment?
I don't really know, but I have been involved in the same pursuit for many years. I became convinced in my late teens, mainly through looking at prehistoric and tribal sculpture, that it is possible to communicate feelings through the making of objects. When I went to art school in the seventies there was much questioning of what the parameters of various disciplines were, not only in sculpture but in all disciplines; how to expand the boundaries of a language.

I was swimming against the tide by being specifically interested in expressing feelings through making objects at a time when there was a lot of reaction against that way of working.

Doesn't every artist express some personal feeling when creating?
It is one of the ways in which visual art has always worked, but there have been other criteria. For example, religious art had a very definite social function; but it is also capable of containing something from the soul of the artist which can communicate with someone from another culture who is ignorant of the particular world for which it was made.

There is an ingredient in any art form which relates to fundamental human feelings. Although words are a supremely efficient way of communicating, there remain large areas in which words are inadequate. It is in articulating these areas of human experience that music and the visual arts find their full potential.

In your creative process, is it a feeling or an idea that will first arise? Or are you primarily trying to evoke a feeling in the observer?
The feeling is discovered and articulated within the working process. Sometimes I see things that feed into the vocabulary I'm using, but more often I involve myself in a pursuit, through which I am able to get in touch with feelings. Sometimes using a formal device, like the sculptural equivalent of a sonnet. I often construct certain rules for myself, parameters within which to explore. Many recent works have been based on the idea of a continuous loop or coil that can be folded and knotted in many different ways. Somehow this provides formal restraints within which I can invent in a less self-conscious way. The opposite would be sitting down waiting to have an idea. Whilst one part of my mind is playing with the formal possibilities, another less accessible part is liberated; one is less self-conscious and thoughts float to the surface. Ironically, freedom is achieved through the imposi-

Wayside carving II

tion of restrictions. It's like trying to remember a dream – the harder one tries, the more elusive it becomes – one must catch it unawares.

The permutations of a coil hold great potential for expression. They tend to be symmetrical and they work on my feelings by a metaphysical connection. In a successful work they have their own spirit, like a yoga pose.

I'm not worried about working over the same territory, because I'm not interested in breaking new ground. My objective is not to find new forms that nobody's ever thought of, but rather to make forms that are capable of inducing fresh vision.

One of my great heroes in sculpture is Brancusi. He made many similar forms; the bird in space series for example. He made dozens of them, but they are all subtly different. The soaring, singing quality he sought relied not on the concept but on the subtlety of form. Sometimes one needs a comparative language in order to see

the nuance of an object. Shapes can be capable of evoking feelings without direct representation; they may allude to a number of different things. We tend to understand the unknown through the known, the unfamiliar through the familiar. One is reminded of things – it is the language of suggestion and the combining of different associations – like a poem as opposed to a piece of prose.

What is your relationship with Common Ground?
Common Ground is run by Sue Clifford and Angela King. They had seen my work. Sue telephoned me and explained their philosophy. It sounded visionary and parallel to the way I was thinking. They believe, as I do, that there is an important link between the arts and wider issues, such as environment and community. Many people feel alienated from where they live, having no control over decisions that affect their lives. The arts could play a role in opposing the pragmatic, mate-

118

Still life – Kilkenny limestone

rialistic philosophy of the society we live in.

Much of the environmental movement is, quite rightly, angled towards practical, urgent things rather than addressing the underlying attitudes and philosophies which result in our inability to live in a sustainable way with the rest of the world. There is a wider issue here, something more fundamental than the symptoms. We all know, when we see sheep in the fields, that the sheep aren't just a certain number of packets of lamb chops, that a forest is more than so many lengths of timber with a certain monetary value – it's obvious. But somehow we are living in a world which ignores intrinsic value in favour of material worth. One of the most important things about art as a cultural endeavour is that it acknowledges the idea of things having intrinsic value. Of course, art too gets sucked into the same commercialism as everything else; objects are only worth a certain amount of money if they are attributable to the right artist and the same artifact is worthless if it

isn't. However, we value art fundamentally because it is good in itself. Hopefully, we've just about reached the point where we acknowledge that people have intrinsic value in themselves rather than as an economic unit. It wasn't so long ago that slavery was abolished. Yet we still don't recognize that everything else has its own intrinsic value as well.

In this context, what is the inspiration of your own artwork?
The desire to communicate my subjective feelings through making objects. I wish to communicate through visual and tactile metaphor, on a gut level, through association and juxtaposition – like the stone split open with its interior revealed on the river island. My hope is that the work may just strike a chord with somebody and take them off on a journey of their own imagination. A kind of reconciliation of the inner world with the outer world would be my ultimate hope. ●

JAMES URSELL

Garden of Love

He built a giant wicker bowl of coppiced branches. *By Tom Trevor*

IN SUMMER 2000 the artist James Ursell returned to his native North Devon to make a garden. Nestled deep within the ancient wood of oaks and alders that lies at the heart of the farm where he grew up, Ursell named his creation after William Blake's poem of lost innocence, The Garden of Love. Despite the complexity of its handmade architecture, the lifespan of this secret place was to be one season only, and even now it is rotting back into the undergrowth, never to be visited again.

Approaching along a muddy track, one could not help but notice a sense of familiarity, as if you always knew this place existed somewhere in England, waiting to be discovered and entered into. The first sight of human intervention was a flash of reflected sky that soon revealed itself to be a small lake, dug out like a clearing in the woods, with a nucleus of trees left growing on an island at its centre. Later a rowing boat would carry us across, by the light of a candle, to the island, where a two-tiered ring of turf seating encircled a smoky mud oven; but, for now, attention was drawn away to a tunnel disappearing further into the woods, enticing the visitor back into the dark-greenness of the interior.

The earth was boggy underfoot, but a raised path of roughly hewn branches showed the way. At one point it split, rounding a small pit that contained a smouldering log fire, then continued on into the heart of the garden itself. An oval of light signified another opening at the end of the tunnel. Entry was through a small aperture that led up into a giant wicker bowl of coppiced branches, woven into the living trees of the wood. Clambering up into this enormous dish, one's first instinct was to fall back upon the sloping wicker-work and stare up into the sky which, once again, opened out above you, fringed by the canopy of the wood. From this vantage point one gradually became aware of small arrangements of plants, growing on the sloping surface of the circular matrix. At first you recognized the Great Bear, the Plough and then the whole microcosm began to fit together. It was the constellations of the August night sky, mapped out in summer flowers. At the very centre of this floral solar system was another fire of roughly chopped logs that blazed brightly, growing warmer and brighter as its counterpart above gradually disappeared over the Western horizon. Dusk descended, and with it the real cosmic spectacle began to unfold in the clear night sky, mirroring and mocking the little world below.

The Garden of Love was the culmination of a series of remarkable hand-built structures that Ursell has made in response to recent astronomical events. After a period living in Berlin, where he developed a reputation for his performance-related installations, he returned to the West Country in 1999 for the solar eclipse. To mark this occasion he constructed the prototype for a giant camera obscura out of straw bales, projecting the sun's obscured image on to the floor of a darkened room. It was accompanied by a vast kite, or flying 'ecliptic stelli camera'. Following this, at the turn of the millennium, he erected a vast mirror in a field of cows, in front of which local villagers were persuaded to re-enact the scene from Rembrandt's 'Nightwatch'. As a twin piece to the Garden of Love, at Spacex in Exeter he transformed the main gallery into a Septomorphic Filter, based upon the seven (planetary) circles of the Ancients, using hundreds of barley-straw bales, fresh from the harvest (and ready to combust).

Ursell's temporary time-based installations could be described as deliberately 'local', eschewing the laws of exchange and consumerism to investigate the particularity of place and his own cultural roots in rural North Devon. The original Latin derivation of the word 'culture' was literally 'tilled land', as if grounding all social life in the local possibilities for cultivation of a particular piece of earth. To the East of Eden it seems that we are condemned to reconstruct idealized visions of Nature, as if the microcosms we create are somehow removed from the society we live in and its processes of cultural representation. But if the 'natural world' is everything that exists beyond human intervention then we can never know it directly: our experience of nature is always mediated through culture and history. Just as it is impossible to regain the innocence of childhood, or repair separation from the womb, there can be no return to Eden. The collective desire for a 'lost paradise', however, remains a powerful social dynamic. Whether we are to harness it as a force for change, to arrest the destruction of the environment, or continue to use it as a tool for the maintenance of social divisions is the choice we face. One might say, a matter of free will. ●

THE GARDEN OF LOVE

I went to the Garden of Love,
And saw what I never had seen:
A Chapel was built in the midst,
Where I used to play on the green.
And the gates of this Chapel were shut,
And "Thou shalt not" writ over the door;
So I turn'd to the Garden of Love
That so many sweet flowers bore;
And I saw it was filled with graves,
And tomb-stones where flowers should be;
And Priests in black gowns were walking their rounds,
And binding with briars my joys & desires.

– William Blake

MARIANNE WEREFKIN

Nature Touched Her Soul

Paintings that are imbued with spiritual radiance. *By Anne-Lise Clift*

WHAT ATTRACTED me to the artist Marianne Werefkin was as much her life as her art. Two years ago I made a pilgrimage to Ascona, a small Swiss-Italian town on the shores of Lago Maggiore, where Werefkin lived for the last twenty years of her life.

During my visit to Ascona, I was able to see Werefkin's work in the Museo Comunale d'Arte Moderna, an experience which helped me to understand Werefkin's belief that art was a religious act, and painting a manifestation of God. Werefkin's mystical and meditative approach to art is reflected through her paintings, which are imbued with a spiritual radiance, standing as a living testimony to her own 'inner vision'.

Werefkin was born in 1860, into a rich aristo-cratic family in Russia. In her youth, spent between the cities of Lublin, Moscow and St Petersburg, Werefkin's main interest was always painting. By the age of fourteen, encouraged by her mother, she was having private art lessons with a succession of teachers, one of whom was the famous social realist painter Ilya Repin, with whom she remained for ten years. It was during this time that Werefkin started to represent figures drawn from the margins of society – peasants, servants and Jewish people.

WEREFKIN'S SPIRITUAL outlook was formed whilst living in St Petersburg, Russia, where she was exposed to a remarkable cultural atmosphere. In particular, Theosophy and Anthroposophy prompt-

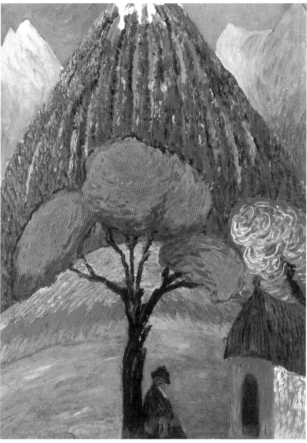

The red tree

ed the concept of the artist as clairvoyant. Well-read in the works of the Russian Symbolist writers and having written some Symbolist poetry herself, Werefkin was also interested in the esoteric concerns of Russian Symbolism, which included questions of artistic synthesis and art in a spiritual era.

However, her life was to change with the meeting of a fellow student, Alexei Jawlensky, in 1891. Werefkin adopted him as her protégé, dedicating herself to furthering his career, at the expense of her own. For the next ten years, she devoted herself to an inner search, both on a personal level and on an artistic one, exploring her inner struggles in a diary called 'Lettres à un Inconnu', in which she emptied her soul and formulated her own theories in art.

As she poured out her innermost feelings and thoughts into her personal journal, she seems to have undergone an inner journey of reflection, reassessment and transformation – finally concluding her diary: "I look into my heart and I see calm. I am able to close this book." Having found resolution within herself, Werefkin bought some sketchbooks and started to draw, and to paint again. However, her style had radically changed. Abandoning her realistic style and oil paint, Werefkin started to work in gouache, tempera and watercolour.

THE PAINTINGS AND drawings from this new period reveal the various thematic interests and

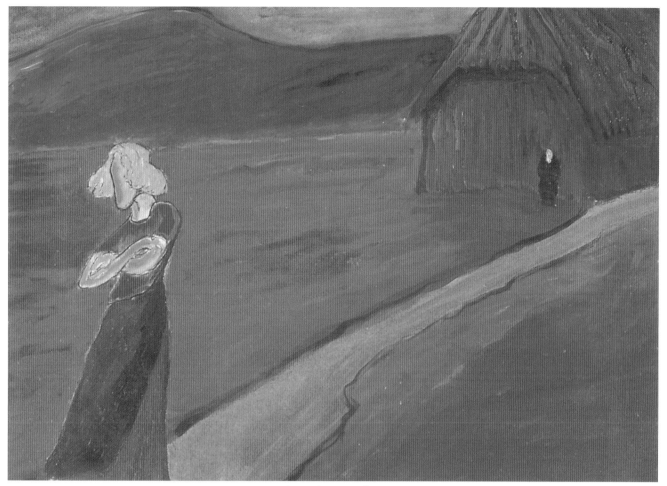

A tragic atmosphere

concerns of her art. These include the use of a road or path to symbolize the passage of life and the transitory nature of human existence. Blue mountains are also used to depict a sacred presence through the mystical significance of colour. The strong presence of nature, in fact, is a feature which Werefkin continually employs to convey a transcendent power. Werefkin was seeking to depict both the tragedy of human existence and the possibility of spiritual reconciliation: "We artists must be reconciled with life, and passing through sorrow and pain, know it in all its forms. Upon the ruins of our life, we must build for others the temple of hope and faith: this is our duty."

As a natural extension of Werefkin's spiritual awareness was her compassion for the world, revealed through her recurring focus upon social topics – including the peasants' displacement from their natural environment by the industrial world. This concern Werefkin carried with her as she moved to Switzerland with the outbreak of World War I, to live in Ascona amongst the Ticino people, where, for the first time in her life, she found hap-

piness within a community which accepted and loved her, affectionately nicknaming her 'The grandmother of Ascona'.

Throughout the following years Werefkin developed an original style. The work of this last period concentrates on three main themes: the surrounding lake and mountains, the peasant community, and images inspired by the life of St Francis. Finally, Werefkin started to paint the 'joy of being in harmony with Nature', reflecting a sense of contentment and rest, which she felt in Ascona in her old age.

Werefkin's funeral in 1938, which was conducted at her wish by a Russian Orthodox priest, was an unforgettable event to which the whole community turned out, following her coffin to the grave and singing in loud voices. This image recalls a scene from one of her paintings, with a procession of people, along a path, leading to a place of rest. Most fittingly, Werefkin was buried in Ascona, where she said that she had learned "not to despise any human being, to love both the great happiness of the creative process and the misery of life, and to consider them the great treasures of the soul." •

HUMAN SPIRIT

I believe in Michael Angelo,

Velasquez and Rembrandt,

in the might of design,

the mystery of colour,

the redemption of all things

by beauty everlasting,

and the message of Art that has

made these hands blessed.

George Bernard Shaw

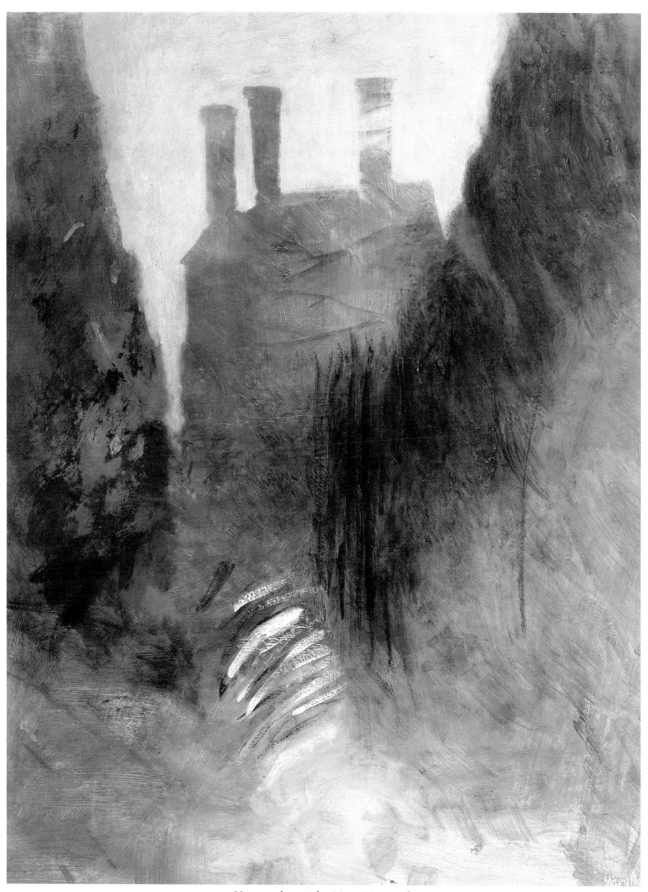

Hay newly cut, by Mary Newcombe

DANIEL De' ANGELI

Healing Colour

In search of radiance and transparency. *By Selina Mills*

LIKE HIS PAINTINGS, Daniel De' Angeli is a man hard to categorize – shy and discreet in manner, but mystical and strong in his vocation to art. His solo exhibition in 2001 at the Cork Street Gallery, London, entitled 'Distant Resonance', showed work that exactly expresses these words: paintings that are echoes of recognizable forms melting into colour, but being neither a figurative nor an abstract declaration.

"I have been striving to make my paintings more and more essential and I have been eliminating objects for some time," De' Angeli says, "but they are not abstract. I suppose I would call them very elemental."

The elements, says De' Angeli, are a good place to start in discussing his work, as colours, textures and light that emanate from the land have fascinated him since he was a boy. Much of the inspiration for his paintings, he says, has come from woods, mountains, lakes and ancient standing stones.

"The falls and the folds of the land meeting water inspire me deeply and allow me to slow down and attain silence in a way which is very important in art. The natural world and its ancient temples evoke energy and silence that you need as a painter to learn to observe." The idea for his 'The Sound of the Earth' painting, for example, came out of a trip to Crete. On a walk with a friend to a cave 150 feet below sea level, which led to a point so tiny he ended up crawling on his knees, he heard a deep sonic boom that vibrated a primitive call from the earth. De' Angeli says it is this type of experience that moves him the most.

"In reality, the earth is the centre of mystery in our life. Despite the thick layers of civilization and mobile phones, we are still not very far away from our origins, and nature has the power to take you back to the elemental, to a state of surprise and to silence."

De' Angeli says that he often reaches this state through walking. He walks everywhere, given the chance. Walking, he says, allows him to live in the moment. In 1996 he walked from St Jean-Pied-de-Port in France to Santiago de Compostela, and his relationship to art changed completely. "There is a visual power to walking which I have never experienced in any other way," he says. "I think inside each person there is the possibility of living in a tangible but contemplative dimension. But walking – the act of putting one foot in front of the other and continually moving – brings me closer to that state."

Walking and a reliance on his own internal vision have provided De' Angeli with an inner strength that constantly rejuvenates his relationship to his craft. His influences, however, have also been an eclectic mix of Eastern and Western traditions. These began with his early years in Buenos Aires, where he was allowed to paint in the studio of surrealist painter Juan Battle Planas, but also included years in Florence and the Art Academy of Urbino, where he studied and became friends with the Egyptian artist Adel Elmasry, discovering ancient Eastern techniques.

"I am a Western painter facing East," he laughs, "but I am not connected by identity to any one place. Nature just fuels my dreams and imagination and my job is to try and translate this vision." Eastern influences have included not only the study of Japanese etchings and ink colours, but also the influence of the Japanese Wabi-sabi philosophy, which literally translated means 'the art of the unfinished' – the rough, or things left in their natural state. This, says De' Angeli, ties in with his need to create something that is not overly worked.

"Light is essential for me, as it can give space to the canvas. So I work in very thin transparent layers because it offers me the opportunity to create colours. I spend hours literally scratching the surface of the colour to obtain subtle progressive gradations." Technique, therefore, is as important as intent in the creation of colour and light, and part of De' Angeli's daily challenge is finding and grinding the raw pigments to create his visions.

"I find the magnetic sensuousness of colours totally irresistible," he says. "They continuously vibrate – generating moods and feelings, and react to imperceptible changes of light in a room." In 'A Hidden Lake', the test for him, he says, was whether through the layering of colour upon colour, using ink, oil and acrylic, he could show transparency and radiance.

"The more I paint, the less I know," he says.

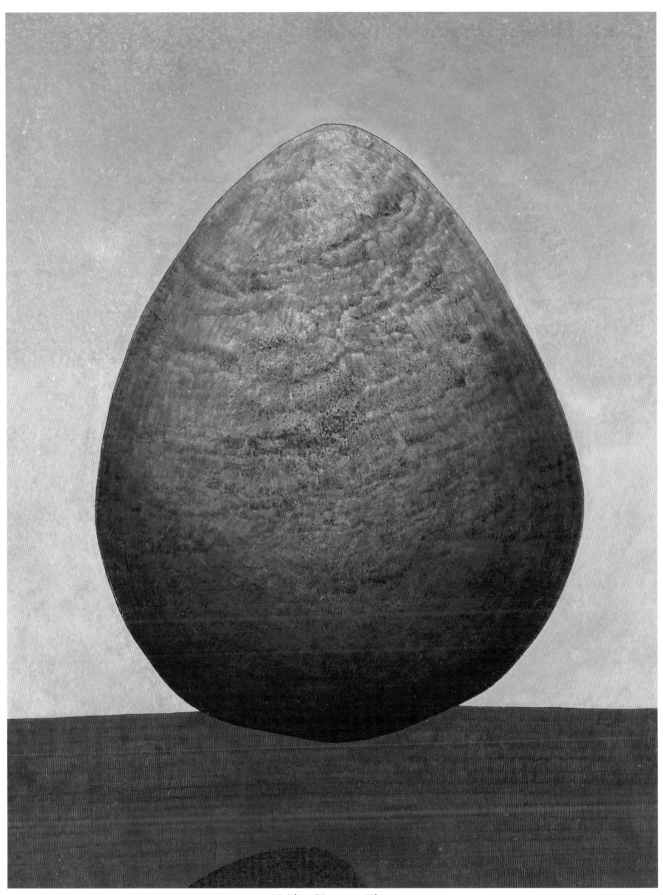

Neither Here nor There

127

Great Mother of the Night

A Hidden Lake

"That is the mystery and that is what challenges me every day. But technique is very important because it links you to the masters of the past. The problems I have today are the same difficulties artists have faced for the past 500 years."

Other essential aspects of his technique include simply inventing new textures by creating his own surfaces; gluing natural different-textured papers together and mixing oils, acrylics and watercolours are an essential part of his working day. "I am always fighting with materials," he jokes. "A canvas can be a boring thing because it has little texture so you have to create it. A great part of my effort at the moment is that of creating interesting surfaces where I can use different techniques to discover new colours."

It is this continual carving out of textures and new colours that he relies on to translate his dreams and that lies at the heart of his work and his belief in life. "Colour is a powerful language that expresses impeccably our emotions," he says. "It talks directly to the heart, without the often confusing mediation of the intellect. As in nature, we react to colour in an immediate and almost instinctive way."

And ultimately, he says, this is important because colour has the power to heal. He learnt this not from his time in art academies or from studies of the old masters, but from a medium who specialized in colour healing. "I learnt that each colour is a living entity that transmutes different wavelengths of energy. These can translate to different levels of human consciousness and can heal and provide peace."

Perhaps it is this sense of peace about his work that attracts such a diverse range of collectors, and resulted in the overwhelming success of his show. De' Angeli is humble as to whether he succeeds in reaching people. "I don't know if I heal people, but I am clear that my art is not a vehicle for tragedies." ●

ELISABETH COLLINS

A Woman of Radiance

The great thing about the whole world is love.

Interview by Timothy Hyman and John Lane

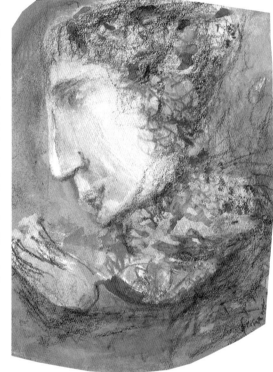

Magician with manuscript

A T THE TIME of this interview in 1999 Elisabeth Collins was ninety-five. Her career must be one of the oddest in history: almost eighty when her earlier painting began to be widely seen; and then a steady creative flow, a true late-flowering, with work being purchased in her tenth decade by the Tate Gallery.

A striking but essentially reticent person, she continued, after her husband Cecil Collins' death in 1989 to live alone high above a Chelsea square. She read voraciously and adventurously and managed to get about London on buses, visiting an ever-widening range of close friends. This exchange is offered in tribute to an artist and a woman of extraordinary radiance who died in January 2002.

John Lane: You have said that you particularly love Elisabeth's paintings. Why?
Timothy Hyman: There are two kinds of painting by her. The first is the pre-war work, which is narrative, it's creating a scene, it's got an immediacy and spontaneity. But the later work gives me a kind of silent challenge; these paintings are coming from quite a deep place.

JL: How do you respond to that, Elisabeth?
Elisabeth Collins: I think it's absolutely true. What you're trying to do in painting is to be the way you ought to be, to be the way you want to be, and not the way somebody else may think is fashionable or interesting. I've also tried to convey a feeling for the intimate relationships between people, just by their movement. I don't think about it but that's really what I'm aiming at.

JL: Timothy touched on these two approaches: the earlier, firmer sort of work and then the later, more intangible, lyrical paintings. Were you conscious of the difference?
Well, what I do is make a few marks and somehow or other develop a painting out of those few suggestions.

JL: So, you don't start with some kind of preconceived idea?
Not usually. I often start with a bit of line somewhere. It's all so transitory what you do. You begin and then you don't know what's going to happen next. It just happens.

JL: You studied sculpture, didn't you?
Yes, I started to make sculpture at Leeds School of Art. Henry Moore had just left and when I went to the Royal College he was there. He was a great influence on everybody, just by his personality.

TH: Why did you make the transition to painting?
Because sculpture is so messy. It needs room and all the rest of it.

JL: Then you met Cecil Collins. Do you think you were influenced by him?
I'm sure I was, but I remember thinking, "That's not what I want to do."

Meeting in the snow

When I left art school I didn't do any painting for ages, because I was in the country trying to be alive. Cecil and I walked to Plymouth, and things like that. What I remember are things like the bombing of Exeter, which was a tremendous drama – all the mess, and the naked hand in the gutter. I didn't recoil from it. It just sank in.

JL: Why do you always use gouache?
For ease. Anyway, I'm not trained in oil painting. I don't know about gouache either, but it's certainly easier, more possible.

JL: When do you know a picture is finished?
When you can't do any more to it and you put it on the wall and you pass it every day; and if it isn't finished, you think, "Oh, the ears of the cat need lengthening," and you lengthen them.

JL: I envy the imaginative freedom that women
seem to have. You seem to be able to paint like a flower coming into bloom. Yet you also had an academic training at an art school. That didn't make you self-conscious?
No, it didn't really, because I'd just had a terrible row with my family – they had expected me to stay at home and do the flowers! So it gave me enormous happiness to escape to the art school.

TH: Would you dislike it if somebody called your paintings dream images?
They aren't dream images, but it doesn't matter. They kind of grow in themselves. You look at them and they have their own being and you find it. It just speaks for itself. That's why they're spontaneous-looking, because they just happen. You see what is coming and encourage it a little.

TH: Do you think you learnt a lot from Mark Tobey's classes at Dartington?

131

We were given huge sheets of paper and no subject. We just drew something or painted something. Then Mark would put them all up on the wall and ask people questions, which they could seldom answer. The questions were not about construction but rather about meanings. At that moment you sorted out, a little bit, your feelings about painting.

JL: When do you feel a painting is finished? Is it because it's formally finished, the colours all work, the paint is fresh, etc.; or is it because you've managed to create a world, an atmosphere?
It's the latter. Sometimes one has to do very little to make it live. But at other times you have to work a lot until the painting comes to birth by itself, or with your help a little bit. You just have to keep alert and change things and not mind ruining a nice colour, a nice shape somewhere, not mind ruining the whole scene!

JL: So, do you throw them away then, or do you persevere with them?
I think they disappear. They withdraw themselves – modestly.

TH: And do you feel you know roughly which are the good ones and which aren't?
Yes, but I don't take it all that seriously.

JL: Your paintings are not extrovert in their joy. There's a slight melancholy about them.
Yes. Oh, yes. I had a lot of melancholy in me. I'm getting over it now.

JL: How did you feel about having that first exhibition at the Albemarle Gallery? Was it a sort of vindication? For years Cecil was the sun and you were the moon, in shadow. You didn't worry about that?
No. It's just the way things happen. It's no good worrying about things like that.

Greek Woman

TH: You once did say that you had a certain regret that you hadn't kept up your talent in your middle years.
In a way. But I look at the women painters; they're not happy today. In any case, there has been an awful lot I never thought about, because I was always thinking about the next meal or cleaning the house or something – all that was going on at the same time – very strongly. Things didn't occur to make it happen and Cecil didn't push things to make it happen. I think Cecil was quite jealous.

JL: If you had to give advice to young women painters today, what would that be?
Just live a good, free life. Not an imprisoned life like we all lived.

TH: So you just waited until, fifty years later, fate gave you time; and then you started painting again.
Well, the opportunity arrived.

TH: Would you describe yourself as a Christian?
No, never.

JL: Everybody nowadays uses the word spiritual. How would you feel about that word in relation to your work?
Well. Spiritual. Well … simply, of the spirit – and what's the spirit? Nobody knows. So it's a nice vague word. It defines something you can't define, I would say.

JL: Would you say your work had a spiritual dimension?
If we're using the word 'spiritual' and we don't know what other word to use, yes. What other word can you use? It's all part of the whole world.

JL: I'm amazed by your delight in everything.

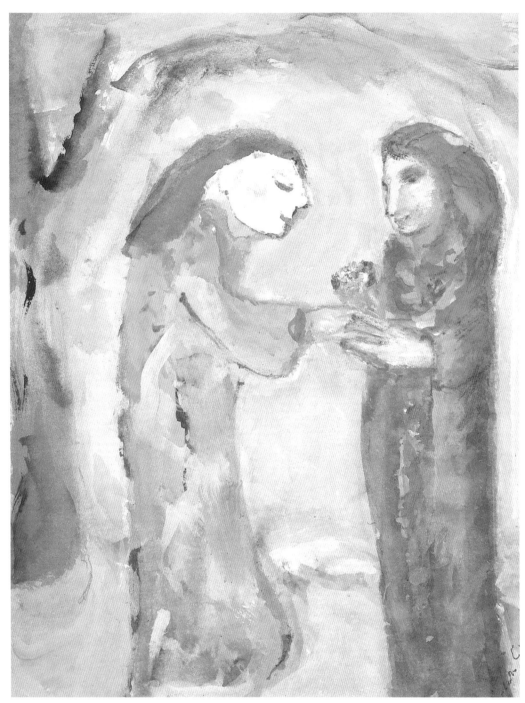

The Gift II

Yes. I find it harder and harder to be critical, because things and people's lives are changing. You can't be critical about people's lives – doing all the wrong things – because how can you know what is the right thing?

JL: How would you feel, Elisabeth, if all your work were destroyed?
Oh, I wouldn't mind. The world's full of paintings. I wouldn't feel "Oh, my life's work's gone!"

JL: So, what is your motivation for painting at all?
Well, I just like it. It's just part of my life. The great thing about the whole world is love. That's really the only thing possible, because it's all a great mystery, thank God, and you never know where it will come, where it will go, in all its different aspects. You can never know. I'm not quite sure about there being universal love, love from elsewhere – I'm not quite sure. I think God has his moods. ●

Passing Through (detail)

JOHN DANVERS

In Search of Awareness

Creating a sense of place. *Interview by John Lane*

The close observation of landscape emerged in European painting in the later years of the sixteenth century, in parallel with the rise of the scientific world-view. Today, objective landscape painting is no longer of prime concern. Instead, artists like John Danvers are exploring a multiple approach.

YOU'VE DESCRIBED how your works are records of awareness, insight and contemplation, transposed into a visual poetics of place. What does that mean?
I'm trying to do a number of things. I'm interested in landscape and place – places that I've been to, places that I've travelled through. The drawings exist to increase my awareness of place. I like to incorporate both visual elements and poetic texts usually written on-site, or during the process of making the work. While there's a distinction between the verbal and the visual, I want to integrate them, producing something that lies somewhere between a drawing and a journal. Although they are a product of my experience and enquiry, I want them to be intelligible and accessible to other people.

What would you hope that an observer might get from the contemplation of one of your works?
Some kind of insight into the place that the drawing is about, some sort of insight into my negotiation of that place, my being in that place, the

Passing Through (detail)

thoughts and responses that I've had to it that would encourage the people who look at it to reflect back on their own understanding of particular places that they've visited themselves. We talk about a place as if it's an object or substantive thing, but, of course, a place is just as much an experience of an object or locality.

Would you say that in some ways your approach is an extension of Cubism? Cubism wasn't limited to a single point of view, and your own work involving memory, time, place and objects is likewise multidimensional.

Yes, certainly, the multidimensional quality is really important. Experience is a multidimensional phenomenon. I have sensations and memories, and hopefully there's some kind of echo or analogy of these in the works that I make. Although visually they don't look like Cubism, I think there is a link. Cubism modified the way we look at things and reconnected us with more ancient modes of representation and participation.

Do you think that concern for memory, history and time is most directly expressed in the visual arts, rather than, say, in music?

There's a tendency in music towards the abstract. I wouldn't say that the visual arts are in any way superior to music; they are different. Although music can evoke places that one has visited in an abstract way or through mood, the visual arts are more specific, and have an enduring presence that allows people to look closely and explore the layered qualities of experience.

You have talked about an ecological approach to landscape. Can you explain what you mean by that?

Well, a number of different things. Using collage in the loosest sense of the word assists this quality of multidimensionality and how the various parts fit together into a whole. I'm also employing lots of different signs, words as well as images, which together give a sense of unity, which is the kind of experience that I tend to get in the landscape.

Considering we are living through a period of massive environmental mutilation, what help is your art to that crisis?

I hope I can prompt people to think about the world that we inhabit and how we inhabit it. The art I'm involved in is emancipatory. I don't think the arts are particularly good propaganda tools for an ideology. There's a quieter but possibly more important function that they have, which is to pose questions, to celebrate and to be sensitive. ●

MARIANNE HALL

Sculptures of Sorrow

Working with clay leads you from pain to peace. *By Chris Hall*

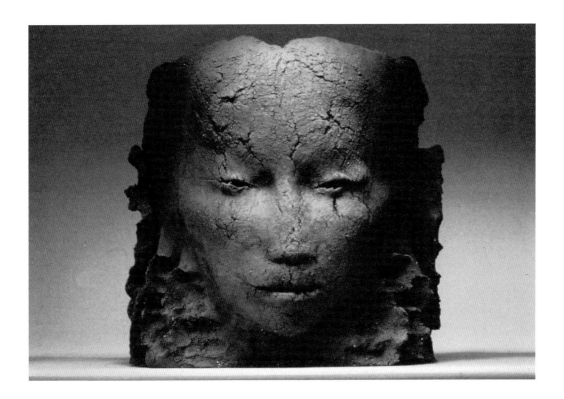

I SAT IN MARIANNE's spacious studio on my journey from Stockholm to Gothenburg, quite unprepared for what was placed before my senses. Each sculpture was a call to contemplate, a mantra to meditate.

I was a reluctant witness to a moment of deep emotion. Exactly what was happening or what had happened wasn't clear, but a woman stood in vigil over a partner lying tense and inert before her. It was a spectacle of heart-rending grief. Their features were oriental, but their predicament was universal. Indeed, they embodied a truth that encompasses all our futures and even the fate of all existence. The nadir, when life mysteriously seeps away. That moment of poise when there can be no explanation, no justification, and creation rests at the still point of imperceptible movement, resembling extinction.

In a quiet suburb of Västerås there was time to allow the deepest human pain to penetrate. A disturbing challenge to recognize and accept images lying at the core of our existence. Yes, to acknowledge the pain of wounds that lie almost too deep for our tears. One image might have been enough to prise open my calloused sensibilities. Yet, with every successive figure, a new hurt was witnessed and painfully accepted. To know such pain is vital to our being, but everything within us will seek to deny it, avoid it, push it away, cover it up.

Ultimately all true art becomes transcendent. I continued to reflect and sift through what remained of my intimate encounter with the distilled nature of Marianne's figures – each one insisting on an unusually intense quality of attention to a particularly profound level of pain from a source of collective experiences that were mined from the archaic depths of the unconscious, with an uncanny precision and poignancy.

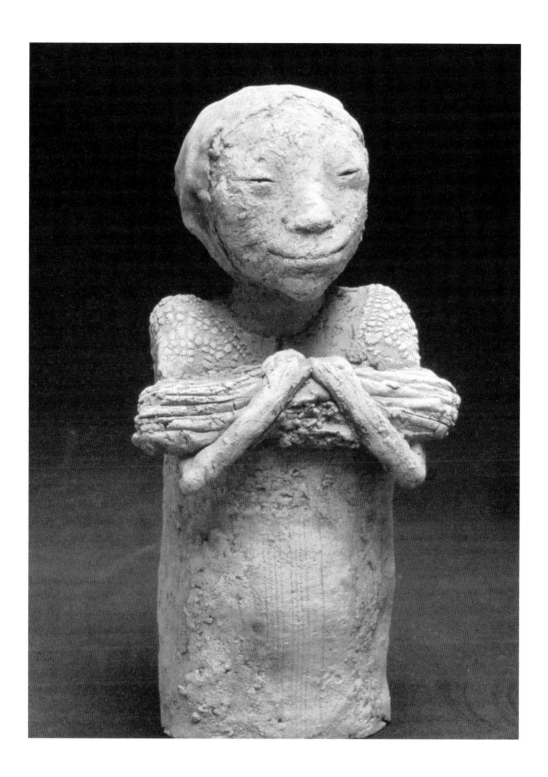

Marianne also makes masks. Sheets of grey clay are pressed outwards with the utmost sensitivity, emanating the blissful serenity of Khmer sculpture. So much peace flows from these presences. Marianne has said that the pressure from her finger tips gradually and deliberately reveals the light through the emerging cracks. Here is yet another challenge to our conception of a peerless beauty: the incipient disintegration of the Buddha-like mask.

I marvel at Marianne's achievement, her search for the expression of what lies so deeply buried within the human psyche and the discovery of a fitting context in which to reveal this. It follows that, given the peace and tranquillity of a space set apart, these indelible images generate their own ambience. But they do so eloquently ask for their own sacred precinct. Perhaps by their very nature they will seek and find it in our hearts. ●

BRIAN HANSCOMBE

An Imaginative Engraver

A copper–plate engraver who combines craftsmanship with creativity.
By Gabrielle Hawkes

"THIS ART WORLD is very competitive. I don't advise your son to take up art." Such were the words spoken to Brian Hanscomb's mother when she sought advice from the school on her fourteen-year-old son's artistic inclinations. However, Brian is now known as one of Britain's leading copper-plate engravers and his unusual pastels are highly-prized. Brian has that fusion of mysticism and originality within him which is the mark of the visionary artist. In his studio in Cornwall, on the edge of Bodmin moor, Brian explained to me what copper-plate engraving involves. First, he takes a sheet of copper, inspects it for any impurities or scratches, and these he 'stones' out with small blocks of stone. He then polishes and burnishes the sheet with emery paper until you can see your face in it. Next he takes his tools, chisel-like and carefully sharpened, with interesting names like bull-stickers, spitstickers, lozenges and multi-liners. These are Victorian in origin, and were given to him when he worked in the print trade. He has already sketched out his design on paper and he engraves it in reverse on the polished copper surface. The ink, thick and sticky, is rolled on to the plate with a roller and forced into the lines. The excess ink is wiped off and after a few trial proofs, the plate is printed on to hand-made paper using a manual press, which hasn't changed much in style since the fifteenth century. Editions are usually limited to about 100 prints.

Brian Hanscomb's engravings are often miniatures: they range in subject from the overtly religious ones of earlier days, such as a St Francis with a gentle loving face blessing birds in a flowerstrewn landscape, to wild-life and landscape studies. A regular exhibitor

Tor Down

at the Royal Academy, all eighty of the available copies of his hedgehog engraving sold there in 1989. A limited edition of 'Sun, Sea and Earth', comprising eight engravings of West Country landscapes, is now displayed in the V & A alongside work by such masters as Ravillious and Bewick.

Now forty-six years old, Brian grew up in Watford, and heeding the advice of his teacher, avoided formal art training. He went instead into the print industry at sixteen, where he became an industrial engraver. In those days, before the advent of modern technology, magazine-printing relied heavily upon the old craft of copper engraving. "It was highly skilled work, repairing plates, cutting lettering, working under a magnifying glass, but although it was a good training, it wasn't creative." He sought his own creative outlet during tea breaks, working away on odd scraps at his own designs, to the mystification of his work-mates. In 1978 he created a significant engraving which expressed all his feelings and aspirations. Entitled 'Christ Appears in the Factory', it illustrates a busy printshop in which tortured faces huddle around the huge machinery, "to some extent mirroring my own state in the soul-destroying factory environment". In the background, beyond a hellish landscape of smoking mill chimneys, is a revelation of hope, a vision of a promised land in the clouds into which people are being drawn. Brian left the print factory in 1978.

He settled in Somerset and devoted himself exclusively to his own work. A sensitive and complex man, Brian does not regret his time in the print-factory or the lonely years after this when he struggled to make a living. He sees everything which happens to him as "part of a journey". ●

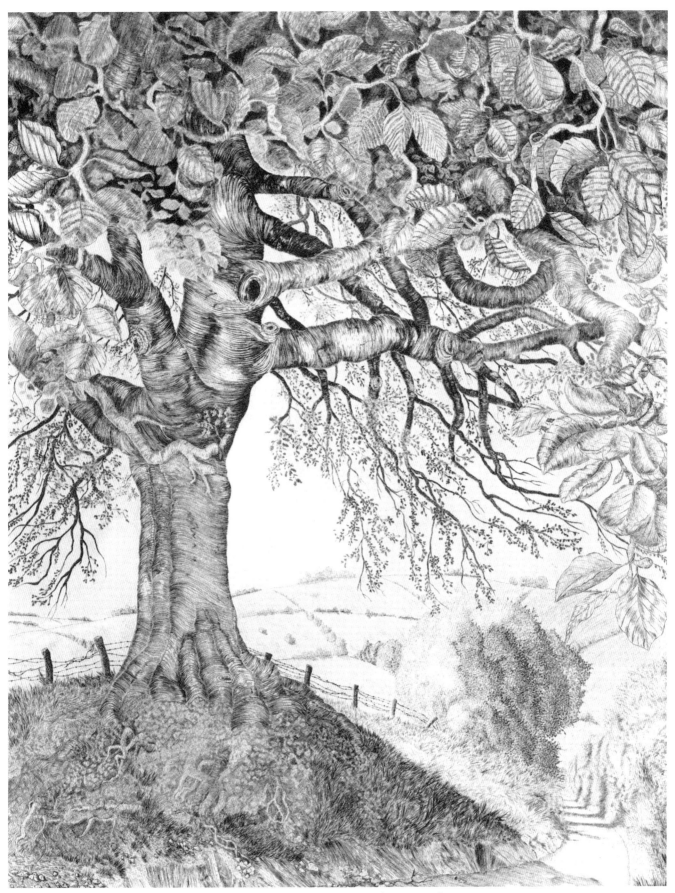

Beech tree in Kimpton (copperplate engraving)

139

BEN HARTLEY

Always a Beginner

A painter, a poet, a colourist and a gentle humorist.
By Bernard Samuels

ABOVE THE FIREPLACE in my sitting-room hangs a picture. Painted in bright colours, it appears to be in two halves. To the left, the background is vermilion; to the right, bright orange. Against the vermilion stands a man his back to the viewer, wearing a flat cap and a waist-coat. He has one slipper on and one slipper off. To the right, set against the orange, are all kinds of things: two large hooks with bills speared on to them, a pocket watch, its chain stretching out behind it like a tadpole, as well as a teapot, a mug, a newspaper rack and a clipboard.

The picture is called 'Home Economics' and is by Ben Hartley, a painter I knew for the last twenty

Gobble, Gobble, Gobble

years of his life. It has pride of place in my sitting-room because I cherish its warmth, its innocence and affection. However, there is an aspect of the picture which tells us something else. In spite of the company he has from his dog and all the objects in the room, the man is alone. Ben Hartley lived alone. In childhood he was alone because of a congenital problem in his chest which forced him to stay indoors. A sad fate, given that he was born and grew up on the edge of the Peak District, next door to his grandparents' farm at Mellor, a village just beyond the conurbation of Manchester.

DRAWING AND PAINTING, reading and observation seem to have been his only childhood occupations. His wish to spend his life as an artist meant that he left grammar school early to go to his local art schools, then to London and the Royal College of Art during the 1950s. He detested the idea of having to live in the great city. Fortunately lodgings were found for him at the house of Carel Weight, then a lecturer in painting at the college, later professor. This connection led to a lifelong friendship, much valued by both men.

Ben spent the greater part of his adult life in Ermington, a village not far from Plymouth, where he taught at the College of Art. Alone in the countryside, a devout Christian and a dedicated painter, he lived a life of great intensity. At one point he made attempts to be accepted as a priest in the Anglican church but was rejected on health grounds. However, not long afterwards, he was received into the Roman Catholic church.

My involvement with him came somewhat later, when, as director of Plymouth Arts Centre, I was introduced to him by one of his fellow tutors. He had by then been living in the area for fifteen years but had made virtually no effort to sell or exhibit his work. So perhaps I met him just at the right moment. By then he had evolved a vision for his

Home Economics

BERIT HJELHOLT

Weaving with Light

Tapestries in which art and craft come together. *By Lindsay Clarke*

In the eye of the storm

THE QUIET LABOUR of spindle and loom were once so intimate a part of household life that our language remains rich in its metaphors; but when we speak of a high speed train as 'a shuttle', or talk ecologically about 'the web of life', the references lack the tactile and visual actuality they once held for our ancestors. Even the common exhortation 'Let's get weaving!' has forgotten how much of its force is owed to the slow, painstaking process by which a loom must be dressed with its warp before the weaving can begin.

Of course, few people nowadays feel the need to cultivate the skills that hand-weaving requires, and those with the vision to lift that craft to the level of high art are fewer still – which is only one of the many reasons why Berit Hjelholt is a person of rare value. Photographs can give only a diminished sense of the scale and texture of her tapestries, but even in reproduction you feel the impact of their emotive power – the way they exalt the senses and stir the heart. A larger understanding of their imaginative reach comes with knowledge of the artist herself and of the Danish landscape where she lives and works. The homestead Berit shares with her husband, the distinguished psychologist Gunnar Hjelholt, is on Thy, the wide-horizoned, airily-lit island that caps the Jutland peninsula. Within walking distance of her studio are the dunes of the Vesterhavet coast overlooking Jammerbugten – the Bay of Sorrows. Here the limestone cliff rears above the strand to gaze out across the Skagerrak towards Norway. On clear days the colours glisten with rinsed clarity in the salty light while, in the rhythmic striations of soft rock, the cliff face tells its own geological story. Offshore, a solitary, cormorant-haunted stack called Skarreklit used to stand steeple-like above the foam before it collapsed during a night of violent storm in 1975. "In the old days," says Berit, "it was believed that this was Earth's edge, and on the ocean side of the rock were the words 'Northwest of here there is nothing'. The legend has it that, once a year, a bird comes to sharpen its beak on the stone and, when Skarreklit is worn away, the world will come to an end. There is only a little left showing above the water now."

WHEN I FIRST MET BERIT, one frozen January several years before the storm, she was working on the vast tapestry, 'Day', which celebrates the landscape of Bulbjerg and Skarreklit. The piece now hangs in the boardroom of the Danish National Bank, but what astonished me at the time was its intimate identity, in both material and visonary terms, with the environment within which I saw it taking shape.

Berit had spun wool from the fleece of the sheep grazing the fields behind the cliff. She had grown her own flax there, and coloured the yarns with vegetable dyes distilled from other local plants. Now she was returning what she had taken by weaving it back into the landscape as known and loved in her inward vision. At the same time it was as though, through this long alchemy of patient labour, the land itself was realizing something at once new and very old about its own inward nature. So strong was the impression left on me by this powerful, tranquil process of transubstantiation that, twenty years later, those memories returned unfaded to furnish images for my own fictional weaver in *Alice's Masque*.

A recent exhibition mounted in celebration of Berit's seventy-fifth birthday brought together the harvest of a lifetime's work. It's a life that began in the fishing community of Munsala in Finland, where in the 1920s weaving was still as much part of domestic life as mending the nets. Childhood voyages in her father's boat taught Berit the power of natural forces together with the need to flow responsively with them. She was given her first spinning-wheel by her grandmother when she was thirteen. Later, her developing skills in drawing and embroidery took her to college in Helsinki where she studied pattern-making. From there she went on to Stockholm, working for the textile artist Ann-Mari Forsberg before graduating from college. Marriage to Gunnar brought her to Copenhagen, and the raising of her own family in the 1950s left little time for other work.

BERIT'S FIRST ESSAYS in tapestry were mostly small images drawn from memories of her childhood in coastal Finland, but then a journey to the east brought new illuminations. The quiet discipline of Japanese aesthetics, the qualities of slatted light through bamboo-screens, the figurations of calligraphy – all influenced the focussing of her personal vision. Other inspirations would come from her study of neolithic cave-paintings, Lappish traditions and the Native American medicine-wheel, yet the roots of her imagination remain firmly earthed in the land- and sea-scapes of her native Scandinavia. Berit's vision flourished to maturity when the family moved north to Thy, and the sensory impact of the natural world found a feeling answer in the symbol-making powers of her soul. "Nature always enters my work," she says. "I need that foundation of experiences. But my beliefs, my unconscious, my soul enter into the tapestry as I work. It is neither 'naturalistic' nor 'abstract'. Fantasy and intuition go into the weaving and very often I am quite surprised – sometimes shocked – when the tapestry is out of the loom. Not till then do I really see what I have been doing." Perhaps none of the visual arts requires the maker to sustain a single vision over as long a period of time as the weaving of a complex tapestry. The wish to create the image may come swiftly enough, but "how to hold the inspiration, dreams, thoughts which started the process, during

ANDRZEJ JACKOWSKI

The Art of Atonement

He discloses immense anguish and yet offers redemptive moments of hope.
By Peter Abbs

The Bower

AS I WRITE, I LOOK at a photograph. It is of a middle-aged man. He has a long lean face and holds a warning finger against his thin lips. Be silent, he seems to say, be minimal in all that you do. Underneath the photograph there is a quotation from his writing: "There is no solution because there is no problem." It is a picture of Marcel Duchamp, the first conceptualist.

We are not as familiar with his work or his image as we are with Picasso's, yet it is now turning out that his influence may be greater than that of the maestro. Indeed, it might be claimed that if the exuberant Picasso ruled the first half of the twentieth century, the minimalist Duchamp has ruled the second half. For behind all the essentially tedious work gathered in the cerebral rooms of our Museums of Modern Art there lurks the silent influence of Duchamp with his thin finger at his lips.

Of course, this is only to note a dominant prevailing fashion, a systematic flight from the aesthetic and the imaginative. The philosopher Hegel was convinced that art had reached a state of depletion at the beginning of the nineteenth century and would never again recover. "Art" he wrote, "no longer affords that satisfaction of spiritual want which earlier epochs and peoples have sought therein and have found therein." He went on to state that the abstract and speculative and scientific nature of his own time conspired against any further artistic renaissance.

In the dark light of Duchamp's work and influence we might be tempted to call Hegel a remarkable prophet, but, of course, it is not as simple as that. Much great art has been created since the death of Hegel. And then again art does not have to be of its time. Its creation can be antithetical to the age. In this view, art should seek to express those elements of metaphysical and poetic life which have been repressed or disregarded under the rule of technology and the force of general abstraction. It exists to keep open states of being and states of apprehension which are in danger of being lost. Its function is visionary and corrective.

The more the age insists on the redundancy of expressive and imaginative art, the more it may paradoxically need it. At the moment, the avant-garde has become the Establishment. By a curious irony, the anti-art of Duchamp thrives as pure orthodoxy. It has become a deadly kind of tradition. A tame absurdity. A conservative iconoclasm which threatens nothing and no-one.

Yet the more banal and vacuous the dominant art becomes, the more there grows at the same time an all but inexpressible yearning for the deep imaginative art it has all but destroyed. Out of this deep boredom there emerges a new passion for the excluded element. People begin to look again for an art dedicated to meaning through the sensuous transforma-tions of the materials used. They search for artists whose work invites profound acts of aesthetic contemplation – in brief, they seek out the antithesis of conceptualism and the creative answer to it.

ONE SUCH ARTIST is Andrzej Jackowski. For some years now he has been concerned to articulate through his paintings the inner life of reverie and its own associative logic. His work moves and animates somewhere between dreaming and waking. As a young painter finding his way he drew for years only with his left hand so as to break the spell of natural representation. His truth is imaginative truth to the inner world and to those elected objects which carry its poetic language. His most powerful images derive from the cellars of the human memory, either his own personal memory of a very precarious childhood or the collective memory of the human race. The paintings are particularly powerful when the two sources of imagery merge and we find ourselves standing awe-struck before a vast image which is both deeply personal and yet also archetypal.

In the foreground of one painting a vast head floats on the tide; behind it there is a small boat in which a man is carrying a roll of canvas; behind the boat is a stormy and turbulent sky. The images carry with them deep resonances – historical and archetypal – concerning annihilation and redemption, work and reparation. Indeed, the latter seems extremely important in the work of Jackowski. The signs and artefacts of labour – pots, tools, ladders, fences, walls, chairs, tables – litter his canvasses. It is as if we are the sum total of what we have made or struggled to make, and that what has been made is always at risk, always threatened by the erasures of time, the cosmic indifference of nature and the destructive energies of the human mind itself. Significantly, many of the painter's most shocking images derive from the Holocaust.

The dominant note of a Jackowski painting is dense and sombre. His work moves across a somewhat limited but convincing spectrum from freezing trauma to quiet expectancy. In his exhibition 'Albums and Aliens', the extreme ends of this feeling spectrum were marked by two fine paintings. One is called 'Toxic Tank'; the other is entitled 'The Boy Who Broke The Spell'.

In both paintings, in a characteristic metaphysical leap an ordinary table becomes a sacred altar – a holy site of possible sacrifice and possible transformation. In Jackowski's world of engaged reverie, the most ordinary object – a shoe, a discarded toy, an insect, a case – can become a most extraordinary carrier, bearing some universal portion of human life. Thus again and again, in his recent work the simple everyday table becomes a terrible altar for a variety of possible transmutations.

Toxic Tank

In 'Toxic Tank' the table is white and functional. On it stands the tank with a blood-red lid. Inside the tank there is the suggestion of moving fish but at the bottom lies a bloody fishlike body (is there a reference here to the 'fish' Christ?) or, possibly, a raw aborted foetus. At one side of the table stands the white 'priest'. He is faceless. He is the expert, the bureaucrat, the nameless one, the one who performs but has no idea what he does. Where his heart should be there hangs a cold stone-like object. But the most dreadful element in this most disturbing painting is the shocking pink daubed with bloodcoloured strokes which forms not so much a background as the dimension of feeling in which the unredeemed and unredeemable objects

stand. 'Toxic Tank' is a version of the Holocaust and, contemplating it, we become its appalled and implicated witnesses.

In great contrast, 'The Boy Who Broke The Spell' is permeated with an expectant light and has a serrated green-brown 'background'. In this painting the table is red and has a pink cloth laid over it. On its surface there lies a long thin box, a greyish coffin. Lying inside, only partly visible, is the figure of a young boy. He could be dead. He could be sleeping. He could be waiting. He could, certainly, be dreaming.

Near the boy's feet on the table is a jam-jar with some flowering twigs, and near the jar is a single red shoe. The table casts a darkish shadow on the som-

Study three

bre brown floor. Against one of the bright red legs of the table there rises a spiky plant which breaks into a subdued orange flame. The painting expresses a sense of profound expectancy, of possible resurrection. It expresses the feeling of Holy Saturday suspended between the unspeakable Good Friday and the joyous Easter Sunday. It is almost celebratory, and is the antithesis of 'Toxic Tank'. Placed together they work dialectically, giving us compelling images of the contrary states of human consciousness. They are fine examples of the contemporary metaphysical imagination.

Andrzej Jackowski is neither comfortable nor fashionable, but he is a significant painter. He has evolved his own distinctive style to depict the sta-

tions of our being. In the most powerful of his metaphors he discloses immense anguish, the fear of disfigurement, the prospect of annihilation. But he also offers redemptive moments, the moods and modes of atonement, the place of hope, the power of expectancy. If by metaphysical art we denote that art which re-describes and re-positions the objects of our daily phenomenal world so that they become the metaphors of our own predicament, then it certainly seems essential to include him in any list of new metaphysical painters.

We may not be a problem in need of a solution, as Duchamp claimed; but we are a predicament in need of metaphors so that we can see a little more clearly who we are and who we might be. ●

GILES KENT

In the Garden of Gaia

Sculptures that are an embodiment of simplicity and serenity. *By Philip Vann*

ORN IN 1967, the sculptor Giles Kent now divides his time between his home and studio in south-east London and residencies in outdoor sculpture sites in England and abroad. Since graduating in Fine Art Sculpture at the University of East London, Kent has enjoyed residencies and sculpture commissions for gardens and woodlands in many English counties, and also in Sweden and the Czech Republic.

To encounter a sculpture by Kent on a gentle sylvan saunter, or a more arduous trek through primaeval-seeming undergrowth, is to be stopped in one's tracks in awed surprise, to be rooted to the spot at the sheer surreality of what's on view. He claims that even animals sometimes react like that; startled deer having been known to sniff with peculiar curiosity around his transfigured trees. So far he has made sculptures out of beech, sycamore, larch, lime, sallow, maple, oak, pine, cypress, Lebanon cedar, spruce, alder, yew and chestnut. He says: "It's practical and fulfilling to work with dead standing trees, recycling something that's dead. It's also just so good to work in the place where the tree itself has grown."

The forms he makes are often intimated by the types of tree. Oak guarantees durability and longevity: his works in oak often look tough and squat. A recent sculpture in sallow, though definitely solid, has the appearance of three tall, delicate, translucent ascending waves. He says, "I like working in pines, because I like that soaring straightness, and I like the pine environment – with all those straight lines to work with." The other noticeable difference he finds between different woods is their colour. "On the whole my work is about experiencing wood's inherent qualities," he says, "interacting with its forms, creating space in and around it and relating the work to the surrounding landscape and its presence. The materials and sites I choose enable me to try and express feelings of growth, balance, freedom and truth that I look for in myself and which I perceive to exist in nature."

I HAVE VISITED Kent during three of his sculpture residencies. At the Grizedale Forest sculpture park,

9,000 acres of wooded hillside in Cumbria – where not a single one of the dozens of sculptures on view is in sight of another – one of Kent's most singular works emerges literally out of a small mountain lake. It consists of nine carved Sitka Spruce trunks, the tallest of which is fifteen feet out of the water, all poised at different heights in a gracefully asymmetrical grouping. In the sunlight, they first appeared to me like nine luminous double-pointed pencils or glistening blades piercing both the sky and (via an almost pristine reflection) the water.

All of the trunks have been hollowed out twice. "The visual qualities of nature lie in simplicity and repetition," says Kent. "I try to keep it very simple, repeating forms, trying to work with the lines and shapes around." The lake ensemble indeed demonstrates simplicity, and serenity too. It is imbued with wonderfully varied nuances.

To visit the Gardens of Gaia in Kent at dusk, as I did, was to encounter a group of seven Scots pines which formed a kind of magic lantern show. Each tree had been carved in multiple alternate sections, so that a reasonably regular segment of bark (pierced by a square hole all the way through the trunk) was followed by a segment severely sawn right down to the bone, so to speak, or to the bare, pale, rounded wood. These slender forty-feet-high trees – each with as many as fifty regularly alternating segments – glowed with a literally inner light, as the descending sun pierced their cores.

For the Hannah Peschar Sculpture Garden in Surrey, Kent created in his studio two sculptural groups, each composed of three figures. Three lime trunks, the tallest six feet, have been carved into the oddest sinuous and orbic forms: bulbous at top, with what appear almost like folds of skin lapping underneath with, at root, powerful bases, like heavy truncated thighs. Roots, bulbs, scrotums, penises, vulvas, flowers, foliage and the human body: this sculpted trio suggests all these things (and more) simultaneously. Their core subject, like that of all Kent's sculpture, appears to be the amazing fertility of both nature and the human imagination, and a timeless stillness beyond. ●

Three carved Western Red
Cedar trunks, Canada

TONY LANE

Luminous Art

Paintings that recover some of the lost power of images. *By Mark Kidel*

FRIEZE is one of the contemporary art world's trendiest publications. It is cold, hard-edged and slick. Surprising then to find in it, a few months ago, an advertisement for an exhibition at London's Dreamtime Gallery by a painter whose work, displayed in the ad, seemed completely at odds with its surroundings. The painting 'Table, Wounds' by New Zealand artist Tony Lane had a depth that felt incongruously soulful.

Tony Lane's paintings stand fiercely against the mainstream. The current state of a-spirituality and the triumph of commercial priorities conspire with an insatiable need for information to produce a culture in which the merely factual rules supreme. The cult of data – literally, those things which are given – has become a religion, a kind of cargo cult in which surface is often worshipped at the expense of depth, the dazzling sparkle of wit and intellect rather than the murk and darkness of soul. In the age of instant communication, art is very often about the quick fix.

That the most successful British exhibition of recent years should have been called 'Sensation' is, therefore, hardly surprising. The intentionally controversial nature of much of the material drew large audiences – which is not necessarily a bad thing: it is good to get people into art galleries, and equally good to get them talking about art. Much of the appeal of the work included had to do with its immediate and sometimes shocking impact, and the way in which it stimulated strong reactions both emotional and intellectual. This is work that stimulates talk rather than silence. The artists address obvious contemporary issues and supposedly bring art into the street. But is this what art is about?

There is nothing fashionable or controversial about Tony Lane's paintings. Is he ahead of his time, or *passé*? His self-exclusion from the march of artistic progress, which cultural commentators seem to think must proceed in rigorously linear fashion, is not a mark of outsider eccentricity; neither is it purely a matter of living so far from the places in which art trends are determined. For while Lane stands, strictly speaking, outside history as we commonly perceive it, he belongs unquestionably to a tradition, without in any way playing at post-modern irony or pastiche.

Lane refuses to be drawn into the snares of art history, with the imperatives it implies for the artist, whether he or she chooses to rebel or comply. For the artist's revolt is as history-bound as the slavish imitation of previous generations, or the nostalgic return to a lost 'classicism'. True originality, however, as Tony Lane's work makes quite clear, means perpetually re-inventing art, but forever on first principles. Tony Lane's time is circular rather than linear. He is interested in the perennial rather than the contemporary, in tune with unchanging values rather than seduced by new ideas. Tony Lane's paintings are directly connected with the work of the Italian primitives. The relationship is complex though: on one level, Lane's subjects might be perceived as the imagined details of a Cimabue that never was. On another, they share with the luminous paintings of the *trecento* and *quattrocento* a status as objects of spiritual reflection. They draw us away from the mundane, towards the numinous. They lead us away from ideas and from intellect, and into the world of the imagination.

Lane uses some of the same techniques as the Italians of the Middle Ages, painting on *gesso*, a thin layer of plaster applied on wood, using a great deal of gold and silver leaf. He also makes his own frames. This is the work of a craftsman, and it could be argued that craft today is one of the refuges for the artist who wishes to escape the prison of words. Lane's paintings have great presence. They impose themselves, with the aura of ritual objects. They are tools for reflection, subtle mirrors rather than pictures with a clear subject or message.

The apparent content of Lane's paintings draws from a wide range of sources, some of them Christian. The imagery is never obvious. It eludes interpretation. Much of Christianity's power as a symbolic language has been lost – at least in our conscious minds: in part through the literal way in

Two tables

which the central fictions and images have been interpreted, and in part through the subversion of image promoted by iconophobic Protestantism. It is perhaps not entirely coincidental that Christianity's sacred images and the iconography of advertising should share today an absence of soul. There is too much manipulation, too much obvious symbolism, and the ubiquitous and deadening presence of the literal mind, for which one thing must always stand for another, and meanings must be clear and simple.

Tony Lane's paintings recover some of the lost power of images, a potentiality whose source lies in awe and mystery rather than 'in-your-face' literalism. They are to be approached with the unfocussed vision of the heart rather than the directed gaze of the intellect. Veils and shrouds, sometimes torn, play an important part in Tony Lane's paintings. His work celebrates the hidden and the secret: not so much the disinformation of intentional obscurity

so common in much twentieth-century art, as a refusal to reduce his work to a message that might be decoded and interpreted.

Tony Lane is reluctant to talk about his paintings. Although moved to write about them, I was equally reserved about saying too much. I am driven to write negatively, to describe them in terms of what they are not, or to reflect in more general – or veiled – terms about their feeling of mystery, a mystery which beckons rather than forbids. Mystery – the absence of immediate information or understanding – has always been central to spiritual quest and philosophical endeavour. The questions that cannot be answered are probably the ones most worth asking. Just as eroticism thrives on the refusal to bare everything, art – the realm of eros as well – thrives on a certain impenetrability, the promise of revelation sometimes so subtle as to be almost imperceptible: something which cannot come at the flick of a switch or the spin of a CD-Rom. ●

157

Pilgrim's Path

SHAKTI MAIRA

Pilgrim's Path

Integrating spirituality and art. *By Elizabeth Rogers*

CREATIVITY STRIVES TO transcend the limitations of human attitude and perception, to reflect back to the great creator – Nature. Such a sense of organic nature and enduring journey permeates the life and work of the artist Shakti Maira. In 2001, after residing for over two decades outside of India, he moved back to live and work in New Delhi. Even the title of his most recent series, 'Pilgrim's Path', echoes his familial heritage and ongoing course of physical translocation and personal exploration. He is the inheritor of a spirit and strength born of a family which moved multiple times, spanning eras from the earlier time of Buddhist Afghanistan to his birth in India on the eve of Partition and Independence, when his family once again relocated from Lahore, now in Pakistan, to the redefined India.

Upon completion of his economic and business-management studies, Maira similarly embarked upon his own continental shifts: living and working in Mumbai (Bombay), Manila, Los Angeles, Sri Lanka and New Hampshire.

An artist since childhood, his first solo exhibition took place in Mumbai in 1973. Twenty-two one-person shows later around the world, his work has been widely collected in both private and museum collections, including The National Gallery of Modern Art, New Delhi. Primarily a self- or perhaps

Pilgrim's Path

life-taught artist, Maira continues to work in multifarious media – paintings on canvas and paper, etched stone, printmaking, and sculpture in bronze, terracotta and stone.

What more fitting place in which to partake of such eternal and present spirit than India? This global and lyrically spiritual artist reasserts the significance of art in a world fraught with turmoil, conflict, uncertainty and repeated violence. In such times one should turn to artists, for they aspire to wisdom and awareness, that most solitary and spiritual quest.

'The Pilgrims' refers to the old pilgrim's path from Varanasi to Sarnath, which Maira traversed many times. Following that bearing, he caressed the earth, along with umpteen memories of old footsteps, hearing that the Buddha walked this path.

Maira's work is visually beautiful, burgeoning with naturalistic strokes and imagery, at once moving and centred, reminiscent and catalytic. This series of paintings touches and strums one's kinetic chords, as if a poignant stream of consciousness, a familiar tune plucked forth from an intoned note. Could it be that this artist reaches inside each of us, using one universal palette, an infinitesimal brush, a harmonic convergence? He speaks of such closeness as the 'spiritual in art', as a psychological form and energy lying behind the actual technical rendering and production: the inherent language spoken by the artist.

IN MAIRA'S WORK, the definition of space and line is blurred, as between human and nature, art and energy. A reactive versus responsive aesthetic experience probes the divorce of modern times from the organic and spiritual. Maira affirms that the spiritual in art only takes place on such a responsive level. He strives to create a connection, a bridge, between one's individual path and an actual natural place that connotes a broader joy. Nature is fundamental to the origination of these paintings, just as the notion of aesthetics is essential to spirituality. Maira creates his art to share this experience of the dynamic spirit, of bliss.

His understanding of 'contemporary Dharma art' aims to share the process by designing something to help others connect to and realize their own potential bliss. His art is not an escape. It asks others to become 'present' – in the here and now.

Despite the conjured subject matter, the traditional philosophic inspirations and references, Maira's work does not create iconographic aids for meditation or visualization. His art reaches outwards to involve and enfold others, to stimulate them to explore for themselves these inner and outer pathways. ●

HAROLD MOCKFORD

Acts of Discovery

Deep aesthetic routes into the imagination. *By Peter Abbs.*

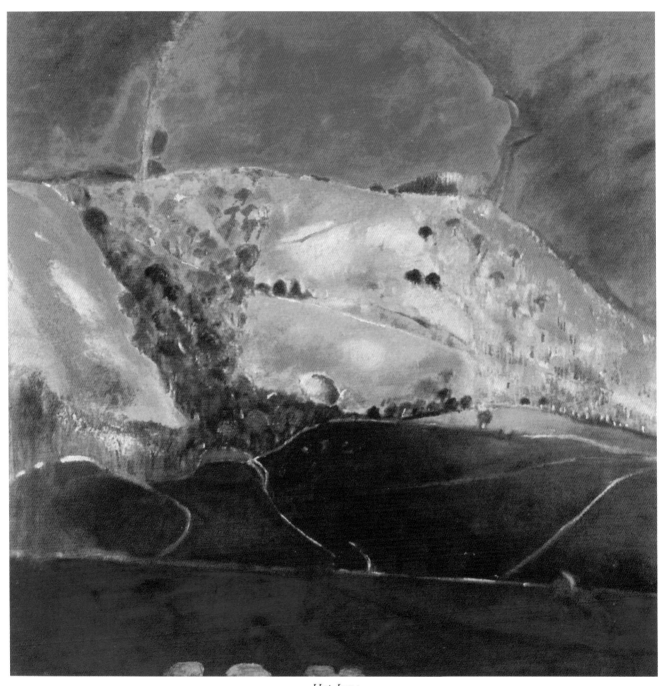

Hot June

CONCEPTUALISM IN the visual arts is still very much in vogue. One still hears of applicants to certain fashionable Art Colleges being asked at their interview such a futile question as: *What would you do with three blocks of wood?* The intractable problem with Conceptualism is that it bypasses the deep aesthetic routes into the imagination.

Indeed, Conceptualism in the visual arts is all but a contradiction in categories. Concepts refer to generalities while art entails specific practices. Art involves a sensuous embodiment through vital interaction with a physical medium. No medium, we might say, no art. The embodied image, in turn, demands a sensuous and imaginative attention from the spectator. Art creates images for contemplation, not conceptions for analysis. It is an intensely physical activity – an erotic activity – working towards the spirit, towards meaning, towards value. What is so strange is that in our century such an animating, life-enhancing, activity has been consistently threatened by a movement that offers so much less: an art against aesthetics.

The painter Harold Mockford lives at the far side of such fashions and the daily manufacture of instant reputations. He is, at once, a quiet visionary and a determined outsider. For him, art is the expressive means of rendering his own spiritual apprehension of the world.

He has lived all his life in Sussex, and after some preliminary training at Eastbourne College of Art has educated himself, avoiding schools so as to keep faith with his developing vision. His isolation and independence has kept his handling of paint agile, personal and deeply poetic.

But it would be wrong to conclude that while Mockford's vision appears naive he is a naive painter. Far from it. His work testifies to a number of deeply sublimated influences: Samuel Palmer, Van Gogh, Pierre Bonnard, Carel Weight, Mark Rothko. The diverse influences have been finely assimilated into a style that has enabled Mockford to convert the Sussex landscape and seascape into the most compelling images of magical transformation. Not unlike the isolated William Blake, Harold Mockford has nominated his own tradition to create his own distinctive mythology.

Anyone familiar with Sussex around Eastbourne will have no trouble identifying the immediate physical locations which are the sources of most of his paintings. Again and again, in his direct dramatic canvases one recognizes the actual site. And even if one doesn't know the exact place, one immediately registers the feminine undulations of the Downs, the slender church spire rising above a clump of trees, the small gates, the long stone walls, the disappearing chalk paths and the treeless uninterrupted horizons. One could draw a fifteen-mile circle around Eastbourne and have immediate ownership of Mockford's landscape. This is where the artist was born. This is where he has lived his life. At one level his work is an epiphany in paint to the small patch of nature and culture he was born into and, no doubt, many of the chosen sites are resonant with childhood memory. What we have, then, in his extensive work is a wonderful local affirmation.

YES, OF COURSE, we recognize the place in the painting – and the title of the work often simply names it. But we see something else as well – a unique poetic transformation. An act of alchemy. In this transformation the recognizable outer object becomes simultaneously the ambiguous vessel of inner meaning. The transposition of literal colour into imaginative colour is indicative.

In Mockford the English grey sky can often hang down in veils of red and orange, the fields stretch across the canvas in an unfamiliar dark ochre, the sheep and horses stand in unapologetic blue, and the white chalk cliffs rise into a cloudy green. But the poetic choice of colour is not an isolated event – it is merely part of an entire transposition of nature into another spiritual key. Working always from memory, Mockford consistently dramatizes his immediate perceptions, tends to add narrative elements, finds or invents small moments of radiance – a wave breaking white near the cliffs, sunlight hitting the corner of a field or a remote patch of water – and converts the local into the universal.

Quite often in his work there is a sense of impending drama – as if one stood at the edge of an imminent apocalypse or some moment of spiritual revelation, or simply near a small gate which, if opened, would lead into a childhood paradise where everything is complete and the smallest object bright with its own significance. In fact, the free-standing country gate – both taking us into and cutting us off from the ground on the other side – is a key Mockford emblem, and an excellent example of how a quite ordinary object is converted into a symbol of the human spirit. The outer geography carries the inner landscape of the soul. The paintings greet us like events which are about to take place. They are not conceptions but mysteries about to unfold – if we can only learn to live inside them.

For example, in the painting 'Waiting to Go' (1994), the more we look at it the more we feel caught up in a dramatic but not quite resolved moment. The sky shifts through three colours – dark rust, orange, pale ochre – not unlike a Rothko painting, except that at the centre float two naive clouds taking us away from pure abstraction and locating us in a magical figurative world. Mockford is keen to keep us in a world of representation, but it is a world of magical redescription rather than simple denotation.

He is, as I have implied, the master of dramatic

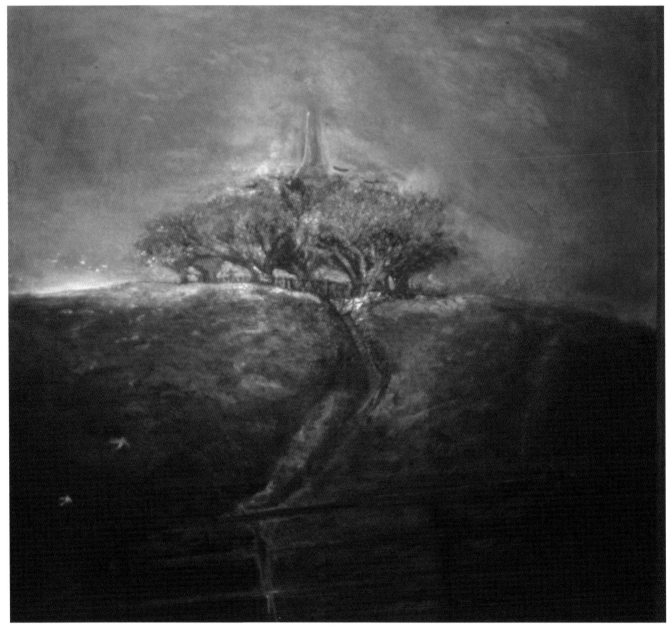

Sacred Mound

imagination. Under the clouds and to the left we notice the ferry boat returning to Newhaven from Dieppe. As our eyes drop to the foreground of the painting we notice the parked cars, the brown fences and the buildings, above which on the sagging telegraph wires gather swifts and swallows ready to migrate. Then, finally, beneath these congregating birds one notices three tiny figures standing at a gate which would appear to open straight into the sea. Two of the figures stand close to each other, a man and a woman; the third figure – a woman – stands slightly apart. Here are all the elements of a small human drama over which the sky stands like a biblical revelation. The painting is animated by a half-resolved tension set up by the three dramatic levels of land, sea and sky, by the

suggestion of imminent return and imminent departure, and also by the three figures standing against the gate. The colours are full of expectancy.

NOT ALL OF Mockford's paintings fit the pattern I have described. There is an austere sequence of autobiographical paintings which stand apart. One of these was recently bought and then after a short time returned to the painter. The owner had found it too uncomfortable to live with. Too disturbing. One sympathizes. Yet these paintings are courageous visual explorations of inner unease and dislocation.

Harold Mockford describes his paintings as acts of discovery. The day I meet him to discuss his work he is working on a painting based on a woman he has seen feeding some wild birds in Seaford. This

162

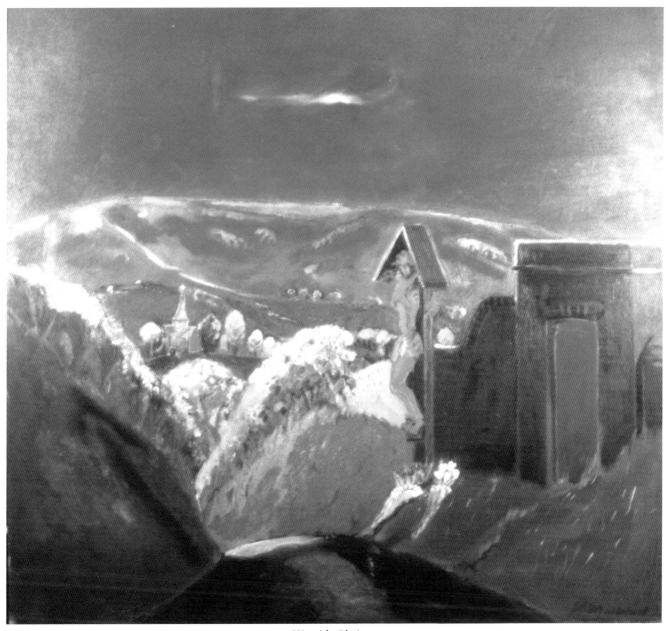

Wayside Shrine

moment of observation, he explains, was a heightened moment of perception. It is the starting point of the new work. But as he works on the image it moves more and more into metaphor. It accumulates further meaning. The woman comes to symbolize a portion of being – in particular, a living concern with the natural order. As the painting evolves, so, Mockford explains, he will add new elements of story. This will further charge the original vision and keep it vital. Then when the painting has reached a certain telling moment of strangeness he will leave it and turn to the next composition. The painting does not reach a formal perfection but, rather, a point of mystery which can be taken no further. Everything he says confirms my judgment that his paintings are, at root, dramatic metaphors of the

soul held up for our contemplation, physical and metaphysical, local and universal at the same time.

In his book of collected reviews and short essays, *Testimonies*, Michael Hamburger talks about poetry being both anachronistic and utopian. It is anachronistic because at its deepest level poetry works outside time. It is utopian because, beyond its immediate personal and geographic context, it is always both nowhere and everywhere – forever present. Mockford's paintings have the same powerful virtues. His best work tangibly demonstrates the union of art and spirit and points us way beyond the world of instant reputation and mesmerizing fashion. Not concepts, but revelations. Only one who has kept himself apart from the tyranny of fashion could have painted them. ●

FERNANDO MONTES

Artist's Stone

Making sculptures vibrant with colour, texture and form.

By Valerie Fraser

FERNANDO MONTES'S work is instantly recognizable: stark landscapes with silent, immobile figures or fragments of ancient architecture, painted in muted greys tinged with blue or brown, and always against a sky of the purest white. At first glance these paintings appear to belong to the well-established Latin American indigenist tradition. Throughout Latin America the rural peasantry is still predominantly Indian, and in the 1920s artists identified in it a theme which suited their countries' burgeoning nationalism, a theme which was their own and which demonstrated that Latin America has a culture quite separate from that of Europe, a culture with ancient roots and with an affinity with the earth. Within this artistic tradition the image of the woman is especially pervasive: with long black plaits and motherly proportions, and often seated on the ground, in touch with the land and the landscape.

But although Montes's work may be descended from this tradition, there are other strands woven into it: some much more ancient, some entirely contemporary. Most striking is the way in which his work over the past twenty or so years is so evocative of stone, in colour, texture and form. This is surely no accident. In the Andes, stone has always been valued as the essential element of the earth. It also links the different levels of the world: stone crags and mountain tops give access to the upper world of the air and the sun, while caves, crevices and cracks – the gaps between the stone of the earth's surface – lead down into the earth's womb, the source of water and so, in conjunction with the sun above, of life.

As stones may conserve life in an altered state, so they can have feelings: they can become tired or distressed; they may speak, or weep blood or tears.

Fernando Montes's work evokes this tradition of stony metamorphosis. It is not hard to imagine his figures of women and children as in some stage of transition from flesh and blood into permanent stone monuments, even mountain ranges. Or perhaps it is the other way around: perhaps the mountain peaks and rocky outcrops are being reincarnated into human life.

This close relationship between the human and the natural world is also an essential characteristic of ancient Andean architecture. With Inca architecture it is often hard to tell where a natural rocky outcrop ends and the human interventions and additions begin. The architecture often seems to grow out of the surface of the hillside: the two are deliberately blended together, the worlds of the natural and the artificial interlink and overlap. Fernando Montes goes further, stripping his landscape of vegetation to emphasize the affinity between the rocky mountains (the bones of the earth), and the stone architecture.

It is illuminating to consider Montes's paintings in the context of this ancient and fundamentally Andean tradition of abstraction. His work is representational, yes, but it represents an almost platonic idea, an abstracted reality where the underlying qualities of permanence, silence and simplicity are made manifest. The people, the landscape and the architecture have had all that is miscellaneous, particular, transient, or merely decorative distilled out of them, and what is left are the solid foundations, the stone at the core of the Andean world. Montes's work is a metaphor for this process: a metaphor for the traditional Andean view of stone as a living sentient element that also encodes the past as a living power in the present. •

Gate of the Temple

165

JOHN MEIRION MORRIS

A Sculptor of Spirit

The artist is a spiritual and cultural mediator. *By Peter Abbs*

JOHN MEIRION MORRIS's sculpture is being increasingly recognized in Wales but is, as yet, hardly known east of her great mountain range. Given the prevailing art-trends or anti-art trends, this is hardly surprising. In fact, to consider his work is to come into immediate relationship with two great questions: the relationship of art to the soul and the relationship of both art and soul to the great traditions of symbolic expression.

To understand the significance of John Meirion Morris's sculpture we have to turn against the dominant energies of our century and re-envisage the role of the artist as a spiritual agent. This is no easy matter and the task is fraught with difficulty. From the start, one is almost bound to be misunderstood. Even the words we need – 'mystic', 'visionary', 'sacred', 'spiritual', 'cosmic' – seem all but corrupt and close to inner exhaustion. The language necessary for the analysis hovers on the edge of vacuity inviting conceptual confusion and the failure of any precise communication. And yet the attempt must be made, because again and again, against the ideology of Modernism, many of the most significant artists throughout the twentieth century have insisted on the spiritual nature of their work.

Comparing modern functional architecture with that of the thirteenth century, Nikolaus Pevsner wrote: "While in the thirteenth century all lines . . . served the one artistic purpose of pointing heavenwards to a goal beyond this world, and walls were made translucent to carry the transcendental magic of saintly figures rendered in coloured glass, *the glass walls are now clear and without mystery, the steel frame is hard, and its expression discourages all other-worldly speculation.*" (my italics). It is as if Modernism could, from this point of view, be described as the organized repression of the spiritual and transcendent.

Yet, while this does express the dominant view of what Modernism was largely about, the paradox remains that many of the greatest artists of our century espoused dramatically different views: views which celebrated the sublime, the spiritual and the mythical. What we now need to hear is this other story – what might be named the forbidden story about Modernism. We need to hear the artists' voices and their declared intentions and in response recast much of the narrative of the twentieth-century art.

For example, Egon Schiele exclaimed: "Art cannot be modern; art is primordially eternal." Max Beckman wrote: "One of my problems is to find the self, which has only one form and is immortal – to find it in animals and humans, in the heaven and the hell which together form the world in which we live." Kandinsky, attracted to Theosophy, wrote: "The veiling of the spirit in the material is often so dense that there are generally few people who can see through to the spirit." Phrases such as 'primordially eternal', 'the immortal self' and 'the veiling of the spirit' hardly represent the discouraging of all "other-worldly speculation" demanded by Pevsner.

The intellectual scandal is that the critical account given by Modernist critics may well not fit the best paintings or sculptures – one thinks of the work of Henry Moore, Epstein, Brancusi, Modigliani – or the declared intentions of their makers. The ideological construct of Modernism would appear to collapse before the actuality it claims to describe and, at that moment, a new imperative is born – the need to locate what has been suppressed and denied by so many critics: the spiritual dimension of modern art.

THE WORK OF John Meirion Morris has a particular importance here, for his work is unremittingly metaphysical and mythical, and his intentions have been made clear in a number of unapologetic statements. Without question, he belongs to the unacknowledged spiritual tradition of the twentieth century – particularly to the sculptural tradition of Moore, Brancusi and Epstein. Something of the scope of this archetypal work is brought out well by Epstein in his *Autobiography* (1955) where he wrote of Indian sculpture:

166

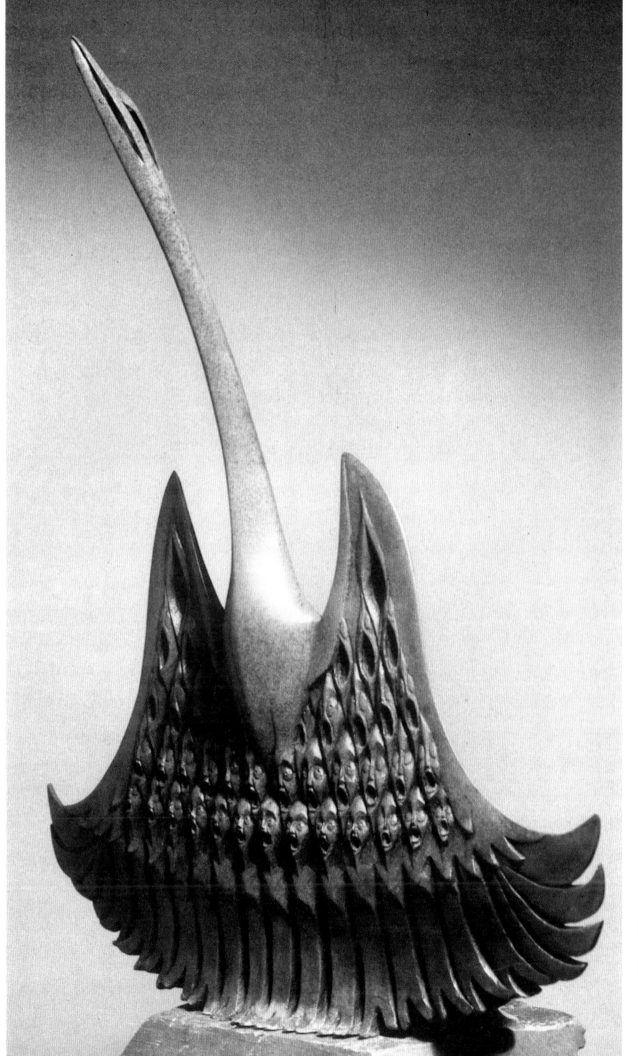

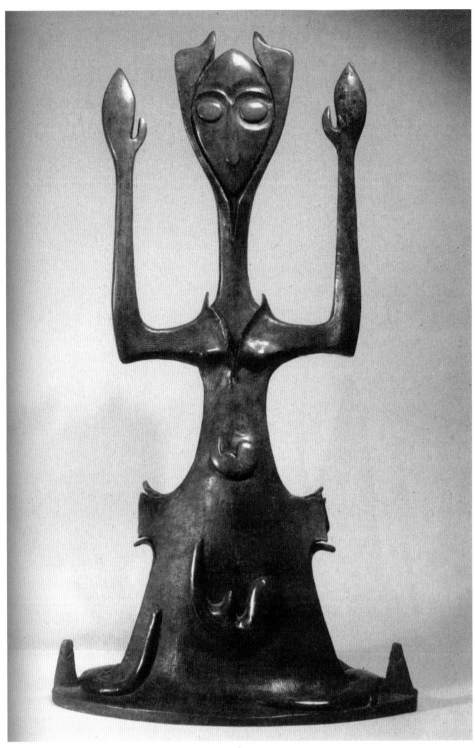

Modron

"In Indian work of this nature there is a deeply religious element, sometimes amounting to a fury of passion which is elemental in its power. Shiva dances, creating the world and destroying it, his large rhythms conjure up vast aeons of time, and his movements have a relentless and magical power of incantation. . . . The modern sculptor, without religion, without direction, tradition and stability, is at a terrible disadvantage compared with the sculptors of previous periods."

In this great primordial tradition art is never for the sake of art but for the sake of the spirit and the enhancement of individual and communal life. Art is not a formal exercise but a transformative activity.

Describing his own approach, John Meirion Morris has written:

"Sculpture for me is a kind of meditation. I meditate on images which enter my imagination; in other words I respond instinctively to them and develop them, whether they be images of protest or mythical or religious images. One experience which forms an essential part of the mythological/religious images is the traumatic experience of life and death. I find that the experience of death, or inner release, forms an intrinsic part of the rhythm of life, the creative process and religious experience. While meditating I feel instinctively that I am getting in touch with something basic and religious which is part of our essence as beings and part of nature."

THESE IMAGES MIGHT best be conceived as archetypal. Yet their actual expression is always inside a specific culture and it is here that we encounter the other essential aspect of John Meirion's work. It is profoundly traditional. It is Celtic in rhythm and organization and deeply influenced by the La Tène period of Celtic art. If the images arise spontaneously in meditation they are yet shaped by a tradition which lies at the root of his own culture. The very urgent and very ancient come together. At its best, the fusion is as remarkable as it is complete and utterly unselfconscious.

Morris's sculpture demands a particular kind of attention. In looking at a work by John Meirion we are frequently confronted by a single gaze which would have us be still and would transfix us by its power. The gaze would freeze us in our tracks and make us not restless explorers of the aesthetic but spellbound contemplators of some elemental truth.

Look at 'Modron', for example. The work directly confronts us. The only visual movement allowed is a vertical movement up and down the length of the long body. If the impersonal wisdom of the face (framed by the leaf-like emanations of nature) first arrests us, then our gaze, held in by the two uplifted arms, is only free to follow the line of the elongated neck down to the womb (where there is embryonic life) and then further down to the base of the figure where stretches a fallen corpse-like figure. The only movement then left by the fierce symmetry of the icon (for icon it most certainly is) is the return journey upwards through birth to the serene contemplative consciousness of the head. The narrative of the sculpture operates solely through the vertical axis and its meaning is clearly metaphysical. Enlightenment, it declares, comes out of the affirmative recognition of birth and death. If birth is the thesis and death the antithesis, then the synthesis lies in an understanding which transcends both and creates the third term of spiritual understanding. At the same time as the figure represents the all-inclusive goddess, it embodies the deciduous Tree of Life: buds, leaves, calyxes, branches are active throughout the work. The act of contemplation takes place within the biological world. There is no Cartesian or Christian dualism here. The spiritual exists within the matrix of nature. Mind and body are different aspects of the same driving energy.

As with early Celtic art, John Meirion Morris's work is highly symmetrical. This is particularly true of 'Modron', where, if one were to split the image down the middle, one would be left with two virtually identical parts.

Again, the symmetry of 'Bran' – a symbolic bird which directly confronts us with its male and female oppositions – has an almost mathematical rigour. On either side the piece advances upwards from *three* wing pieces, *two* dragon's tongues, to *one* elongated crying head. Similarly, as if to emphasize the spiritual element, the elongated neck and head (the top half) is smooth while the bottom half (linked to nature and femininity and death) is rough, textured, elaborate. Once again, one is reminded of a metaphysics which envisages consciousness rising up through the manifold of nature to give expression to its essential spiritual meaning. At the same time the bird is also *Welsh* (its dragon's tongues are unmistakable) and symbolizes, at another level, the plight of a culture which faces extinction. The scream is the cry of anguish before such a prospect. The mythological bird can carry febrile political messages and more effectively for their being part of a greater system of meaning and allusion.

Most recently John Meirion Morris has turned to the role of public monumental sculpture. His 'Tides of Time' is another symbolic bird designed to stand twenty-eight feet high above the side of Trywerin reservoir, where a Welsh village was flooded to provide water for Liverpool in the sixties. The icon is a powerful protest against cultural and material exploitation and an assertion of the freedom and power of the Celtic spirit. The bird's beak, as in 'Bran', rises into the higher dimension of consciousness, while the great splayed wings bear within them a chorus of shrieking and outraged heads sounding their lament for an exploited nation. John Meirion Morris has explained: "I believe it is the role of sculpture to make people aware of their identity, their cultural roots. Without roots, without identity, one cannot fly." Here, again, one finds an expression of the artist as a spiritual and cultural mediator, making public truths that are in constant danger of being forgotten. One can only hope that funds will be forthcoming to enable the erection of this soaring monument.

If Epstein lamented the position of the modern sculptor without religion, direction or tradition, here, at least, is one living sculptor in Wales who has located his ancestors and put their vision and their artistic formulations to further creative use, to remind us of all but lost spiritual and political possibilities. There is hope yet. ●

MARY NEWCOMBE

Visual Poems

Her work is underpinned by humour, humility and simplicity.
By Christopher Andreae

Bees in Lavender

THERE IS SOMETHING very quietly subversive about Mary Newcombe's art. First, there is its humour.

This is innate and not contrived. It is a pointed humour derived from original observation that comes from a sense of individual differences. Everyone, she remarks, has something to say that is entirely their own.

Her humour in no way conflicts with the poetry and vision of her work. It unexpectedly shifts perspective and breaks through cliché to something true. This sort of humour is very serious.

Part of her humour is the way in which she integrates paintings with words. Her titles can be much more than tags.

A picture of 1988 called 'Poppies angered at a passing cloud' enchantingly epitomizes this. The delicately translucent petals with their strangely menacing interiors, the warm-glowing background and the quick slash of cloud – the shadow-casting intervention of dark vapour that might make the flowers close their petals and thus shut out welcome insects – comprise a visual poem, both true and humorous; and the title, which has the feeling if not the form of a haiku, does more than describe; it fulfils the painting.

Newcomb's purely primitive – and humorous – solution in this painting to the question of how, within the limited confines of a smallish rectangle of linen, to show both the close-up poppies and the threatening cloud (realistically hundreds of feet above) is uninhibited and inspired. It reminds me of her enthusiasm for the works of Paul Klee, who can contain a cosmos in a few square inches. And yet there is not the slightest hint of a stylistic likeness to Klee here; her art is remarkably uninfluenced by other artists, however inspiring she finds them.

At one time Newcomb found something that struck a chord when she was reading a note about the Japanese Zen Buddhist monk-painter Sengai. The writer was Harold P. Stearn. He observed: "There is a simplicity and unprofessional naivety and charm to be found in the paintings and calligraphy of Sengai . . . [He] was blessed by a fine talent and sense of unselfconscious awareness . . . Many of Sengai's works have warmth and humour, and one can sense the humility of the man." Newcomb notes: "I never thought at all about Zen Buddhism nor have any knowledge of it but . . . it seems that I must have arrived in my own way at a similar pattern of thinking."

SECOND, COUPLED WITH her humour, is her anti-pretension.

She has an economy of statement that undercuts the high-flown and the hyperbolic. There is something about this that is in tune with the rural. Michael Mayerfeld Bell in *Childerley*, a study of 'nature and morality in a country village' (1994),

points to a difference between 'moneyed villagers' and 'ordinary villagers' in the way they express aesthetic appreciation for the countryside around them: with the 'ordinary' villagers, 'short responses were the most common'. Newcomb has lived and worked for nearly half a century in rural East Anglia and, although she perhaps falls into neither the 'moneyed' nor the 'ordinary' camp, she has the country in her bones: as she herself quotes (from *The Land* by Vita Sackville-West), "the country habit has me by the heart".

Newcomb's unpretentious economy is certainly true of her Diary, written in the late 1980s. It is a remarkable document, shot through with improvised disclosures of her thought and working processes; it cries out for full publication.

And economy also characterizes the flood of highly original drawings made outdoors in Suffolk and Norfolk or on her various travels. They are intuitive and straightforward. 'Magpie flying up from a wet road' is just one example: startling in its apparent spontaneity, it is about as far from an ornithological illustration or a stuffed specimen as a bird study could be: bursting with the life of the moment.

Newcomb has some sort of placidly deflationary comment at the ready for the overstated, the too-wordy, the self-regarding performances that are often called 'art'. But it is her work above all that deflates the importances and cutting edges of the art world.

THIRD, LINKED TO HER humour and her anti-pretension, is her childlikeness.

Newcombe wanted to be a painter from a very early age. This was frustrated by circumstance and convention, and by the fact that she was bright. A middle-class upbringing; the intelligence to do well at school in the subjects which were, unlike art, on the curriculum; and the perception that in wartime she should be 'useful'; all this conspired to make her a university graduate in the sciences and subsequently a high school teacher of the same.

Although her interest in fauna and flora was keen, and fostered by times spent at field study centres, teaching science seemed to her utterly repetitive.

Her subsequent story has been a triumphant escape from the merely routine (though not in the least from hard work), and her art has been a voyage of discovery, not only of the world around her, but of the child-streak inside her.

Her directness, her innocence of response to the fascinations of colours, light, birds, flowers, insects and people, as well as her fortunate freedom from the academicism, career-building tactics and cloning tendencies of the Art School, all contribute to an art of ever more sophistication which still retains the disarming candour and openness of the childlike.

She does not attach 'greatness' or 'importance' to

The entire goldfinch flock

her work, but takes the approach of having something 'to say'; of concentrating, as she works, on saying it, rather than on how she will say it; and then, once she has said it, of stopping.

She resists the temptation to spoil a painting by elaboration and finesse, once an idea has been realized convincingly for her. A painting may take time and struggle, but she knows instinctively when it is finished. Over-explanation is not her way.

Having learned the dreariness of repetition as a school-teacher, she keeps her work as an artist happily free from it. And although 'nature' – rural nature – is her subject, her approach to it is emphatically not that of a scientist. It is tempting to read into some of her paintings and drawings coded ecological messages, but if such messages are to be found, they are inherent rather than pedantic. She is a highly intuitive artist and not at all programmatic, political or theoretical. She is a 'naturalist'

only up to a point (what she draws from her observations are not conclusions but drawings and paintings): she is not an 'Observer's Book' illustrator or a deadly accurate botanical artist or a pursuer of rare species. Her naturalist side is subsumed in her artist side. And she is really more like the child who mixes wonder and matter-of-fact acceptance in her encounters with the natural world.

FOURTH – AND AGAIN inseparably from her humour, her anti-pretension and her childlikeness – there is the fact that unrepentently, in an art world which finds it increasingly unacceptable for art to be inspired by the rural, she is a country artist. This aspect of her work is probably the most subversive of all.

Most 'rural painting' today is dreadful: bogged down in pension-supported amateurism, evening courses and, worst of all, in the 'professional' die-

Boat in a low setting sun – casting its shadow over the reeds as it passes

hard nostalgia of table-mat and calendar picture-making and decorating.

Laura Ashley prettiness; the marketing of an Edwardian lady's diaries; magazines for city people devoted to rustic nostalgia (but no mention of the smell of silage); TV gardening programmes, country-house visiting, the bric-à-brac of National Trust shops, DIY books on how to bodge a milking stool or make a butter-mould . . . all told, the country-side has become so mythological that even urbanized people of demonstrable intelligence find themselves believing it has long since completely vanished.

In its connection with serious, or seriously-taken, art, it might as well have vanished. One of the recurrent ideas in Newcomb's work is 'disappearance', testing the limits to which the invisible can be expressed in visual art. There are paintings in which birds or people are no longer there. A recent paint-

ing of all-but imperceptible subtleties was called 'Shadow of a small rare plant, the botanic gardens'.

It is not without a certain grim factuality that it can be recorded that Newcomb's recent travelling retrospective, and the first (far from modest) book about her work, while they have been featured or discussed sensitively by sympathetic newspaper critics and in magazines slanted toward country living and designing interiors, have aroused no more than fractional interest in a single art magazine – and there her work was treated chattily by a celebrity as something 'collectible' (and indeed it is – so what?) instead of being discussed as art.

The book about her – although bookshops have typically shown minimal interest in it – has been arousing startled interest among those clever enough to have found or ordered it. Their usual question is: how could such an intriguing, different, idiosyncratic artist have escaped their attention so long? ●

173

WILLIAM PEERS

Walking and Carving

Process counts more than the product. *By William Peers*

A S A YOUNG MAN of twenty, I, too, with a friend, walked the path of many before me, from Land's End to John o' Groats. A path of a thousand arduous miles. The reason for walking I can only put down to a youthful spirit of adventure, a restlessness and a wanting in some way a 'trial of life'.

After two or three weeks we became accustomed to walking long distances. With each day the process became more of a meditation. The struggle to get up, eat, pack and walk became more automatic, leaving room for thought and conversation, to enjoy the journey perhaps. Our arrival in John o' Groats was strangely flat. I sat and stared out to Orkney. Had I secretly hoped to find fulfilment or some truth?

Several years later while walking in the Himalayas I fell ill from dehydration through climbing up to too high an altitude too quickly. Three days were spent in bed, and a fourth drinking endless cups of tea to recover enough strength to walk at all. Leaving the rest lodge on the morning of the fifth day, I fell in with a man from China. We both walked very slowly, but only he out of choice. Not only did he walk impossibly slowly, but he was forever stopping. At the end of the day, after countless stops and distractions, we had covered only about a mile. Had I been in good health, this lack of progress would have frustrated me, and at first only my lingering illness kept us together.

After a few days, however, I began to enjoy his company. He had great curiosity and gave the

impression that he was where he wanted to be. One day while sitting on a wall he told me that there were two types of climber: those who climb to reach the top and those who climb to discover what is along the way. This simple observation struck me at the time and has been bubbling away on the 'back-burner' of my mind ever since. There seems hidden in the words not only a truth about walking, but different approaches to life and to my particular interest – carving. That concealed truth has become pivotal in my approach to all three.

I started to carve stone with the help of an eccentric man I met several years after leaving art college. I began a sort of apprenticeship – 'sort of', because there was no formal arrangement. I helped him as the young often help the old, with enthusiasm and strength. Not only carving stone under his direction, I hoed onions, moved boats and patched chimneys. In return I received payment in marmalade, elderflower wine, and occasionally some cash. With tirades and comical insults flying regularly from this roaring bear of a man, our days were never boring. Sprinkled among the storms there were sporadic nuggets of wisdom. When he recognized my tendency to hurry things, he advised and encouraged me to work in stone. Stone would, he said, slow me down. He urged me to work entirely by hand,

avoiding all machine tools, thus slowing me down further. As it's hard to rush in stone, and mistakes are difficult or impossible to rectify, this still seems to me good advice.

Machines are noisy and clumsy and a further barrier in the translation of thought, feeling and emotion from mind to stone. Working by hand does, however, go against the 'modern way', which is to use machines, such as pneumatic chisels, to work more quickly. Unfortunately, the excess dust and vibration that these machines produce has caused many sculptors to retire early.

There are perhaps a million footsteps on the path from Land's End to John o' Groats . . . a million blows of the hammer in a carving. In fact, it matters little how quickly I reach the end; what counts is what I discover along the way. I am aware that if my mind wanders while carving, if I start to become distracted by the radio, then the carving becomes dull, weaker. This is perhaps not surprising, but what is more surprising is that even the simplest marks seem to suffer in the same way. The quality of a carving seems to come, at least in part, from the intent. The unimpeded flow of intent (or lack of it) remains in the stone. Where the intent was strong throughout the carving, the work shines. Each chip is a thought and each step a record. ●

ZDZISLAW RUSZKOWSKI

A Painter on His Own

Singing lyricism. *By Roger Berthoud*

MANY POLES HAVE enriched this nation's cultural life, the novelist Joseph Conrad being perhaps the most famous. Among those of more recent vintage was a remarkable and lovable painter, Zdzislaw (Zdzis, generally mispronounced Zish, for short) Ruszkowski (1907-1991), who was brought up in Poland but lived in London from 1944 until his death. His work, once he had thrown off the influence of the post-Impressionists, was notable for its originality and singing lyricism, his life for its extreme simplicity and a remarkable relationship with two wealthy patrons: Tom Laughton, Yorkshire hotelier and brother of the famous actor Charles Laughton, and Maurice Ash, a frequent contributor to these pages until his death in February 2003. It was through Ash that I came to know him.

In the art world Ruszkowski was not so much unrecognized as under-recognized. Despite a succession of one-man shows in leading West End galleries, a good deal of appreciative critical coverage, and a major retrospective at Leeds City Art Gallery in 1966, the wider recognition that his work deserves eluded him. That worried his admirers more than Zdzis. He scorned what he called the stock exchange of reputations, remained impervious to the dictates of fashion, and was confident that posterity would recognize his worth.

What makes his painting so special? At first sight there is clearly a debt to Bonnard in particular. But Ruszkowski's work is one stage further away from reality than Bonnard's, more distilled, more abstracted. At its best, it is remarkable for the never strident boldness of its colour, the strength of its design, the sheer beauty of the paint work, and its sense of light. Ruszkowski renders water with particular brilliance.

Nature was his chief source of inspiration, though many of his landscapes also include people. As he told me once: "To me, what I see is not the crucial point. It is rather the vision I get from seeing. That is what I want to express. To fix the vision I construct a sort of abstract skeleton before putting on the flesh." Summing up his philosophy, he said: "I

believe in God, but God is produced by human beings . . . in nature, which is eternal and continuous, always renewing and regenerating itself; and in its wonderful influence on human beings once they are in contact with it."

Many artists can claim that they live for their work, but Ruszkowski carried that further than most. He was fortunate that for much of his career his wife Jenifer earned a steady if modest income from the BBC. Even when his work was not selling, Zdzis was thus able to work continuously at their home in Chalk Farm, north-west London. In earlier days he escorted their two children to and from the school bus, did the shopping and cooking, but otherwise strove to transfer his vision of the world to rectangles of canvas in an environment devoid of newspapers, radio and television. It was an austere life, punctuated by bursts of Polish conviviality. Thanks largely to the support of his two main patrons, he was however able to travel for extended and fruitful periods to Scotland, Ireland, Greece, Italy (Venice) and France, for example; and he acquired a studio in Lyme Regis. Part of his personal charm was the seeming innocence that sprang from the simplicity of his life.

His talent declared itself early. From an early age he had a passion for drawing, doubtless inherited from his father, a landscape painter who taught art at the local lycée. As a child he was obsessed – presciently, perhaps – by horses, soldiers and battles. When the Germans invaded Poland in 1914, the family (Zdzis was then seven) escaped to Russia, returning in 1918. Zdzis subsequently studied painting in Cracow, whilst scraping a living. Later he visited France for extended periods and came heavily under the influence of Cézanne's work. When the Germans again invaded his homeland in 1939 he joined the Polish army and was sent to Brittany, whence he escaped to Scotland via Spain, Portugal and Gibraltar. There he married Jenifer McCormack in 1941, three years later moving to London, where her parents lived, with their two small children. For the rest of his life he remained based in and around Hampstead.

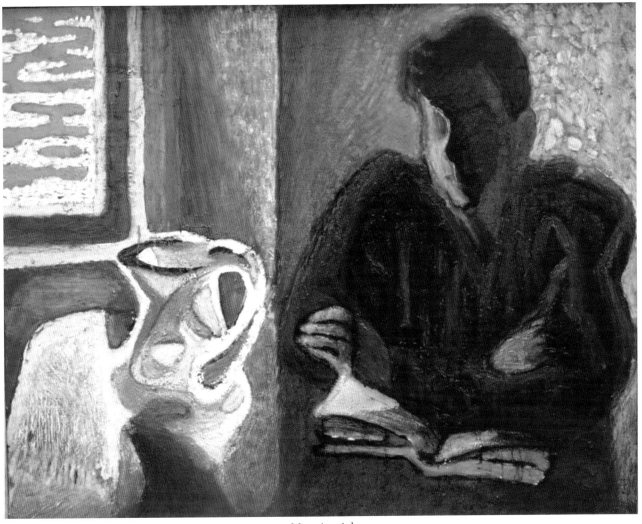

Maurice Ash

Ruszkowski met the two men who became his great patrons and friends in the early 1950s, following his second one-man show at the Cork Street galler of, Roland, Browse and Delbanco. Tom Laughton was to acquire more than 100 examples of his work, many of which were hung in his three family hotels in Scarborough; Maurice Ash had several dozen in his Palladian mansion in Devon, as well as works by Courbet, Cuyp, Rouault, Moore, Hepworth, Christopher Wood and others.

Not content with mere purchases, Ash commissioned a memorable portrait of his wife and elder daughter Kate, and for a time lent Ruszkowski the idyllic boat house on his estate, looking out across a broad tidal sweep of the river Dart; and invited him to stay at his villa in Cap d'Antibes. Laughton in turn facilitated two extended trips to a cottage on Loch Maree, in Ross-shire. In enjoying the close friendship and old-fashioned patronage of these two remarkable men, Ruszkowski was very fortunate. Towards the end of his life he was cherished by

a London collector and businessman, Michael Simonov, who also bought extensively and wrote a valuable introduction to *The Paintings of Ruszkowski* (Mechanick Exercises, London, 1982), which has 50 colour plates and comments on each painting by the artist. An earlier study by the critic J. P. Hodin was by then out of print.

Simonov's book inadvertently alerts the reader to Ruszkowski's Achilles heel: he is an uneven painter. His handling of the human figure is superb in a number of portraits, but sometimes clumsy and unconvincing in scenes combining figures and landscape. Sometimes his desire to impose a pattern makes his work hard to read. But at his best – and he was frequently at his best, especially in his landscapes – his work is like a cry of joy. In Nietzschean terms, he was a yea-sayer.

One has to be an optimist to share Ruszkowski's confidence that posterity will appreciate his true value. But *Resurgence* is doing its best to help, dear Zdzis, wherever you are. ●

KEN SMITH

Sensuous Stone

Embracing the primordial in sculpture. *By Philip Vann*

IN HIS TAUT, curvilinear, muscular stone sculptures, Ken Smith explores how people relate with one another – and so with wider nature – in a spirit of naked and poignant intimacy. These works are invariably grounded in the human form (though he has been known to make the occasional animal or bird figure). They portray the solitary individual deep in ecstatic or desolate self-absorption; lovers melding into each other in a state of sensuous grace; groups of people upholding each other in tender familial embraces. Above all, his at once rough-hewn yet delicately intricate carvings move us because they evoke how primordial human qualities of dignity and vulnerability, gentleness and powerful resilience, are inseparably linked.

Ken Smith was born in Manchester in 1944. Immediately after the war, his father took the family to live in Japan and Singapore. Though Ken was brought back to live in England, aged about four, he retains early Asiatic memories of "images of paths and being scared of coming across a snake, gutters after the monsoons, poking holes through rice-paper windows in the bedroom, and lying in bed with a gun near you to protect you against burglars and bandits." It is fair to say that his sculptures, made as an adult, convey curious unconscious echoes of some of these early childhood impressions. His carvings are full of meandering lines and channels, unmistakably snake-like forms, and fluid, coiling shapes evoking dynamic outpourings of water. Some of his huddled human groups seem to be intuitively guarding against, yet also embracing, unseen terrors and danger.

He was seventeen when he started an apprenticeship as a carpenter-joiner, when he learnt what he called "respect for tools, respect for materials". Three years later, searching for inner meaning and direction in his life, he retreated to live in a friary. He says that he found it "terrifying at first; the peace and quiet and tranquillity"; but he learned there how "to be independent, and it had a great effect on my personality. Some of the friars were really good people, and some of the older ones spent a lot of time talking to me about art." A later bronze sculpture, 'Cowl', which he describes as "a beautiful pure form evoking a very peaceful time in my life", is a majestically serene description of both the literal and spiritual fabric that clothes the monks' lives.

While at the friary, he studied part-time at a nearby college, where he learned to carve. This proved a fresh, liberating experience, especially since, as he now believes, "I had no influences whatsoever." He says he had then heard of Michelangelo and Henry Moore but had no idea or preconceptions of what their works were like. It was only when he went on to attend Walthamstow Art School in London in his early twenties that he became aware of other people's art. Though he soon found himself admiring classic modern avantgarde sculptures by Gaudier-Brzeska, Archipenko and (early) Moore, he consciously decided not to be over-influenced by them.

IN 1993 AND 1997, Smith made two carvings – one in brownish ham stone which is satisfyingly raw in its carved effects, the other in polyphant (which he buys from a West Country quarry), whose lovely blue-grey, iron-oxide-speckled surfaces are sculpted to become melodiously curvaceous and smooth – both devoted to the sufferings of people in the war-ravaged Balkans. They show a tragic trinity of integrated figures – a mother and clearly howling father with a dead child in their arms. In the polyphant version, it appears as though a single parental arm encompasses two orbs, representing the child's head and body – appearing like a serpent wrapped around two infinitely precious eggs.

A late 1990s' polyphant carving, 'Strength in Unity', also depicting a mother, father and child in sinuous, interlocking forms reminiscent of buds, eggs, cylinders and vertebrae, shows a family in postures of loving mutual care. What is noticeable here is how the bulky paternal figure, whose right arm protectively envelops his slighter wife and child, is in fact literally dependent on the rooted support of his family: without them, his sturdy figure would lose balance, simply fall away and, no doubt, be shattered.

When Smith originally made a maquette for what turned out to be the polyphant sculpture 'The

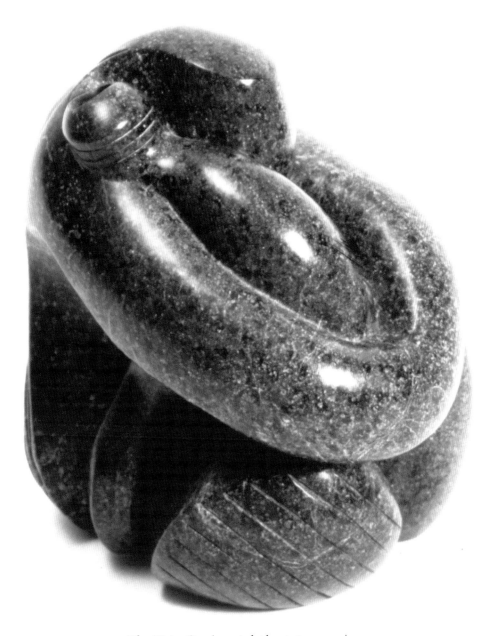

The Water Carrier – polyphant stone carving

Water Carrier', the piece depicted a mother holding a child tightly in her arms. The finished sculpture actually depicts a person, indeterminate in gender, holding some kind of lidded vessel or bottle in a characteristically serpentine embrace. In fact, the water bottle itself could be observed as a fiercely loved child in a maternal embrace. There is a mystical and symbolic equivalence made here between child and water: both are the well-spring of life.

SMITH'S FAVOURITE TOOL is the hacksaw blade, with which he can flesh out his orbic figures. But after extensive hacksawing, he often returns with a 'little chisel'. "I go round, break up the area a bit. I start putting more sharp things in, but not losing the roundness." Thus in 'The Water Carrier', simple parallel lines have been incised to describe the rim of the water vessel and the abstracted form of the subject's feet.

In another sculpture, depicting a figure deep in meditation, the form of his fingers held over the top of his head has been sharply chiselled out; the resulting shape uncannily also resembles a bird's plumage. Long, craftsmanlike contemplation distinguishes all Smith's work. "The process of stone is very slow", he says, "because it takes a long time to carve it! And that gives me time to think. I'm normally a very quick thinker but with stone I'm quite meticulous. I think sculpture is what I was made for really." ●

JEANINE de WAELE

A Way of Being

Paintings luminated by nature and spirit. *By Jenny Balfour-Paul*

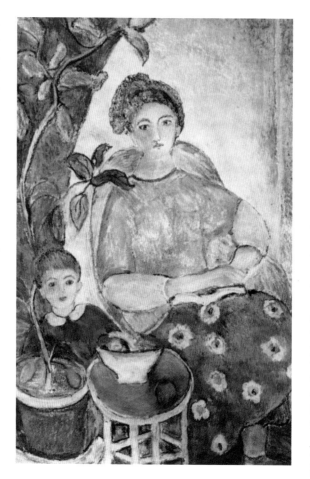

TALKING TO Jeanine de Waele about her life is much the same experience as looking at her paintings. There is an elusive quality to this artist. Jeanine has an attractive, almost childlike instinctiveness in her response to nature, which is reflected in her paintings.

Jeanine's upbringing could hardly have been more rooted in the natural world and the rhythms of the agricultural seasons. As she recounts her childhood in the south of Holland, she portrays an extended family whose lives were dominated by the family business of linen production. Idyllic early memories include riding in horse-drawn carts during the flax harvest, and the freedom to make huge bonfires, climb the tallest trees and bicycle with the wind along the flat paths beside the canals. Among dominant family influences were her paternal grandmother, a descendant of the Flemish painter Quentin Massys, and her father, who took time out from the business to introduce his children to the museums of Europe. Despite these visits, Jeanine was not encouraged to be an artist, either by her parents or by the milieu of a restricted convent schooling as a teenager. Instead, she made up her own mind one day when, as a child, she was drawing with a new set of pencils. But her father's influence was strong, and on returning to Devon after her father's funeral, Jeanine was so moved to find all the local fields of flax in flower that this sparked off a series of paintings.

One senses that Jeanine still misses the bedrock of family support that underpinned her childhood. Since the 1980s she has had her own family around her in her house, full of character in the shadow of Totnes Castle, and wider 'family' of the community that gravitates around Dartington Hall. But between the two periods of grounded family stability came formative years of travelling in Europe and feeling her way as a painter.

It was not always plain sailing, but her creative voice came under some pivotal influences. Among these were a spell in Amsterdam taking art and education courses and time spent as a model for the Spanish painter Joachim Torrents Llado, who repaid her with drawing and painting lessons. Meanwhile, transatlantic journeys as crew on sailing ships reinforced her sense of adventure.

Then Jeanine met Andrew, her future husband, and together the pair lived for two years in Deya in Majorca, a mecca for creative artists since World War Two, most famously the poet Robert Graves. Here Jeanine encountered among others the American painters Dorothy and Bob Bradbury, and her real art education began. Every day she went out into the dazzling landscape, sat on the ground and painted. In the evenings the artists would discuss their work, and above all the mystery of colour.

These two years came at a vital point in Jeanine's career as an artist, and she has never looked back. After experiencing the warmth and reflected sea

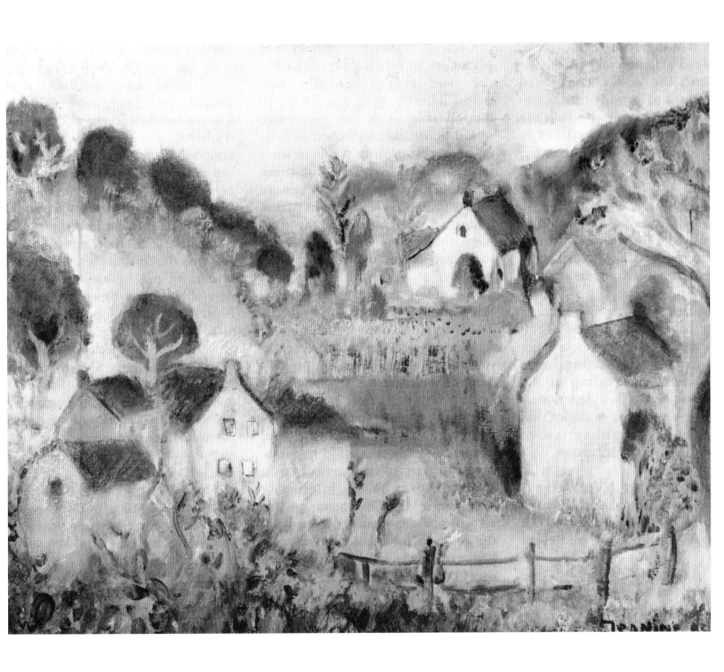

light of Majorca, it is small wonder that years later Jeanine was so inspired by the special qualities of the Scilly Isles that on a painting trip there she produced a most successful series of paintings. But the rural landscapes too of her beloved Devon, seen even from the rooftops of Totnes, are always filled with warmth and light. I think Jeanine would be incapable of painting a muted grey and brown landscape – these colours are simply not in her vision. To her, colour is not a photographic representation of reality, but is instead an expression of emotion, a means of portraying a spiritual response to nature.

For this reason she loves yellow, a joyful colour, and its complementary turquoise blue. She is never

happier than when an owner of one of her paintings tells her that it lifts the spirit. 'Visionary' is perhaps a word that aptly describes much of Jeanine's work. All her paintings spring from reality, but something happens as she works on them in her modest studio. She begins by drawing and painting the bones of a work directly in the landscape, or resorts to still lives and portraiture when the weather is bad (bringing in elements of the outdoors such as flowers). But she feels too overcome by nature to aspire to represent it exactly. Instead she nurtures her paintings in her studio, sometimes for several years, until the moment arrives when she can use her memory and imagination to transform them into something more personal. ●

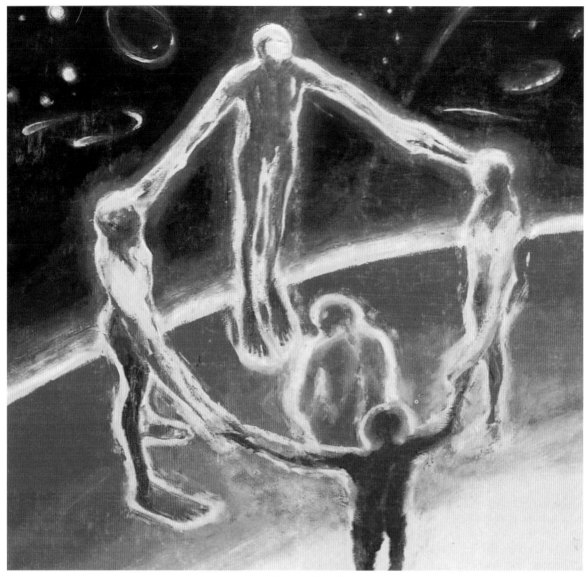

Celestial Ring (detail)

FRANS WIDERBERG

Northern Lights

Humanity's spiritual heritage. *By John Lane.*

ALTHOUGH FRANS Widerberg has exhibited his paintings in this country – in 1987 in Brighton and in 1992 at the Barbican Gallery in London, as well as a number of smaller shows – he is relatively little known. Which is deeply unfortunate, for, as Michael Tucker writes in *Frans Widerberg: Pictures, A Journey*,

"Over the last thirty years he has produced a uniquely inspiring body of work – a body of work which, in its reshaping of the theme of figure and landscape, and its simultaneous revivification of ancient aspects of humanity's spiritual heritage, merits the closest attention."

Widerberg's paintings are exceptionally large in

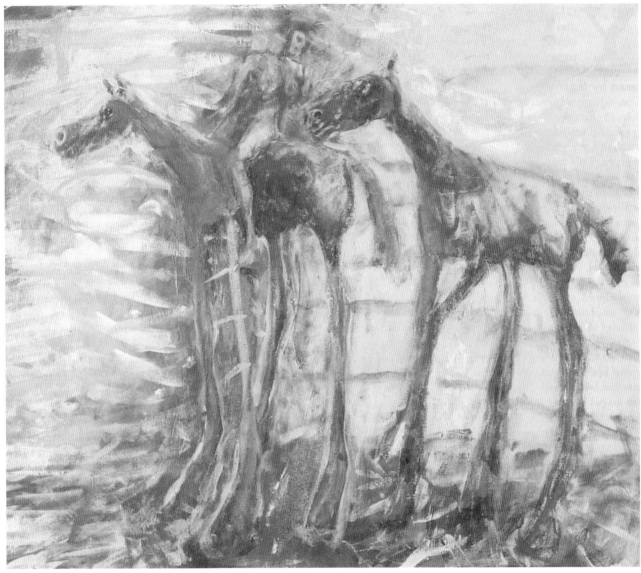

Horses and Rider

size, brilliant in colour, almost burnished as if caught by the sun – light streams from them as from an inner fire. Their subject matter almost always includes naked human figures, sometimes solitary, sometimes mounted, sometimes standing in groups, sometimes hovering; ecstatic figures floating or falling through the cosmos. Something cosmic irradiates his entire work.

A spectrum of strong colours – reds, yellows and blues – emphasizes this point; suns and stars also help to suggest the cosmic nature of Widerberg's art. This is not the space of French and English painting, but the deep, infinite, yearning space one finds in the painter Edvard Munch; a space where, with ease, the soul can fly or contemplate the transparent majesty of life's deepest energies. To see, says Widerberg, is to listen to the language of light. But Widerberg's paintings suggest not only irradiation, but the soul's ecstatic, healing journey towards the paradisical heights.

Interestingly enough, Michael Tucker's beautifully produced book is subtitled 'A journey', and the journey to which it refers is, for me at least, the Shaman's journey into the cosmic dimension of existence. Seen from this perspective his art can be understood as an important and very beautiful contributor to the rediscovery of the sacred in our time. Let Michael Tucker, who writes with such deep understanding of and sensitivity towards Widerberg's art, have the last word. "Not for nothing", he says, "does this artist characteristically render humanity and nature in the same rainbow-envelope of pure, energizing colour. Like the poetry of Rilke, the art of Frans Widerberg offers us a naked, yet essentially relational breathing space for the soul. Exploring this painterly and passionate space, a space as intelligently yet intuitively conceived as it is sensuously realized, we can begin to breathe deeply; we can begin to make the world." ●

Nightshade

JOHN WILDE

A Parade of Beauty

He makes you love the beauty of a wormhole in a leaf. *By Donna Gold*

FROM THE CENTRE OF America's heartland plain, golden and scrubbed – comes John Wilde, a painter whose luminescent dreamscapes scratch the great longings of humanity: life, love, beauty and death.

Immersed in a deep knowledge of nature, Wilde (pronounced will'-de) paints an odalisque wrapped in tendrils of a strawberry plant, echoing Botticelli's 'The Birth of Venus', veiled in her golden hair. A strawberry is what covers Wilde's woman, but the strawberry she hugs to her breast is huge, half the

size of her torso. Wilde's title, 'To Make Strawberry Jam', becomes part tease, part salute to the artist's Wisconsin home, which is located smack in the midst of the great American farmland. Here, fertility is celebrated annually, though obliquely, at agricultural fairs across the state. Those huge melons, those swollen zucchinis exhibited with such pride, can they be anything but suggestions of other forms of natural swelling?

But Wilde's disturbances embrace life. His brilliance is that life for him encompasses distress and

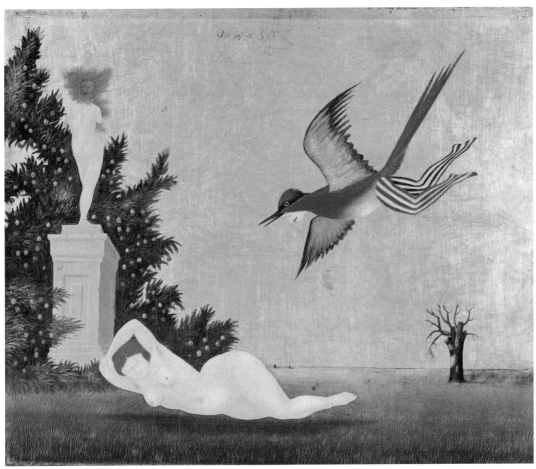

The Dream

death as well as beauty and bounty. Wilde is also one of the best draughtsmen around. A Wilde turnip or beetle is a feast for the eyes, but Wilde won't leave it as mere flora or fauna. He spears the beetle and sets the turnip next to a glass of wine on a tablecloth that could use a bit of ironing – and lets the turnip levitate.

In a quintessential Wilde painting, 'Two Red Birds, a Dagger and a Revolver', a beast with a raccoon tail, a human face and a large dog's body stands with its four-fingered, humanoid hand on a bright red bird. That bird is crushed but another flies overhead. What has happened? Why is the red bird dead? What are the papers that fly overhead? A love letter? A red letter day? A warning? We look. We ponder. We don't dare interpret. Beyond craft beyond nearly perfect craft, I should say – Wilde brings us to wonder, and that's where we, the viewers, remain. His paintings feature the sublime, the essential, and, for that reason, the turbulent. They don't flinch, but they don't make judgements either. One creature stomps on another. That is. All may die. That, too, is. Death is part of life, after all.

Disturbing, fabulous, Wilde's paintings are not about interpretations, but about relishing the improbable, the unknowable, just as a woman first fully understands death only when she holds her own given life, her own child, in her arms.

"WILDE LOVES LIFE," says Penelope Schmidt, who has shown his work in her gallery for fourteen years. "He knows what's of value. And his work comes from true experience, from working in his garden, walking his fields, collecting bird skulls – he understands the wonderful regenerative quality of nature, how skulls and fruits relate formally as well as metaphorically."

Fortunately for us, over sixty years many of his experiences have made it on to paper and canvas. Drawings and paintings rest in some of the finest museums across the United States, though Wilde's work has not been popular for much of his life: in the midst of the great abstract expressionist revolution, his art always had a subject. Now that magical realism is becoming popular, his work is gaining greater notice.

In Wilde's world, life is sensual, life is confused, life is tormented, life is full. Should we only just look, life is a parade of beauty. And this gentle, kind man helps people to look, to notice and above all to love. As Schmidt says, "Wilde makes you love the beauty of a wormhole in a leaf." ●

185

CHRISTOPHER WOOD

Timeless Sanctuaries

Work that grows out of an imaginative inclusiveness.

By Nicholas Usherwood

"All that moves me most deeply in Nature are the unfathomable things – deep water, skies, clouds, effects of light, waterfalls – everything which has yet to be painted."

– Christopher P. Wood:
sketchbook note *c*.1988–90

ALTHOUGH WRITTEN nearly fifteen years ago at what was, effectively, the start of his painting career, this scribbled sketchbook note still defines the essential character of Christopher P. Wood's work, the poetic realization in paintings of landscapes at once both closely observed and intensely imagined, where interior and exterior worlds meet in images of an ever-increasing complexity and mysteriousness of thought and feeling.

For it was images, or rather the general lack of them in the work he had been producing as an art-school student – first in his native Leeds (where he was born in 1961) and then, subsequently at Chelsea School of Art in London, in the mid-1980s – that first created in him what he later described as a moment of profound shock and fear ("a sense of fracture and life without meaning") and then the slow realization that "the absence of images might have played such a vital role in this fracturing process."

Turning his back on a promising future producing paintings in a very slick and contemporary Young British Artist manner – his immediate Leeds contemporary was Damien Hirst – and a sell-out postgraduate show at Chelsea, Wood returned to live and work in the North of England. This return to his childhood roots, so to speak, was crucial. The Wharfedale landscape close at hand that he had known and walked time and again as a child now became the close subject of scrutiny. The drawings and watercolours he now made of it marked an immediate and dramatic shift in his art. The radically simplified green wooded valleys, field bottoms and moorland tops of Wharfedale became the starting point for an increasingly complex imaginative journey into an interior landscape: one filled with mysterious objects and markers intensely suggestive of the historic and human life within it that continues, essentially unchanged in feeling, to the present day.

Wood's works are images of wholeness and inclusiveness. Moreover, these images have a great deal of significance at a point when the worlds of scientific and artistic thought are both, equally, poised at a moment of fundamental and necessary change – that paradigm shift in thinking so well encapsulated in the philosopher Mary Midgley's remarkable book *Science and Poetry*. In it she makes an impassioned plea for a new vision of the world in which we live, one where science at last begins to accept the consequences of the levels of complexity we keep discovering about ourselves and the physical world we inhabit, and one where poetry and art begin to provide the kind of concentrated language and imagery through which the human imagination can begin to grasp these complexities more powerfully.

It is, as far as science is concerned, a plea for a new wholeness of vision in which humankind finally lets go of the old mechanistic idea of the world as a 'thing' and takes on the urgent task of reaching an understanding of our place within it as one – conscious – thing in a world of objects themselves no less intent on the question of being.

Certain poets and painters, disregarding the pseudo-avant-gardist, ironist fashions of their time, are responding in their own characteristically intuitive way to these new demands. For example, the Polish poet Adam Zagajewski, in *Another Beauty* (2000), has remarked that the most absorbing questions are the ones we cannot answer, that there is something mysterious in the way the Earth and things exist, in which the idea of nothingness that troubles certain thinkers is simply not their concern, for, as he goes on to observe, they agree to every kind of light, every kind of weather, so that they may seize each moment and exist: simply being in the moment is a serious enough reality for them.

Feast Day

This could almost stand as a description of the intensity of feeling that also inhabits the settlements of delicate, upward-soaring ladders, probing plant-like antennae and enigmatically engraved rocks that populate Wood's recent landscape painting. 'Feast Day' (2002) is an outstanding example. With its luminous traceries of rainbows and streamers of colour, empty, waiting chairs and burning fires, strange clouds of glittering dust and glimmering earth lights, open doors and ambiguous architec-

tural structures and occasionally, too, a solitary bird, it creates a kind of parallel universe both ancient and immediate in character, somewhere we know already in our imaginative hearts.

Wood's own commentary on this astounding and profoundly emotional imagery, which he sees as emerging out of that "infinite stream of lyric truth stretching unceasingly in time and space and artists working in a symbiotic relationship with it", would seem to reflect something of this same sensibility

189

Escape Route

towards 'things'. The plant-like forms are "listening posts, listening to the world, the whole vision of a perfect world"; the colonies of ladders linking heaven and earth, part of "a timeless paradise garden ready for people to come into and be", the physical world quietly awaiting the arrival of a new order of thinking people, prepared to be on terms with it. And then, perhaps, in emulation of Dante at the very end of *Paradiso*, to climb up the ladders and to find, at that point, "the love that moves the sun and other stars".

In an artistic climate that has acquired the unhelpful habit of ironic disengagement and where any kind of painting other than that engaged in self-referential, abstract mark-making is dismissed as adhering to 'traditional values' and therefore not to be considered seriously, this passionate affirmation of the greater more urgent truths of such ecstasy and poetry in painting can give such work an utterly unfamiliar charge of emotion.

Yet, paradoxically almost, it is precisely through the tenderness and brimming fluency with which they are painted, the constant, unexpected richness of the colour Wood uses, that his paintings truly engage us, providing the vehicle by which we are taken on a journey, with the artist, to these timeless sanctuaries of our consciousness. And the feeling too, that in the very making of these paintings the artist is setting down and exploring things he doesn't know, reacting to these images that emerge at the end of his brush with almost the same kind of awed astonishment as ourselves. ●

190

Artists' contact details

If you wish to contact one of the artists featured in this book and his or her name is not included in the list below, please write c/o Resurgence, Ford House, Hartland, Bideford, Devon EX39 6EE.

Robin Baring www.annebaring.com. annebaring@freeuk.com.

John Bevan Ford www.fordart.co.nz. fordart@clear.net.nz.

Cecil Collins' pictures can be seen at The Tate Britain.

John Danvers www.johndanversart.co.uk. Danfam@beeb.net.

Alan Davie Dealer: René Gimpel, Gimpel Fils, 30 Davies Street, London W1K 4NB. Tel: 0207 493 2488.

Daniel De'Angeli www.danieldeangeli.com gk.enterprises@virgin.net. Agent: Gillian Elliott, 3 Hazelmere Road, London NW6 6PY. Tel: 020 7624 0486.

Chris Drury www.chrisdrury.co.uk c/o Stephen Lacey, Gallery 1, Crawford Passage, Ray Street, London EC1 3DP. Tel: 020 7837 5507.

Andy Goldsworthy Agent: Michael Hue-Williams, 21 Cork Street, London W1S 3LZ.

Keith Grant Gamlegata, P.B.7. 3834 Gvarv, Norway.

Morris Graves www.morrisgraves.com.

Chris Hall (no relation to Marianne Hall) is also a sculptor. His work can be seen at The Abbey, Iona, among other places.

Marianne Hall Snostormsgatan 9, 72350 Vasteras, Sweden. Tel: 46 21 803370.

Joan Hanley jhanley@jlc.net or gtable@jlc.net. Joan Hanley, Green Table Productions, 711 Wilton, NH 03086, USA.

Berit Hjelholt Ellidsbolvej 37, 9690 Fjerritslev, Denmark. Tel: 98 22 53 53, Fax: 98 22 57 22.

Andrzej Jackowski www.jackowski.co.uk. Gallery: Purdey Hicks Gallery, 65 Hopton Street, Bankside, London SE1 9GZ. Tel: 020 7401 9229.

Janakpur Art c/o Rebecca Hossack, 35 Windmill Street, London W1P 1HH. Tel: 0207 436 4899.

Ynez Johnston c/o Penny Schmidt, 26 East 10th St. Apt 8G, New York, NY 10003, USA.

Giles Kent www.gileskent.co.uk. Tel: 020 8692 3895.

Victoria King is an artist living in the Blue Mountains in Australia.

Tony Lane lanestevenson@xtra.co.nz.

Richard Long www.richardlong.org. www.therichardlongnewsletter.org.

Nicky Loutit www.nickyloutit.co.uk. jonnygathorne@freenet.co.uk. Art Dealer: Sally Hunter Fine Art. Tel: 0207 727 2869.

Shakti Maira Shaktim2@vsnl.com. B-273, Greater Kailash 1, New Delhi 110048, India.

John Moat www.johnmoat.co.uk. amoat@tiscali.co.uk. His new book of poems *Hermes and Mary Magdalen* with etching illustrations will be published in 2004 by Typographeum Press.

Harold Mockford 45 Hillcrest Road, Newhaven, BN9 9EE. Tel: 01273 611616.

Fernando Montes fernandomontesP@hotmail.com. Studio: 57 Compton Road, London SW19 7QA. Gallery: JARFO 8F Jo-in Bldg., 5 Hiramachi, Saiin Ukyo, Kyoto 615 0022, Japan.

John Napper c/o Mrs P. Napper, Steadvallets, Bromfield, Ludlow, SY8 2LB.

David Nash c/o Haines Gallery, 49 Geary Street Fifth Floor, San Francisco, CA 94108, USA. Tel: 415 397 8114 Fax: 415 397 8115. info@hainesgallery.com.

Margaret Neve 18 Greville Place, London NW6 5JH. Gallery: Robert Sandelson, 5 Cork Street, London W1S 3NY. Tel: 020 7439 1001. Fax: 020 7439 2299. www.robertsandelson.com.

William Peers info@jmlondon.com. www.jmlondon.com/pages/artist/330.html John Martin Galleries, 6 Burnsall Street, King's Road, London SW3 3ST. Tel: 020 7499 1314.

Peter Randall-Page www.peterrandall-page.com. contact@peterrandall-page.com. PO Box 5, Drewsteignton, Devon EX6 6QN.

Haku Shah hakushah@jindalonline.net. 16 Nemnath Society, Narayan Nahar Road, Paladi, Ahmedabad 380007, India. Tel: 6636741.

Greg Tricker Tel: 01453 834975. His book *The Catacombs* is available. Gallery: Piano Nobile, 129 Portland Road, London W11 4LW. Tel: 020 7229 1099.

Janine de Waele www.jeaninedewaele@catch.com. jeaninedewaele@hotmail.com. By appointment at Totnes Art Labs, 12 Castle Street, Totnes. Tel: 01803 865344. Webbs Gallery, 67 Webbs Road, London SW11 6SD. Tel: 020 7223 1733.

Frans Widerberg's book (*Frans Widerberg: Pictures, A Journey*) is published by Labyrinth Press, Skoveien 2, 0657 Oslo, Norway. Tel: 00 47 2255 0205.

John Wilde Spanierman Gallery, 45 East 58th Street, New York, NY 10022-1617, USA.

Evelyn Williams www.evelynwilliams.com. evelyn@evelynwilliams.com. 12 Finsbury Park Road, London N4 2JZ. Tel: 020 7226 4916.

Notes on Contributors

Peter Abbs is Professor of Creative Writing at the University of Sussex and the Poetry Editor of *Resurgence*.

William Anderson is a poet.

Christopher Andreae is an author.

Roger Ash Wheeler is a homoeopath practising in Devon.

Jenny Balfour-Paul is a writer and lecturer on art.

Roger Berthoud worked for the *Independent* newspaper.

Emma Critchton-Miller is a journalist and TV producer specializing in the arts.

Lindsay Clarke is a novelist.

Anne-Lise Clift is an art historian.

Valerie Fraser is a lecturer in Latin American art at the University of Essex.

Suzi Gablik is author of *Living the Magical Life* and other books.

Donna Gold is an American art critic.

Gabrielle Hawkes is a painter and has an art gallery in St. Just-in-Penwith, Cornwall.

Rebecca Hossack runs a gallery in London specializing in native art from around the world. www.r-h-g.co.uk.

Timothy Hyman is a painter and writer.

Mark Kidel is a documentary film-maker.

Satish Kumar is Editor of *Resurgence*.

John Lane is a painter and the Art Editor of *Resurgence*.

Hazel Leslie is a freelance writer and book reviewer.

Oliver Lowenstein edits *Fourth Door Review*.

Selina Mills is a freelance reviewer, writing on art and travel.

June Mitchell was Managing Editor of *Resurgence* from 1975 to 2000.

Thomas Moore is a former monk and author of many books.

Kathleen Raine, poet and Blake scholar, died in 2003.

Elizabeth Rogers is an art historian.

Bernard Samuels was Director of Plymouth Arts Centre from 1971 to 1995.

Ian Skelly is a writer and broadcaster.

Matthew Sturgis writes for the *Daily Telegraph*. He is the author of *Aubrey Beardsley: a Biography*.

Tom Trevor is Director of Spacex Gallery in Exeter.

Nicholas Usherwood is a writer on contemporary art and culture.

Philip Vann is a writer on the visual arts and an exhibition organizer.

Keith Walker is Canon of Winchester Cathedral.

Resurgence

Resurgence has been described in *The Guardian* as "the spiritual and artistic flagship of the green movement". If you would like a sample copy of a recent issue, please contact:

Jeanette Gill, Rocksea Farmhouse, St Mabyn, Bodmin, Cornwall PL30 3BR
Telephone & Fax 01208 841824 www.resurgence.org

In the USA:

Walt Blackford, Resurgence, PO Box 404, Freeland, WA 98249